THE
PROFITABLE ARTIST

SECOND EDITION

*A Handbook for All Artists in the Performing,
Literary, and Visual Arts*

NEW YORK FOUNDATION FOR THE ARTS

WWW.NYFA.ORG

ALLWORTH PRESS
NEW YORK

NYFA
New York Foundation for the Arts

Allworth Press books may be purchased in bulk at special discounts for sales
promotion, corporate gifts, fund-raising, or educational purposes. Special
editions can also be created to specifications. For details, contact the Special Sales
Department, Allworth Press, 307 West 36th Street, 11th Floor, New York, NY
10018 or info@skyhorsepublishing.com.

22 21 20 19 18 5 4 3 2 1

Published by Allworth Press, an imprint of Skyhorse Publishing, Inc. 307 West
36th Street, 11th Floor, New York, NY 10018.

Allworth Press® is a registered trademark of Skyhorse Publishing, Inc.®, a Delaware
corporation.

www.allworth.com

Copublished with the New York Foundation for the Arts

Cover design by Mary Belibasakis

Library of Congress Cataloging-in-Publication Data

Names: New York Foundation for the Arts.
Title: The profitable artist: a handbook for all artists in the performing,
 literary, and visual arts / New York Foundation for the Arts.
Description: Second edition. | New York, New York: Allworth Press, An imprint of
Skyhorse Publishing, Inc., 2018. | Includes bibliographical references and index.
Identifiers: LCCN 2018019442 (print) | LCCN 2018020282 (ebook) | ISBN
 9781621536451 (eBook) | ISBN 9781621536420 (pbk.: alk. paper)
Subjects: LCSH: Art—Economic aspects. | Art—Marketing.
Classification: LCC N8600 (ebook) | LCC N8600 .P75 2018 (print) | DDC
 706.8—dc23
LC record available at https://lccn.loc.gov/2018019442

Print ISBN: 978-1-62153-642-0
eBook ISBN: 978-1-62153-645-1

Printed in the United States of America

Contents

The Profitable Artist, Revised

When our book was first issued in 2011, we did so at the request of our publisher, who had learned about our entrepreneurial training courses in New York City, and thought that our way of approaching the career of an artist might also be of value to creative individuals residing elsewhere. Little did we know then how one book would end connecting us to places all over the country and in different parts of the world. This book is now used as part of core curriculum reading in many universities and colleges throughout the United States, and we have been invited to many outstanding academic institutions to conduct training workshops based on the book.

Our experiences in bringing the lessons of this book via in-person workshops to such places as the Maryland Institute College of Art, Massachusetts College of Art & Design, Rutgers University, Greater Pittsburgh Arts Council, Rhode Island School of Design, and American University, among others, has provided us with an opportunity to gain greater insight, deeper understandings, and wider knowledge on just what it takes for any artist in any discipline to succeed in today's marketplace. Moreover, because the book also brought us to the attention of other countries where artists are looking for international exchanges and presentation opportunities, our reach extended to such places as the China Federation of Literary & Art Circles, Centre for Creative Practices in London, Costa-Rica-North American Cultural Center, Arts Council England, Universidad Francisco Marroquín, and

Instituto Guatemalteco Americano, to name a few. These resources, networks, and relationships have allowed us to deeply mine and reflect upon the tools and frameworks that can best help any artists achieve their dreams. It is our hope that we have taken all of this updated or new information and communicated in a way so that all artists can benefit from it.

We strongly believe in the creative process and the commitment of time it takes to bring ideas together in a way that can communicate to many the unconscious narratives that reside in all of us so that, when we open up, it allows us to see ourselves in others, bridging difficult and complex feelings that often can cause separation or defensive belief systems. That is why, since our founding in 1971, we have awarded more than $80 million to individual artists and emerging arts organizations. We must always support the creative process, we must always acknowledge the artists as a first responder to society's state of being, and we must always provide the gift of time to those who represent the best of civil society. Perforce, we will continue to fund artists and bring them the necessary services that they need to sustain themselves, as it is a privilege to do so.

Last, this new edition of *The Profitable Artist* would not have been possible without the leadership of our Board of Directors and its Chair, Judith K. Brodsky, the dedication and expertise of the NYFA staff, and the support and encouragement of our many funders. Further, I want to thank, with much appreciation and gratitude, all those who individually contributed to the book and to my coeditors, Felicity Hogan and Peter Cobb, for their stamina, determination, and humor in bringing everything together. We dedicate this book to all artists everywhere!

For more information on the New York Foundation for the Arts programming, visit www.nyfa.org.

—Michael Royce
Executive Director
New York Foundation for the Arts

The Profitable Artist

Reading the title of this book, *The Profitable Artist*, you might think that we are asking you to take an exclusively commercial approach to your art. That's not the case. In reality, the purpose of this book is to provide a structured framework of information that will help you move toward profitability, stability, and/or sustainability. We recognize that most artists, despite the fact that they are running their own businesses (and often without realizing that is exactly what they are doing), have not had access to business training and are unfamiliar with many of the terms and concepts in the business world. Additionally, they can often be confusing and overwhelming.

NYFA believes that artists are not only capable of interweaving art and business, but that they are uniquely qualified to do so. Our premise—based on more than forty years of observation—is that artists are innately prepared with the skills needed to be "profitable artists." Artists of all disciplines possess special skills and qualities that they use in their art and can apply to their careers. For example, artists are keen critical thinkers and problem solvers. They combine creativity with ingenuity on a regular basis. They possess a strong work ethic that helps them complete their work, and the emotional fortitude to stick with a project when it becomes difficult. Finally, they are fiercely independent. Any one of these qualities would be highly prized in an entrepreneur; the combination is formidable.

If this seems intimidating, we would encourage you to think about how much hard work and skill goes into making your art. Developing your project or practice professionally is a much easier process. It boils down to having an awareness—and working knowledge—of practical business information in five main topic areas: strategic planning, legal rights and obligations, financial management, marketing, and fundraising. This book aims to bridge the gap between what you know now—your fundamental skill set—and the day-to-day practicalities of running a business in the arts. NYFA recognizes, however, that it is impossible to create a "one-size-fits-all" document that will take you through every step of your career. As we do in our in-house learning programs, we take a high-level approach to these topics and ask you to apply the information in a way that makes sense for your individual situation.

By exploring the relationship of each of these topics to your art, you will understand what you need to know to make informed decisions on the direction of your career and the viability of a particular project or strategy. We have created this book with the thought that you can return to it on multiple occasions for a variety of uses. You can dip in and out of chapters related to what's happening in your career. For example, if you have an event coming up and want to create a marketing plan, the marketing section would be ideal. You may also have more knowledge in one topic than another and want to focus your efforts accordingly.

The Profitable Artist focuses on all artists and art forms because we believe that artists share more similarities than differences when it comes to their professional development needs. This is not simply a matter of artists being more likely than nonartists to run into copyright concerns, or that they deal with grant applications more than the average person. Instead, it is a recognition that the fundamental skills that make for artistic success can also lead to professional success, regardless of the discipline. While we cannot possibly cover all of the major topic areas in a few chapters, we can help you to become more aware of the environment in which your business operates.

There were innumerable contributions to this book from staff and outside experts who support both NYFA and artists generally, and they are thanked and acknowledged later. However, we did want to call attention to the major written contributions by Elissa Hecker, Esq., and Zak Shusterman, Esq., in section 2 (covering legal issues), to Rosalba Mazzola and Julian Schubach in section 3 (covering financial issues), and to Mara Vlatković in section 4 (covering marketing issues). Their expertise and excellent work were both absolutely essential and deeply appreciated.

As NYFA continues to develop curriculum materials in the area of entrepreneurial training, we encourage you to stay connected to our organization via our website www.nyfa.org and to NYFA Learning, whom you can contact at learning@nyfa.org, if you have any feedback about or interest in particular subjects discussed in this book. We will be providing webinars addressing various subtopics of this book, which will enable you to interact with experts and have your individualized questions answered. More information is available at www.nyfa.org.

One final note, as you read through this book: we encourage you to write down your thoughts—questions, aha moments, developing themes, and emotional insights. Then review these writings periodically as you go about your practice and look for ways that your practice and your business for the practice synthesize themselves for a genuine integration of aspiration, inspiration, dedication, and creation to successful realization of your dreams and work. Good luck!

SECTION I

PLANNING AND STRATEGY

Introduction

For an artist, there is tremendous value in looking at the field of strategic planning, especially on the organizational level. Time, study, and resources have long been devoted to creating tools that help large organizations plan effectively. Not all of these tools are useful or appropriate for individuals, but there are valuable lessons that can be applied to your practice or project.

In the first chapter, we will look mainly at more traditional planning techniques. There are a variety of models in existence, all of which may be appropriate depending on the size, history, resources, field, or character of the company or organization in question. Despite the absence of one dominant model, strategic plans tend to have certain basic common characteristics. Most embody a top-down structure, beginning with defining the mission and values of the organization, along with a long-term goal or vision. These are known as a mission statement and a vision statement. Strategic plans then enter an informational stage, where the organization surveys the environment in which it operates and begins to classify some of that information. This is often accomplished through what are known as an "environmental scan" and a SWOT (Strengths, Weaknesses, Opportunities, and Threats) analysis. Finally, the organization uses that information to plan specific goals and objectives that are defined in the context of its mission and vision and the internal and external data gathering (environmental scan) and assessments (SWOT analysis).

In the second chapter, we will look at models that are being used in the start-up world, particularly with technology companies. The focus will be on what are known as the "Business Model Canvas" and "The Lean Startup."

Let's examine all of these techniques in more detail and see how they can be applied to your art career.

Strategic Planning for Artists

A MISSION STATEMENT AND VISION STATEMENT

While mission statements and vision statements are sometimes combined, they have distinct roles. A mission statement is a phrase (or several sentences) that answers the following questions: What does the company/organization do? What is its reason for being, its fundamental purpose or direction? To be able to accomplish this in less than two dozen words is ideal, but very challenging. For example, NYFA's mission is "to empower artists at critical stages in their creative lives."

While the statement's primary audience is internal—serving to give direction and purpose to those working at every level of the organization, as well as other stakeholders (boards of directors, volunteers, and members, etc.), it also communicates to constituents and supporters why they should support the organization.

A vision statement can take different forms. One, it may be aligned with a current organizational strategic goal, stating that, for example, by 20xx the organization *will* be, do, whatever that goal is. More commonly, the vision statement lays out the organization's core values and answers the questions, what is the organization committed to, and what will it refuse to sacrifice under any circumstances (the "nonnegotiables")? Sometimes the vision statement is referred to as a values statement insofar as it is the lens through which all other decisions are filtered. In other words, if a product, service, or activity

does not align with the organization's vision, it should not be undertaken. For example, suppose a funder offered a grant to undertake a project that was unrelated to both the organization's mission and vision. In this case, the mission and vision provide a litmus test for assessing whether to accept. If there was no alignment and it would pull the organization away from other activities related to its mission, accepting the funds would not be beneficial.

When a business or organization sets out its goals to achieve its mission statement, it does so in accordance with the core values set forth in the vision statement. For example, an organization whose mission is dedicated to supporting artists working in photography and engaging audiences through creation, discovery, and education will use that mission as a filter when setting programmatic goals to be accomplished during the future, which means that they are highly unlikely to plan to develop a ceramics or jewelry program.

For an artist, establishing a plan for your project or practice begins with your mission and vision statement. Before you can set goals and benchmarks, or make plans to reach these, you need to have a clear understanding of who you are and what you want. Begin with identifying either your mission or your vision. If you have a project in mind or a clear long-term goal, it makes sense to start with your mission. If you are more focused on your overall practice, clarifying your vision may help you to discover your mission. If you are having trouble differentiating the two, think of your vision statement as those core values and principles upon which you will base your project or practice.

Adding Substance to Your Vision

Recognizing your mission and vision is a great start. However, you still may wish to generate both a written mission and vision statement. These should be clear enough both to guide you and to communicate your mission and vision to the outside world. Think of this as your response to a stranger or a family member asking what you do and why.

That is where the practice of writing a statement (or multiple statements) becomes essential. As we will discuss throughout this book, having the ability to summarize your mission, vision, artistic approach, methodology, and anything else related to your project or practice both verbally and in writing is important. Different kinds of statements are required (or are at least useful), in different contexts. Most visual artists have encountered the term "Artist Statement" at some point, and any artist who has worked with a business or not-for-profit organization has likely come across a "Mission Statement." As we will discuss in later chapters of this book, a statement is a necessary tool for taking advantage of opportunities like grants, jobs in the field, marketing and branding efforts, and even certain legal requirements. While mission, vision, and artist statements are all different things, writing a statement that coherently communicates your message can be very important for your arts business, marketing, or fundraising!

In terms of the actual nuts and bolts of statement-writing, we would recommend keeping it simple, concise, and removing any unnecessary words. You do not want the reader (including yourself) to be confused—try to avoid "art speak," which can be confusing to anyone who is not part of the arts industry. If you have carefully thought through your mission and vision, you will have an easier starting point. One technique is to start with making sure your verbal statement is clear; sit down with several friends or acquaintances and describe both your mission and vision. Give them a few minutes, then ask them to repeat both back to you. When you start to hear consistent results that reflect your thinking, you are on the right track! You may even want to note some of the language that your friends use—if a phrase or term sticks with several people who are not intimately familiar with your project or practice, there's a good chance that you have found a phrase that resonates.

Exercise 1.1: Writing a Mission Statement and Vision Statement

Using the space below, draft 1) the mission statement for your project or practice, and 2) the vision statement for your project or practice. Use additional sheets if necessary, and be prepared to revise.

Mission Statement:

Vision Statement:

AN ENVIRONMENTAL SCAN AND SWOT ANALYSIS

The next step in the organizational strategic planning process is to do an environmental scan and a SWOT analysis. This allows an organization to gather and filter the information it needs to make informed decisions about achieving its long-term goals. Without having done these analyses, it is very difficult to set both the shorter-term objectives and the most efficient ways to reach them, which are at the heart of the planning process.

Artists can benefit from undertaking the same process. Let's examine the definitions of each:

"Environmental Scanning"

An environmental scan is another way of saying, take a look around you. Defined in the business world as gathering and analyzing information about the environment in which an organization operates, environmental scanning emphasizes a thorough and dispassionate analysis. In a comprehensive scan, an organization would examine the political climate and the makeup of the government, all regulations that affect the organization's industry (as well as those that might be under consideration), consumer trends, technological developments, the labor market, aspects of the larger economy like interest rates, and virtually anything else that could affect the organization.

The scan should consider internal issues as well, such as the finances, staff, and even infrastructure. If the organization has done strategic plans in the past, these should be considered as well, if for no other reason than to see how well the organization sticks to a plan.

For an artist, just how comprehensive an environmental scan you are able to do is a question of resources. Most individual artists won't have the time to account for every relevant factor in their environment. However, an environmental scan can take place on a limited basis and still be effective for artists provided they analyze those factors that have the greatest impact on their project or practice.

One might ask how you can know what are the most important factors on which to focus if you haven't yet conducted a full environmental scan in the first place. While that is a fair question, NYFA has observed certain universal issues arise time and time again for artists and their businesses, and an artist can organize a basic scan around these issues.

Every business and organization needs to have a good grasp on issues of finance (including accounting *and* raising funds, which are two very separate skills), law, and marketing. In a large organization, these roles are often specialized, and people with the requisite expertise are hired for those positions. For small businesses and organizations, this may not be possible. This is especially true where the business is run by one person who has to fulfill multiple tasks simultaneously and likely has not had training in all (or any) of these areas. This is the situation that many artists find themselves in when they begin a new project or begin to focus on their practice like a business. One of the main functions of this book is to provide you with information you need to better understand how your project or practice coexists with the practical realities of running an arts business. While we cannot cover every detail, we can give you an overview, help you to ask more targeted questions, identify potential challenges or obstacles, and point you toward resources that will get you the answers you need.

SWOT Analysis

SWOT is an acronym that stands for Strengths, Weaknesses, Opportunities, and Threats (or, to use a more positive word, challenges). A SWOT analysis follows the business's environmental scan and serves

to put to use all of the information that you gathered during the environmental scan in a well-informed analysis.

A SWOT analysis involves examining each of the four categories as they relate to a business, with the first two categories relating to the internal analysis and the second two categories representing an external analysis.

As artists, you will examine each category as it relates to your project or practice. If you are analyzing your entire practice as opposed to a project, you may want to focus on the present and up to no more than three to five years in the future. The further in advance you plan, the more speculative it becomes. Moreover, your strengths and weaknesses will evolve over time. You might initially consider technology to be a weakness, but then take classes and become very comfortable with it, thus turning it into a strength for future versions of a SWOT analysis.

Below are analyses of each of the categories as they relate to both organizations and artists.

Strengths

An organization will begin with those things that it does best, as well as any other resources at its disposal. The organization's ability to adapt quickly (the time between conception and implementation) and its ability to complete projects under budget are both examples of strengths.

Strengths can also include significant resources. This might include a recognizable brand, a well-developed infrastructure to carry out a new task, or even good staff morale.

While many artists will instinctively list those skills related to their art, it's very possible that you have talents and abilities outside of your discipline or the arts in general. Perhaps you are a singer who happens to write well, or a visual artist with excellent public-speaking skills. Both can ultimately be put to use in service of your project or practice. Management and organizational skills are always an asset. Some people are just better than others at certain things, hence the value of collaboration.

Another point to consider is whether you have a background, training, or a degree in another field. For example, someone with an MBA in marketing may also be a fiction writer. Due to economic and sometimes social pressures, many artists spend considerable time away from their art practices and working in another field. If that artist has gained a new skill set in the process, those skills will go down as strengths. The point of this analysis at the beginning is not necessarily to connect strengths to a larger plan, but just to see what is there.

Finally, you will want to look at what resources you have that can be put to good use. These might include savings, grant awards, a well-documented library of intellectual property, or goodwill (used here in the business sense of good customer relationships and reputation in the field).

As a first step to analyzing your strengths, you may want to create several lists. The first will be a list of capabilities that you have. Remember to list everything, no matter how unrelated it may seem. Then make a similar list of your resources. The most effective SWOT analyses are those that do not leave out any potential elements from a category, as that may ultimately lead to an unrealistic strategic assessment.

Weaknesses

Weaknesses are usually the absence of a resource or skill, rather than a fundamental flaw. If an organization is seeking to expand its services into a new market that is dominated by a different language, then the absence of language skills could be a weakness. Similarly, a lack of expertise with an important form of technology in that industry might be seen as a weakness, as well.

For many artists, a weakness is related to financial management. Most people do not acquire financial knowledge without training. Artists are no exception, as the study of art does not necessarily include access to financial expertise. Another example may be time management or not having a sufficiently flexible schedule to achieve their artistic goals. For others, weaknesses may be more specific, such as a lack of computer skills for a project that involves significant use of

online editing and marketing, or no experience with grant writing for a project that requires soliciting external funds. Like you did with your strengths analysis, you may want to make lists of both the capabilities and resources that you feel that you lack or that represent a weakness.

Opportunities

The opportunities analysis typically focuses on external factors, some of which may have led to the need for a plan in the first place. A significant opportunity could be a change in regulations affecting the organization's industry that allows for new activities, or a treaty that allows for trade with a new country or region. An opportunity could also be a development in technology that reduces the organization's costs in a particular area.

For an artist, this could be as large as the emergence of some new form of technology that lowers the costs of your medium, or a new interest in your medium from the general public (perhaps another artist who does work similar to yours has just been in the news for some reason). It could also be that new grants or other sources of funding become available for artists in your situation. Sometimes it is a specific opportunity that led to the new project that initially prompted the SWOT analysis. As with strengths and weaknesses, make a list of opportunities that you have identified.

Threats (Challenges)

The second part of the external SWOT analysis focuses on threats or challenges that the organization faces. Many threats are economic, and if an organization is dependent on using a particular resource, any event that raises the cost of that resource would be a threat. Changes in the job market could be a threat, as well—if the organization depends on staff with certain training, and changes in another industry draw from the same pool of eligible workers, that would be a threat to the organization.

Very generally, this includes anything in the environment that could jeopardize the success of your project or practice. For artists

focusing on work with mass-market appeal, this could include shifts in taste, or for others it could mean that some event has occurred to raise the costs associated with an important raw material used by the artist. NYFA does not consider competition from other artists to be a threat—it is our belief that every artist's work is sufficiently unique to sustain its own market. As we will discuss in Chapter 16 and the conclusion to this book (discussing networking and the value of collaboration), we feel that you should look to your fellow artists as resources, sources of inspiration, collaborators, and potential models. The competition among you for exhibitions, performances, grants, and awards is a reality of the world you are in, not a threat.

Exercise 1.2: Perform Your Own SWOT Analysis

Reexamine your environmental scan in light of the discussion on the SWOT analysis. Try to classify those elements you identified in the scan as either a strength, weakness, opportunity, or threat/challenge.

Strengths:

Weaknesses:

Opportunities:

(Continued)

Threats (Challenges):

SETTING GOALS: SMART

Setting goals or objectives is the hard work of strategic planning and involves testing against the mission, vision, and internal and external analyses. If a company has a well-defined mission, a good sense of its vision and values, and a comprehensive grasp on how internal and external environmental factors affect the organization's current and future options, then setting goals should be a logical process. Developing the goals within this context ensures that they are both unique to the organization and aspirational, but also realistic and grounded in fact. When an organization considers a goal or objective, it will need to confirm that the objective furthers its mission. Having surveyed and categorized the organization's strengths, the objective will draw on the strengths, mitigate the weaknesses, respond to the opportunities, and have factored in the threats. Finally, in order to be a viable choice, any specific objectives will have to align with the organization's vision and values.

There is a widely used mnemonic device for setting goals known as SMART. This stands for *Specific*, *Measurable*, *Attainable*, *Relevant*, and *Timely*. A substantive and useful goal will have each of these qualities. If an organization's goal meets these criteria and filters through the lens of the organization's mission—against the backdrop of the environmental scan and SWOT analysis—the goal is appropriate for the organization to pursue and is set on a course to succeed.

Specific	The goal should identify a *specific* action or event that will take place.
Measurable	The goal and its benefits should be *quantifiable*.
Attainable	The goal should be *achievable* given available resources.
Relevant	The goal should be *relevant* to your objective or the project, require you to stretch some, but allow the likelihood of success.
Timely	The goal should state the *time period* in which it will be accomplished.

For artists, the same conditions apply. The goals (or objectives) you select will ultimately plot the course of your practice or guide your project. Remember that goals can be benchmarks, tasks, measuring points, and sometimes an end in and of themselves.

Let's look at an example. Suppose that an artist wants to increase their marketing presence and branding, particularly online and through social media. However, they do not yet have a Facebook page. The artist makes a goal to create a Facebook page and to reach 50 likes by the end of the month. This goal satisfies the SMART requirements because it is Specific (it has a task to create a Facebook page), Measurable (we can measure both the page creation and the number of likes), Attainable (through personal connections, reaching 50 likes seems doable), Relevant (Facebook is a major player in the social media realm), and Timely (it needs to take place within a month).

Optimal goal setting and strategic planning are identifying which of those types of goals most closely align with your vision, and then choosing the most efficient route to get there.

Here are some additional tips that can help you set effective goals:

- Develop several goals. A list of five to seven items gives you several things to work on over a period of time.
- Attach a date to each goal. State what you intend to accomplish and by when. A good list should include some short-term and some long-term objectives. You may want a few objectives for the year, and some for two- or three-month intervals.
- Be specific. "To find a job" is too general; "to find and research five job openings before the end of the month" is better. Sometimes a more general goal can become the new long-term mission, and you can identify some more specific objectives to take you there.
- Write down your objectives and put them where you will see them. The more often you read your list, the more likely you are to get results.
- Review and revise your list. Experiment with different ways of stating your goals. Goal setting improves with practice, so play around with it.
- If you achieve a goal, give yourself a reward: a cake, a new book, or celebrating with your network.

Exercise 1.3: Get SMART

Let's now apply the SMART objective-setting concept to your goals. Try using this to set some of your own objectives in accordance with your mission and vision statements.

Identify Your Goal: (one sentence)

Outline all potential obstacles or challenges:

Action Steps:

1) _____

2) _____

3) _____

TAKE CHARGE OF YOUR FUTURE: PLAN

Let's now combine the various tools we've discussed in this chapter. These are: 1) figuring out who you are and what you want (mission/vision), 2) where you are now (SWOT analysis/environmental scan), and 3) how you are going to get from where you are now to where you want to be (SMART goal setting). Taken together, these tools will enable you to outline and articulate useful goals that can move your practice or project forward. It makes sense to continually revisit these goals to ensure that they are still relevant for you. For example, perhaps you were accepted into a residency that gave you the opportunity not only to focus on developing a body of work, but also to network with other artists, critics, and arts professionals, thereby possibly accelerating your career. Or perhaps you needed a full-time job that may impact the initial time line you set for attaining your goals.

These tools can be very useful in the area of time management, often a challenging area for many of us. In fact, SMART goal setting includes a time component, so you are being conscious of where you're prioritizing and allocating your time, and also the value of it as relates to your goals for your practice or project.

The tools and guidance in this section both complement and supplement those in other sections. Throughout this book, we will refer back to some of the concepts discussed here, particularly around setting goals, as encouraging informed and purposeful action is a goal of this book.

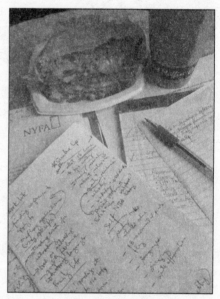

Figure 1. Strategic Planning for Artists, courtesy of Joni Cham (Immigrant Artist Mentoring Program Alum), #AtWork.

The Business Model Canvas and Lean Methodology

In the previous chapter, we looked at traditional tools of strategic planning, borrowing from the worlds of business and organizational thinking. One reason we look to models in other industries is that these tools have been tested extensively, and in contexts where one can easily see whether they work. That said, we recognize that not everything translates exactly into the world of art, and that artists may need to adapt these tools and processes to suit their needs. We recommend approaching this section with an openness to adapt as necessary, and we encourage that kind of creativity!

With this in mind, we are now going to explore two tools (or a tool and a process, technically) that are used very frequently in the start-up world, particularly with technology start-ups. We are doing this for two reasons. One, there is an increasing amount of crossover between creative businesses and technology businesses. Artists are becoming integral parts of start-ups with greater and greater frequency, as the importance and value of an artist's skill set and training (as well as their creativity and sense of aesthetics) gains greater recognition. At the same time, art and services related to it are increasingly the business of these start-ups themselves. As an artist, you may want to understand how the broader entrepreneurial world operates, as there may be opportunities for work there. Two—perhaps more importantly —we believe that these processes are very well suited to the needs of artists. We will begin by looking at the Business Model Canvas and

Lean Startup as they function in the broader entrepreneurial context, and then we will examine them from an artist's perspective.

Before we proceed, a brief note on terminology: throughout this section, we will refer to the "customer," because most of the literature and public conversation about the Lean Startup and Business Model Canvas use that term. If you are going to be a part of that larger conversation, it can help you to be comfortable using that terminology. For your own purposes, it might make more sense for you to think of customers as "patrons" or "clients" or "audience members." Similarly, we use the relatively sterile terms "product or service." Anything that you create could be considered a product—for example, a sculpture, a photographic series, and a musical score could all be considered products—and many actions that you undertake on behalf of someone else could be considered services, such as playing violin music at a wedding, editing raw video footage for a film, or ghostwriting a book.

The Business Model Canvas (BMC) and Lean Startup approach grew out of the frustration that many start-up businesses experienced with more traditional forms of strategic planning. All too often, founders of start-ups (and the investors who backed them) lost considerable time and money because they built their company "on paper," without any idea of whether they were offering a product or service that people needed or wanted. In the words of Steve Blank, one of the pioneers of the Lean Methodology, "no business plan survives first contact with customers."[1] In other words, things change very quickly in the early stages of a business, so any plan you create will have to change, too.

Every entrepreneurial idea is a hypothesis of sorts. For example, "computer users need and want computers that fit in their hands and make phone calls," or "travelers need flexible and low-cost options for accommodations outside of hotels." If you are going to build a

1 Steve Blank, "No Business Plan Survives First Contact with a Customer—The 5.2 Billion Dollar Mistake," *steveblank.com*, last modified November 1, 2010, https://steveblank .com/2010/11/01/no-business-plan-survives-first-contact-with-a-customer-%E2%80%93 -the-5-2-billion-dollar-mistake/.

business based on either of these hypotheses, you'll need as much information as you can get about whether those statements are actually true, and in which ways they are true. Does this describe all computer and phone users? Do you mean travelers in a certain demographic, or on certain kinds of trips? The answers to each could have a big impact on all of your subsequent choices from marketing to pricing to production.

The BMC was created by Alexander Osterwalder to help entrepreneurs at these early, fluid stages.[2] It has two main functions. The first is to help organize your thinking, mapping out all of the hypotheses that underlie every aspect of your business. The second is to make it easy for you to get out into the real world and to turn your hypotheses into facts.

One of the most common problems facing entrepreneurs is that they may have very limited information about the problems or needs of their customers. Whereas large, existing companies have a lot of information about their customers, start-ups are relying on the "vision" or intuition of the founder. Blank points out that most start-ups fail because they lack customers, not because they have problems developing their product or service, which is something many artists can relate to. Therefore, one of the main functions of the BMC and Lean Methodology is to help you to find your customers, sometimes termed "customer development."

Customer Development has two parts. First is the "search," and second is the "execution." The Search is comprised of customer discovery and customer validation, which basically means making good guesses (hypotheses) about your potential customers, then testing those in the real world through interviews and research, and then adjusting and refining your hypothesis until they match. This process is sometimes called "pivoting," and we will discuss it in greater detail later in this chapter. The Execution is comprised of customer

2 Ted Greenwald, "Business Model Canvas: A Simple Tool for Designing Innovative Business Models," *Forbes.com*, last modified January 31, 2012, https://www.forbes.com/sites /tedgreenwald/2012/01/31/business-model-canvas-a-simple-tool-for-designing-innovative -business-models/#2cd4a1b416a7.

creation and company building and basically focuses on the nuts and bolts of building your business and delivering your product or service to the customer. For our purposes here, we will focus primarily on the "search." The BMC is a very powerful tool to aid your search, so let's look at that in depth now.

THE BUSINESS MODEL CANVAS

The BMC is a one-page document that represents all of the important aspects of your business model in a single image. It is made up of nine core "building blocks." Before exploring these nine blocks in detail, let's look at what they are trying to demonstrate. In other words, what is a "business model"? As defined by proponents of the Lean Methodology, a business model is how a company creates value for itself while delivering products or services. And as we mentioned earlier, feel free to substitute the word *company* for something more appropriate to your situation, like *organization*, or yourself!

Value Proposition

The first block is where you place your value proposition. The term *value proposition* basically refers to whatever it is that your business makes or does. But it's a little more nuanced than just asking, "What is my product or service?" Instead, it asks you to look at this *from the point of view of your customer.* The question really is "What *need* do I fill, or what *problem* do I solve for the customer?" Steve Blank draws an interesting distinction between a problem and a need. Problems are narrow, for example, solving an accounting problem or a word-processing problem. Needs are much larger and more universal than problems, which means that your "total available market" of customers is potentially enormous—and the example that Blank uses is entertainment. So even the world's leading entrepreneurs recognize the power and economic potential of the arts!

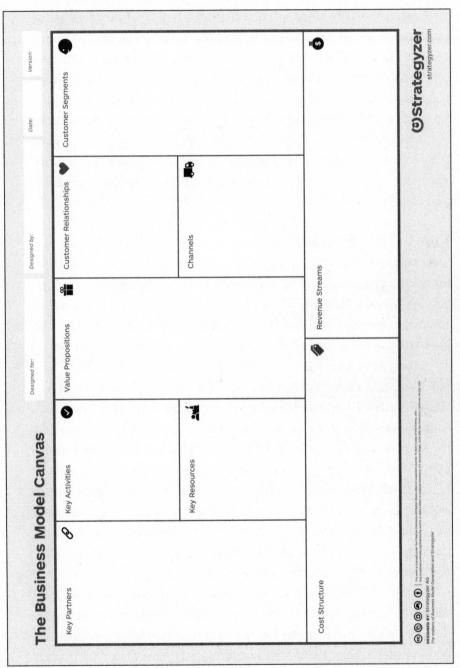

Figure 2. Business Model Canvas, courtesy of Strategyzer (Strategyzer.com)

One example of a value proposition in the business world would be Target, with its slogan "Expect more, pay less." Target's value proposition would be that it allows people greater access to goods through lower prices. An example from the arts world might be a poet who creates personalized wedding vows, or an artist who holds a community sidewalk-painting day in a multicultural neighborhood. The value proposition in the first example would be creating something highly personal and memorable for a special event, and in the second example it would be providing an outlet for community engagement based around an artistic activity that requires teamwork and communication.

Customer Segments

The next block you'll fill in is called "customer segments." Who are your customers, and why would they purchase your product or service? Collect as much information on them as possible, including their demographic, geographic, and other social characteristics. The goal is for you to create a picture (or archetype) of your customer. In some cases, you will have several of these composite sketches. However, it is important to remember that these initial sketches are still hypotheses, and you will need to test them in the real world.

An example might be Airbnb, where the customer segments include host-owners who want to earn extra money, people interested in making new friends, and travelers who want to stay comfortably at a cheap price (this would also be an example of what is sometimes referred to as a "two-sided market," in that the business model provides value to two distinct customer segments who interact with each other, in this case the hosts and the guests who rent from them).

Or from an arts perspective, looking at the previous example, the customer segments would include other artists who could assist with the event, and members of the community who are looking for new ways to interact with their neighbors (this is also a two-sided market).

Channels

Channels follows Customer Segments. It asks: How does my product actually get to the customer? How will I be selling and distributing it? Will it be a physical channel, like a gallery or an agent representing you by reaching out to venues directly; or virtual, like purchasing a book online that is later mailed or downloading music to a mobile device or streaming media content via a cloud source? Or some combination of all of these? Many entrepreneurs think that their customers exist all over the world, but the logistics and practicalities of shipping a product overseas or transacting in a different language can easily be overlooked.

For example, Facebook can be accessed both through a website and through a mobile app, and a filmmaker's film may be viewable in a theater, but also streaming online or available for download.

Customer Relationships

Customer relationships represent the fourth piece of the puzzle. This asks, how do you "get, keep, and grow" customers? "Getting" means acquiring customers and having them do (or buy) something. How will they hear about your website, or know what venue you're performing at, and then how do you get them to actually buy artwork or a ticket? "Keeping" means, how do you keep these customers continuing to use your product or service? And "growing" refers to getting these customers to spend more, or refer others.

For example, Starbucks advertises as one way to get customers and has a loyalty-rewards program to keep and grow them. And many artists undertake crowdfunding campaigns with rewards, getting customers via social media and keeping and growing them through the rewards.

Revenues

Next, you'll want to look at your revenue streams. This block is about asking how you actually make money from your product or service— What is the value, and how are your customer segments *paying* for it? Is it a subscription model based on monthly payments in exchange for

access to your platform (so the value is access to your platform and your work that is contained there, for example)? Is it a direct sale to the customer, or to a retailer (the value is for the product or service itself)? Or is it a "freemium" model, where you offer some kind of base or limited option, with people paying for extra features (the value is the extra set of features, perhaps an ad-free user experience or the ability to download files, as opposed to only experiencing online)?

The revenues block is a different analysis from figuring out what price you should charge. We discuss pricing strategies in the arts later in the book, in Chapter 13.

For example, Apple sells products directly in stores and online, licenses apps and software, and has subscription fees for certain services. And an author might get revenues both from teaching fees, as well as direct sales of their book in stores and online.

Key Resources

The key resources block analyzes the most important assets you need to successfully run your business. Is it a particular kind of intellectual property, such as a patent, trademark, or set of copyright protections? Or is it a financial asset, such as capital to invest or lend, or a line of credit to cover short-term expenses until your revenues come in? It might be physical assets, like a building with rooms to rent if you're in the hospitality business, or a set of airplanes to transport people or cargo. It could be human assets as well, such as research scientists to develop drugs, or skilled craftspeople to make furniture.

For example, Google's key resources might be their data, their intellectual property (especially patented technology), their engineers, and their brand. For a jazz saxophonist, a key resource might be saxophone reeds. You also need to consider how to keep these resources functioning or, in the case of human resources, happy!

Key Partners

This block asks, who are the key partners that your business needs to function effectively? This is often thought of in terms of suppliers,

though it does not have to be limited to that—it could be a strategic partnership as well, perhaps a promotional partner or someone with whom you are sharing a resource. The key questions to analyze are really: What services are they providing for you, and/or what resources are you acquiring from them? How important are these resources or services to the overall functioning of your business (see the section on Key Resources)?

Your business may have many partners, and these partnerships can be dynamic. In the start-up world, they are both dynamic and often short-lived.

For example, Amazon relies on a large network of key partnerships, including logistical partners for shipping, authors and publishers for creating content to sell, and a network of sellers to keep their market-place stocked. For artists who are creating public works, a key partner might be the fiscal sponsors through which they are raising money.

Key Activities

The key activities block asks the questions: What are the most important things that your business does? What activities do you have to perform (and perform well) for the business model to work? Is it making something (production)? Or solving problems for people, like consultants do by bringing their expertise to a business? Or performing a specialized task or service, like law or medicine or music performance? Management and logistics? Where do you need to have expertise, and in what?

For example, an art supplies store's key activities might include marketing and selling paint and canvases. A choreographer's key activities are creating and staging dances and identifying and retaining good dancers.

Costs

We end with the costs block. This is where you bring together all of the previous blocks and ask, What does it actually cost to run this business? What are all of the expenses associated with this business model? You will want to analyze all of the costs, not just the most

obvious ones. Conceptually, it might be useful to think about the costs associated with some of the previous blocks, particularly the "key resources" and "key activities" blocks, as those likely represent the core of the business from an expense standpoint. Which resources are the most expensive? Which activities are the most expensive? Are there available substitutes that won't impact the business model in any way—i.e., have you really analyzed what those expenses are?

You will also then want to make sure that you've addressed many of the typical business accounting questions, and look at depreciation, and fixed and variable costs. You will want to make sure that you truly understand the costs of your business model, as that is the only way to assess whether it is profitable and if your goals and projections are realistic. And the only way to master the costs is by testing all of the assumptions in your previous blocks. You will do that through the customer discovery process, discussed below.

For example, Skype's essential costs include software development, marketing, complaint management, and partner fees. For a designer, their essential costs might be for personnel (if they hire an assistant to work on a public art project, or outsource their marketing activities to others), studio rental, and computer hardware and software.

THE LEAN STARTUP AND CUSTOMER DISCOVERY

The Business Model Canvas does not exist in a vacuum. It was designed to help start-ups navigate a process known as the "Lean Methodology," which, as we mentioned earlier, was developed in part to reduce the risk of investing heavily in a start-up company before it had proved that it was worth that investment. Drawing on many elements from the scientific method, one of the primary thought leaders behind the Lean Methodology was Steve Blank. Eric Reis later authored *The Lean Startup*, which codified these practices.[3]

3 Eric Reis, "Creating the Lean Startup: How Eric Reis developed a scientific method for launching profitable companies," *Inc.com*, September 27, 2011, https://www.inc.com /magazine/201110/eric-ries-usability-testing-product-development.html.

ARTISTS' BUSINESS MODEL CANVAS

For:

Date:

KEY PARTNERS

Who are your suppliers, collaborators, and promotional partners?

KEY ACTIVITIES

What is the core or most important thing you do? Where do you need to have expertise?

KEY RESOURCES

What materials, tools, and employees do you need to execute your project or practice?

VALUE PROPOSITIONS

- Project: What need does your project fill?

- Artistic Career: What value would you bring to audiences through your practice?

CUSTOMER RELATIONSHIPS

How do you reach and convince your audience to buy?

CHANNELS

How does your audience access your art?

CUSTOMER SEGMENTS

Who is your audience?

Why do they attend/purchase?

COST STRUCTURE

What are the costs of the key resources and activities? Are other costs are associated with your project or practice? Assess whether your business model is profitable.

REVENUE STREAMS

How do your audience and customers pay for your work? What are the different ways you get revenues from your practice?

Figure 3. Artists' Business Model Canvas

31

The Lean Methodology emphasizes making good hypotheses about your business model, but then testing these hypotheses immediately with real people, and adjusting based on that feedback. We'll take a brief look at the outline of how the lean process works and then discuss what parallels it has to the artistic process, and how it might apply to building an arts-based business.

The lean approach begins with filling out an initial Business Model Canvas for your business idea, going through the steps we outlined above. While the canvas is an excellent organizational tool, at this point it is still a collection of untested hypotheses. The next step is to turn those intuitions into facts. This is done through a process known as "Customer Development."

Customer Development means going outside of your room, or artist studio, or wherever you created your initial BMC, to test these initial hypotheses in an organized, four-step process:

Step 1: Customer Discovery
Step 2: Customer Validation
Step 3: Customer Creation
Step 4: Company Building

Steps one and two are generally grouped together, which is known as the "search" process, whereas steps three and four represent the "execution." Each of these steps is actually comprised of additional steps, and a lot of trial and error. Let's look at each in a bit more detail.

Customer Discovery

At this stage, you are taking the hypotheses you put on the BMC out into the real world, to see how well you understand the needs of potential customers. Through your value proposition and customer segments blocks, you've identified a need or problem, and proposed a solution. Your next step is to conduct live interviews with potential customers. Were your assumptions accurate? Do these people actually have this need or problem, and are they willing to pay to solve or fulfill it?

Once you've identified which people have that need or problem, you will want to get their feedback about your proposed solution. This involves creating what is sometimes known as a Minimum Viable Product, or MVP. It is basically a bare-bones, scaled-down version of your solution. If you had a web-based business, this could be a landing page with some minimal features. If you had a service-based business, this might be an introductory workshop or basic consultation. If it's a product, it would be a version that was the cheapest possible with the minimum number of features necessary to do what it is supposed to do—essentially a prototype. This is one of the ways in which the Lean Methodology saves money and resources. At this phase of the Customer Discovery process, you will put your MVP in front of customers and get their feedback.

Finally, once you've received feedback on your hypotheses and MVP, you will see how good a match this was. Most of the time your guesses don't match reality, and you need to make adjustments. In lean terms, you need to "pivot," or make adjustments to your business model so that your MVP matches up with your customers' needs. Pivoting can take a lot of forms, including changing the MVP itself, or changing the customer segment you're targeting. For example, your hypothesis might be that your target market is women in their forties, but customer interviews reveal little interest from that demographic but a lot of enthusiasm from men in their twenties. Targeting the second demographic in your business model would be a pivot.

The goal of these various steps in Customer Discovery (loosely outlined as stating a hypothesis, testing the problem, testing the solution, and pivoting) is to achieve what is referred to as "Product-Market Fit," which basically means that you have discovered customers! You would then move on to Customer Validation (which we will address in a moment).

A few other quick points about the Customer Discovery steps— one of the hallmarks of the lean process is that the founders themselves conduct the research. As a founder, nobody else has your vision, so there is value in hearing feedback yourself, especially negative feedback, as opposed to doing so through an intermediary.

Furthermore, only founders can make the kinds of major changes (pivots) to a business model that may be required. Another important point is that you are looking for more than data at this stage. What you are really seeking is insight, which is hard to get from web surveys but can be obtained from in-depth interviews with real people. Insights are what really allow you to make effective pivots.

Finally, many entrepreneurs have questions about how to conduct these interviews. One of the positive aspects of the Lean Methodology is that most of its founders and proponents are open to share their educational resources, so you can easily find lots of examples of other BMCs online, as well as shared experiences conducting interviews. In that spirit, we would recommend *Talking to Humans*, a book by two leading experts in the startup world, Giff Constable and Frank Rimalovski, which is offered as a free download.[4] It walks entrepreneurs through the basics and finer points of conducting customer discovery interviews, which is useful for testing all of the hypotheses you have laid out in your initial BMC (including the later blocks).

Customer Validation

You may believe that you've achieved product-market fit from the customer discovery process, but the only way to really know that is through customer validation. This essentially repeats many of the steps from the customer discovery stage, but with higher stakes. Here, you try to get people to actually buy the product or service, which exists in a stepped-up MVP form (more features, but not everything). And then you see whether people are actually placing orders, or signing up, or using your service, etc. If they are not, then you need to revisit what wasn't working at the customer discovery stage and likely pivot again. The customer validation stage is very important because it allows you to test the business model for real, but without spending lots of money on marketing or other operational aspects of the business.

4 Giff Constable and Frank Rimalovski. *Talking to Humans* (self-published, 2014), https://s3.amazonaws.com/TalkingtoHumans/Talking+to+Humans.pdf.

Customer Creation

If you have successfully made it through the search process, achieved product-market fit, and validated the business model with paying customers, you would then move to the next phase, that of customer creation. This is where you would invest your resources (or investment money, if you have it), focusing on marketing and sales, and really trying to bring in customers in a large enough volume so that the business can be successful.

Company Building

Having successfully gone through the previous three steps of customer discovery, customer validation, and customer creation, your business is ready to exit the start-up phase and to develop the infrastructure and management to continue delivering your product or service to your customers, innovating and adapting where necessary. The lean process is far less concerned with this stage, as it represents the success of testing and validating your business model, but there are important steps to execute here, which usually requires bringing in people with business and management training.

WHY IS THIS IMPORTANT FOR ARTISTS?

The BMC can be a very effective tool for artists to develop a business idea, but can also be used in their practice generally, or with a specific project. The application to business is obvious—that is what it is designed for. The BMC is simple, organized, and visual. It lays out the essential elements of any business into nine categories, and provides an excellent framework to organize ideas and hypotheses about a new business idea. But what about an artist's practice generally?

We believe that the nine building blocks provide a unique way of thinking through your work, especially the first few blocks. What is the value proposition of your work as an artist, and who are your customer segments? That question will be asked in various forms

throughout this book, whether it's from a marketing perspective (defining your work and its place in the market) or from a fundraising perspective (what you are doing, and what population will benefit from your work or project). In the context of the BMC, it's specifically asking who will want to buy your work and why, and the focus is very much on the customer. Every artist makes art for their own individual reasons, and for some, analyzing their work from the perspective of the audience is very much a part of their practice. But for others, this may be a new approach—art is a part of their self-expression, and how it will be received and by whom is of no concern. It may even feel contrary to their artistic identity. And we want to be clear: we are *not* suggesting that you should change your art in any way, or use the BMC and Lean principles to create and deliver art geared for easy mass consumption.

Instead, focusing on the "needs" or "problems" of a "customer segment" can provide for a very sophisticated (and even philosophical) analysis. What impact does your art have on a client/customer/audience member? What motivates them to spend their resources—money, time, attention, and emotional energy—on consuming your art in some way? Are you solving a problem for them, and if so, what is the problem? For example, perhaps people in your customer segment struggle with traditional forms of exercise but would respond to modern dance classes? Or perhaps you are filling a need, such as providing educational children's stories in a particularly beautiful and thought-provoking way?

The BMC and Lean principles provide an analytical framework to make guesses about these questions, and then to test them with real people, while looking for insights. One of the lessons of customer discovery is that having someone say, "I like it," is not very useful, because it doesn't give you any real insight into why they do or do not. And furthermore, if they just say they like it without trying to buy it or sign up and use it, then their "like" means very little. Obviously, this can be different in the arts context—someone may genuinely like a work of art but not be able to afford it—but the basic idea remains

valid. There are different ways to measure passion and commitment to art, and you are looking for passion! You want to know who feels that way about your work, why, and how they want to consume it.

Some artists are uncomfortable with the idea of "pivoting," as it feels overly intrusive on the creative process. And changing the chord structure of a musical composition or color scheme of a visual piece in order to better satisfy customer needs would be just that. But pivoting does not have to mean changing the "product." Instead, it can be a change to the business model that includes numerous other elements. Perhaps it's the delivery system—people want to listen to your music while they drive, but you only do live performances; or they want to see a live concert but live too far away, so they are willing to pay for a livestreamed show. They might live in a space that is too small to display a freestanding sculpture, or have safety concerns with small children, but would pay to view it in another space. And so on—analyzing the channels and customer relationships sections of the BMC might show you new ways in which you can access those people who love (or would love) to consume your work, just under slightly different circumstances.

Moving deeper into the BMC, analyzing the key partners, resources, and activities of your practice can help you to reexamine what you do on a regular basis and to ask whether certain behaviors, relationships, and expenditures are really working for you. This can be true on a business level and on an artistic level. The end of the canvas, which deals with costs, allows you to evaluate the true cost of every element of your project or practice, and to see where you can either trim expenses or increase revenues in furtherance of your business model.

Finally, we want to note the similarities that exist between artists and entrepreneurial founders. Both begin with a vision and, with a lot of hard work and skill, bring something new into the world that has value and enriches society. Both must work through obstacles and often face challenges with money. Both can deal with negative feedback or with people saying, "This can't be done." And both sacrifice for their dreams.

Every artist will be able to identify with the process of customer discovery and pivoting. Artists routinely experiment with different ideas in the studio, practice room, writing desk, or wherever else they make their art, tinkering with different versions of how to express their idea until they get it right. And they often seek feedback from peers and mentors at various stages in their development. In fact, one advantage of the BMC is that artists can share it easily with friends and collaborators and then make changes based on their feedback. That's really how the BMC's designers envisioned its use—the Canvas on a wall, surrounded by collaborators giving honest feedback, and making changes right there.

Iteration, experimentation, and honesty are at the core of many artists' practice, just as they are at the core of the Lean Methodology and BMC. We would invite you to consider whether these could work for you and would encourage you to experiment!

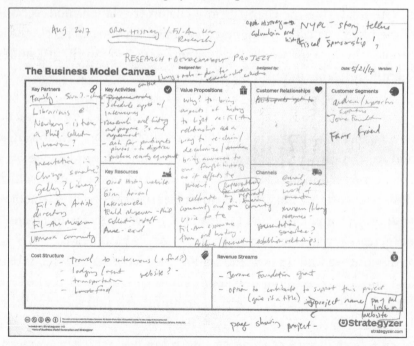

Figure 4. Artist's Business Model Canvas, courtesy of Maia Cruz Palileo (NYSCA/NYFA Fellow in Painting, Artist as Entrepreneur Boot Camp for Artists of Color Boot Camp Participant).

LEGAL ISSUES FOR ARTISTS

Introduction

Many artists find legal issues to be both challenging and intimidating. For many of us, the law involves terminology that we don't necessarily understand, is seemingly ever-changing, and carries negative consequences if handled improperly. But it doesn't have to be the case. In fact, the law can be a great source of protection and security for your creative work, your business relationships, and your assets. With a little familiarity with a few areas of law, you can ensure a lot more peace of mind and clarity for your project or practice. In this section of *The Profitable Artist*, we will cover three areas that are essential to your work as an artist. These are intellectual property, contracts, and business entities.

Chapter 3 focuses on intellectual property, specifically copyright law, trademark law, and patent law. The chapter will help you to understand how intellectual property law helps you to protect your work, and what rights those protections actually grant you. It will explore what steps you can take to ensure that you receive the necessary legal protections and that you have registered your copyrights and trademarks properly. It will also discuss how you can avoid inadvertently infringing on the rights of other artists, and under what circumstances.

Chapter 4 is about contracts. It looks at what are the elements of a contract, so that you will understand how you can form a valid, enforceable agreement. It will also look at some of the common terms that are used in contracts, so that you will have a better understanding

of what these terms actually mean when they are put in front of you by someone else (or, conversely, so you might notice if they are missing when they should be there).

Chapter 5 deals with business entities. It analyzes what legal structures you can use when going into business publicly, including entities like sole proprietorships, partnerships, corporations, LLCs, benefit corporations, and not-for-profit corporations. The chapter looks at the issues of liability, taxes, and the requirements to start and maintain each.

We want to emphasize that nothing in this book constitutes actual legal advice. For that, you should consult an attorney, and we would recommend that you do so if you have any questions about how any of these topics might apply to your specific situation. These chapters are only intended to give you a general overview of each of these topics, so that you will have a better idea of what legal issues might be involved in your practice or project, and so that you will be better equipped to recognize when there is a situation that might impact your rights and legal interests, so that you can consult with an attorney. And there are many attorneys that are very supportive of artists, too.

Finally, we want to thank Elissa Hecker, Esq., and Zak Shusterman, Esq., for their counsel, support, and excellent contributions to this section. Elissa authored Chapters 3 and 4 on intellectual property and contracts, respectively, and Zak authored Chapter 5 on business entities. We are very grateful for their guidance, expertise, and hard work.

Intellectual Property

Artists want to make art. Often, however, the legal and business aspects of what to do with art before, during, and after it is created will depend on an artist's intellectual property rights. This chapter intends to be a guide, rather than specific advice, about the basic legal frameworks surrounding the protection of artistic works. Intellectual property laws, filing requirements for applications for registration, and enforcing one's rights against infringers can be complicated, and creators are encouraged to consult with reputable attorneys who practice in this field for advice and assistance.

An artist's intellectual property rights can create revenue value in a work. Such rights are part of a bundle from which an artist can, among other things, license, sell, transfer, and/or assign any number of rights to another. It is important to understand this area of law.

Intellectual property is a category of rights that encompass primarily copyright, trademark and service mark, and patent. Copyright protects original works of authorship. Trademarks and service marks protect brand names and/or logos for products and services. Patents protect inventions or discoveries. All three are primarily based on federal law and, in most cases, have international protections as well, due to treaties into which the United States has entered or with which it is involved.

The laws governing intellectual property differ from those addressing physical property. Protection of physical property can

include locks, banks, fences, and security systems. Intellectual property exists within, yet is separate from, a physical thing. For example, if one downloads, streams, or otherwise legally acquires a song, then that particular form of the song becomes the property of the purchaser, who may use it for his or her own personal use. However, the purchaser may not manufacture, distribute, change, or play the music in a public venue without a license, or permission to do so. The right to own the song for personal use lies with the purchaser. The intellectual property rights in that song, however, lie with any number of its creators, such as the songwriters, music publishing companies, producers, and record label.

Intellectual property laws in the United States were designed so that creators would have the incentive to create, invent, and discover, while economically benefiting from their works and having protection against those who would otherwise take advantage of their creations without attribution, payment, or permission. It is important

Figure 5. Swarali Karulkar (Immigrant Artist Mentoring Program Alum), *Ethnic, Sensual and Graceful,* from the series *Shades of Swara.* Photo by Noel Valero.

INTELLECTUAL PROPERTY

to understand how those laws can apply both to protect one's art and to use others' creations without infringing on their rights.

INTELLECTUAL PROPERTY

Not the things themselves, but the *rights* that exist in relation to those things, depend upon laws. To "own" something is simply to have the right to possess, use, sell, use currency or methods to exchange it, give others the power to do so on one's behalf, and choose who will inherit it upon one's death, among other options. One can assert or defend one's legal rights in court or through alternative dispute resolutions.

With the goal of incentivizing creators to create and inventors to invent, the US Constitution gave Congress the power to pass laws protecting copyrights and patents, and Congress did so. Article I, § 8 of the Constitution, upon which federal intellectual property protections are based, reads: "The Congress shall have power . . . [t]o *promote the progress of* science and *useful arts,* by securing for *limited times* to *authors* and inventors the *exclusive right* to their respective *writings* and discoveries." Congress subsequently passed laws regulating copyrights and patents. Since then, courts have interpreted those laws, which have been changed and adapted over time. The "writings" language spawned federal copyright law, and the "discoveries" language did the same for patents (trademarks and service marks are based on a separate federal statute).

It is important to be able to benefit economically from individual creations, be able to address issues of recognition and credit, and have the ability to control how the rest of the world treats one's work. The law protects some of these concerns and not others, and artists who understand their rights will be in a better position to address some of their individual concerns through contracts (we will discuss contracts in Chapter 4). By understanding what can or cannot be protected, and what can or cannot be used, artists can more successfully maintain both their creative output and business interests.

COPYRIGHT

A copyright exists in an original work of authorship once it is "fixed" in a tangible medium of expression. The work can either be published or unpublished. Once an original work is created and fixed in a tangible medium, then the author(s) own/s the copyright to that work, regardless of registration with the US Copyright Office. In addition, although not required by law, it is good practice to have a copyright notice (a © on the work, with the artist's name, along with "All Rights Reserved"), as it places the world on notice that it is the artist's copyrighted work.

It is also advisable to file for copyright registration, because registration is a precondition to bringing a lawsuit for infringement and also confers the benefits of being eligible for statutory damages and attorney's fees. It also helps to establish an official time line of creation of the work. To apply for registration through the Copyright Office is fairly inexpensive and not a difficult process. You can begin the process on the Copyright Office's website, which is www.copyright .gov.

Copyright law extends protection to original works of authorship fixed in any tangible medium of expression, now known or later developed, from which they can be perceived, reproduced, or otherwise communicated, either directly or with the aid of a machine or device. We will explore each of these elements in more depth. The following categories of works are protected by copyright:

- Literary works
- Musical works, including any accompanying words
- Dramatic works, including any accompanying music
- Pantomimes and choreographic works
- Pictorial, graphic, and sculptural works
- Motion pictures and other audiovisual works
- Sound recordings
- Architectural works.

These eight categories cover most of what artists produce, although courts often have to be creative when interpreting in exactly which category a particular work belongs.

Words, short phrases, slogans, symbols, and other identifiers are not usually protected by copyright. However, they may be protected under trademark law. Similarly, systems, methods, and devices not protected by copyright may be protected by patent law.

Elements of "Copyrightability"

Not all creative works qualify for copyright protection. The following requirements must be met:

1) Originality

The first requirement is that it be an "original work." However, this is not a qualitative judgment. The amount of originality required is minimal; courts have determined that a work must include "a modicum of creativity" to qualify for copyright protection.

Copyright does not protect "ideas" as such, but, rather, original expressions of those ideas. For example, the *idea* about star-crossed teenage lovers from warring families cannot be copyrighted, but the script, choreography, music, screenplay, and film for *West Side Story* can. Copyright law also does not protect facts, or any procedure, process, system, method of operation, concept, principle, or discovery, although it may protect the way these things are expressed.

2) "Fixed in any tangible medium of expression"

In addition to being original (an easy requirement to meet, although it can be more complicated for those whose works incorporate the work of others), the work must be written down, videotaped, recorded, made into a piece, or notated in some way. There is no copyright ownership for an original idea that is not fixed in a tangible medium. This can be especially important when artists share ideas and then have no remedy upon discovering that others use those ideas in their own works.

Derivative works

One of the copyright elements is the right to make derivative works. A derivative work is a new work that is based upon an existing work. The right to create a derivative work is reserved under the Copyright Act to the owner of the copyright in the original work. Of course, artists are frequently inspired and influenced by the works of others. For example, a screenplay adapted from a novel, or a new arrangement of a piece of music, are both derivative works. A derivative work is itself copyrightable, but the derivative artist cannot claim copyright in the original work from which the new work derives. When creating a derivative work, an artist may need permission from the copyright holder of the original work, if that work is under copyright protection, rather than in the "public domain." A work of authorship is in the "public domain" if it is no longer under copyright protection or if it failed to meet the requirements for copyright protection. Works in the public domain may be used freely without the permission of the former copyright owner. A copyrightable derivative work must include sufficiently new and original material by the new author. Minor additions to or rearrangements of the original work are not enough. Later in this chapter we will discuss how a transformative derivative of another's work may be allowed, depending on the circumstances of the use.

What Kind of Protections Does Copyright Give to an Artist?

The owner of the copyright in a work—who is usually the artist who creates it, at least initially—has a bundle of rights. Broadly speaking, copyright owners have the exclusive right to do, and to authorize others to do, any of the following:

- Reproduce the copyrighted work in copies or phonorecords
- Prepare derivative works based upon the copyrighted work

- Distribute copies or phonorecords of the copyrighted work to the public by sale or other transfer of ownership, or by rental, lease, or lending
- In the case of literary, musical, dramatic, and choreographic works, pantomimes, and motion pictures and other audiovisual works, perform the copyrighted work publicly
- In the case of literary, musical, dramatic, and choreographic works, pantomimes, and pictorial, graphic, or sculptural works, including the individual images of a motion picture or other audiovisual work, display the copyrighted work publicly
- In the case of sound recordings, perform the copyrighted work publicly by means of a digital audio transmission.

Some of these terms have special meanings in the copyright law context. For example, the US Copyright Office includes the following definitional note in its Copyright Basics publication:

> "Sound recordings" are defined in the law as "works that result from the fixation of a series of musical, spoken, or other sounds, but not including the sounds accompanying a motion picture or other audiovisual work." Common examples include recordings of music, drama, or lectures. A sound recording is not the same as a "phonorecord." A phonorecord is the physical object in which works of authorship are embodied. The word "phonorecord" includes cassette tapes, CDs, and vinyl disks as well as other formats.[5]

5 United States Copyright Office, *Circular 56: Copyright Registration for Sound Recordings* (Washington, DC, 2017), https://www.copyright.gov/circs/circ56.pdf.

A copyright owner can make commercial use of the copyright by selling or licensing any one or more of the bundle of rights listed above. Someone who has written a novel, for example, can transfer the publishing rights to a publishing company (in return for an advance and royalties), license the rights to someone else for it to be turned into a screenplay, and also license the rights to someone else for a television series. The copyright owner to a musical composition could license many different musical groups to perform or record it.

When selling a work of art, one is parting with the physical object, but unless the terms of the sales agreement explicitly state that the copyright is also included in the sale, then the artist retains the copyright. Moreover, when granting a license, perhaps for a photograph, it is possible to tailor what rights are granted to the licensee, such as allowing the image to only be used in a particular advertising campaign for a limited time period.

Copyright Infringement

Under the Copyright Act, to infringe a copyright, there must be access and copying. That is, the infringer must have seen, heard, or have had access to the original work and copied it with sufficient substantial similarity. If one cannot prove access, then there is no infringement, even if the two works are identical.

Special Rights for Visual Artists

The Copyright Act does not recognize a creator's noneconomic and personal rights, except in the limited instances mentioned below. As of this writing, the Copyright Office was undertaking a public study on moral rights, specifically the rights of attribution and integrity, which are addressed in this section. In Europe and elsewhere, however, these rights are referred to as "moral rights." Artists should be aware that if they are selling or creating works in other countries, or creating works commissioned by foreign entities, such works may be protected by the moral rights available in those countries.

The Visual Artists Rights Act of 1990 ("VARA") provides in a limited way for some moral rights for specialized visual artists only. This is set out in the Copyright Act, §106(a), as follows:

Rights of Certain Authors to Attribution and Integrity

(a) Rights of Attribution and Integrity—Subject to section 107 and independent of the exclusive rights provided in section 106, the author of a work of visual art—

 (1) Shall have the right—

 (A) To claim authorship of that work, and

 (B) To prevent the use of his or her name as the author of any work of visual art which he or she did not create;

 (2) Shall have the right to prevent the use of his or her name as the author of the work of visual art in the event of a distortion, mutilation, or other modification of the work which would be prejudicial to his or her honor or reputation; and

 (3) subject to the limitations set forth in section 113(d), shall have the right—

 (A) to prevent any intentional distortion, mutilation, or other modification of that work which would be prejudicial to his or her honor or reputation, and any intentional distortion, mutilation, or modification of that work is a violation of that right, and

 (B) to prevent any destruction of a work of recognized stature, and any intentional or grossly negligent destruction of that work is a violation of that right.

VARA introduced the concepts of attribution and integrity to US copyright law. Some muralists, sculptors, and graffiti artists have successfully used VARA to their benefit, upon the planned or actual destruction or removal of visual artworks. Others have tried and failed to enforce their rights through VARA.

VARA protects only a limited number of media: paintings, drawings, prints, sculptures, and still photographic images produced for exhibition only and existing in single copies or in limited editions of two hundred or fewer copies, signed and numbered by the artist. There are also numerous other exceptions, and an artist should not assume that his or her work is automatically protected.

Works Made for Hire

The copyright in a work ordinarily belongs to the person who authors or creates the work. However, in some cases a company, organization, or even another individual will hire an artist to create a work, and whoever does the hiring will be considered to be the "author" and owner of the copyright. Works created under these conditions are known as "works made for hire" or "work for hire," and some special rules apply to them.

A "work made for hire" is:

> (1) a work prepared by an employee within the scope of his or her employment; or (2) a work specially ordered or commissioned for use as a contribution to a collective work, as a part of a motion picture or other audiovisual work, as a translation, as a supplementary work, as a compilation, as an instructional text, as a test, as answer material for a test, or as an atlas, if the parties expressly agree in a written instrument signed by them that the work shall be considered a work made for hire . . .[6]

6 United States Copyright Office, *Circular 09: Works Made for Hire* (Washington, DC, 2012), https://www.copyright.gov/circs/circ09.pdf.

A work created by an employee is automatically a work made for hire. The distinction between an employee and an independent contractor status can therefore be important when determining whether a work is for hire. Unfortunately, that is not always easy to determine, and one of the reasons why the law requires, where the creator is not an employee, that "the parties expressly agree in a written instrument signed by them that the work shall be considered a work made for hire."

There are several important factors considered in this determination. They include whether a salary is paid, taxes are withheld, how much control the commissioning person or entity had over the artist's work (i.e., location, tools), over the artist themselves (schedule, manner of payment, ability to assign other work and responsibilities), and whether the work produced fits in with the commissioning party's regular business. If the creator of the work is determined to be an independent contractor, then the work will be "for hire" *only* if it falls into one of the categories set out in Section 101 of the statute (listed above, in part), and if there is a written agreement between the two parties specifying the relationship as such.

Joint Works

When an artist creates a work with one or more other artist(s), and together they intend to create the work as joint collaborators, with a shared copyright, the result is considered a "joint work," pursuant to §201(a) of the Copyright Act. In this situation, all such cocreators own undivided interests in the entire work, regardless of the actual amounts of their contributions (unless there is a written agreement setting forth the terms and scope of each coauthor's respective ownership in the resulting work). That said, where one entity merely contributes ideas, money, logistical support, or other assistance, that is not considered to be a sufficient contribution to become a joint copyright owner. Thus, for example, if an entity commissions a work and pays for its creation, without more, then that entity is not technically a coauthor; instead, the artist retains full ownership in the

copyright of the resulting work subject to whatever usage rights are granted. Of course, if the artist and the entity have a written agreement specifying that the work is a work for hire, then the entity will become the "author" of the copyright. This is an issue that frequently arises in the arts world, as many works are collaborative and few employment relationships are formal.

Quite often this is a case of simple economics—very few artists can afford salaried employees, and many musical ensembles, dance companies, and theater groups are comprised of independent contractors. That is why it is crucial to have contractual agreements that set forth the parties' understandings about the works. The contract becomes the road map to which all disputes can refer, and hopefully be resolved. By contracting from the outset, artists can address these potentially thorny issues before any misunderstandings or conflicts arise. We will discuss contracts further in Chapter 4.

Term of Copyright

The term of copyright on a work depends on when the work was created. For those created on or after January 1, 1978, the term is for the life of the author, plus 70 years (if there are multiple authors, the 70-year clock starts after the last one dies). In the case of an anonymous author or of a work made for hire, the copyright lasts either 95 years from publication or 120 years from creation, whichever period is shorter. Determining if a work falls into the public domain can be complicated, as the law (and the copyright term) has changed several times. One needs to investigate what laws were in effect at the time when a work was created, and whether subsequent changes to the law modify the calculation.

Registration

Even though registration with the Copyright Office is not required by law, as mentioned earlier, there are several reasons as to why it is advisable. Registration establishes a public record of the copyright, is a precondition for commencing a lawsuit based upon infringement

of the work, and makes the copyright owner eligible to be awarded statutory damages (a statutory amount of monetary damages up to $30,000, or $150,000 if willful, for each infringement) and attorneys' fees. This is frequently far greater than the actual damages suffered. It is also advisable, even though not required, to include the copyright notice on the work to put the world on notice as to who owns the copyright in that work.

Applications for registration are made electronically through the Copyright Office portal.[7] A registrant completes the correct application form (depending on the category of the work), pays a filing fee, and submits an electronic deposit of the work.

Using Others' Works

If someone else's work is protected by copyright, an artist who wants to use it must get permission to do so. Works that are not, or are no longer, protected by copyright are in the public domain. Virtually anything that is commonly regarded as a masterpiece—in the sense that it has withstood the test of time—is in the public domain. A general rule is that works created before 1923 are in the public domain. Therefore, the works of Michelangelo, Bach, Shakespeare, Jane Austen, and the Brontë sisters are all public domain, and that means that they are fair game from an artist's perspective. Artists can perform these works, and derivative works can be created based on them—all of the rights are available. Moreover, documents and publications created by the federal government are also in the public domain. It is important, however, to be aware that translations of works in the public domain may be copyrighted, and to be careful not to assume that derivatives of public domain works are also in the public domain. They may be protected by copyright.

If a work is still under copyright protection, one must obtain a license from the owner to use that work. Most often, licenses are granted in exchange for some type of payment. Sometimes artists will

7 https://www.copyright.gov/registration/index.html.

agree to a gratis, or free, license. As with any transaction, the parties must come to an agreement about the terms and scope of the license.[8] However, artists sometimes encounter copyright owners who will not license a work under any circumstances, or will only do so at a price that is prohibitively expensive for the would-be licensee. In that case, the copyrighted work should not be used, subject to a few exceptions that are discussed below.

Compulsory Licenses

Section 115 of the Copyright Act provides an exception to the general rule that one must obtain permission from the copyright owner in order to use a work on a phonorecord, with regard to musical compositions only: "In the case of nondramatic musical works, the exclusive rights provided by clauses (1) and (3) of section 106, to make and to distribute phonorecords of such works, are subject to compulsory licensing under the conditions specified by this section."

In other words, rather than negotiate directly with the composer or publisher of a musical composition, to make a phonorecord or digital phonographic recording of the composition (sometimes known as a "cover"), one can pay a set royalty fee and have a limited license to use the work for that particular purpose. Section 115 further states that:

> (1) [...] A person may obtain a compulsory license only if his or her primary purpose in making phonorecords is to distribute them to the public for private use, including by means of a digital phonorecord delivery. A person may not obtain a compulsory license for use of the work in the making of phonorecords duplicating a sound recording fixed by another, unless:
>
> (i) such sound recording was fixed lawfully; and

8 See the contract chapter for more details.

> (ii) the making of the phonorecords was authorized by the owner of copyright in the sound recording or, if the sound recording was fixed before February 15, 1972, by any person who fixed the sound recording pursuant to an express license from the owner of the copyright in the musical work or pursuant to a valid compulsory license for use of such work in a sound recording.
>
> (2) A compulsory license includes the privilege of making a musical arrangement of the work to the extent necessary to conform it to the style or manner of interpretation of the performance involved, but the arrangement shall not change the basic melody or fundamental character of the work, and shall not be subject to protection as a derivative work under this title, except with the express consent of the copyright owner. [. . .]

Anyone who intends to use the compulsory license must file a Notice with the copyright owner(s) within or before thirty days after making and before distributing the phonorecords containing the work. There are a few companies and agencies that make this process easier, by acting as licensing agents with the publishing companies and songwriters. These companies, such as The Harry Fox Agency, Inc., issue "mechanical licenses" on behalf of their members, then collect and distribute royalties and take commissions on their services. Other forms of compulsory licenses exist, but the mechanical license is the most commonly used by artists, especially musicians.

Fair Use

This concept, which is commonly referred to as the Fair Use "Exception," is a legal defense to a copyright infringement claim, and not a license to use the work of others. There are four factors used in

the analysis of fair use, which are discussed below. These factors are guidelines that courts adapt to situations on a case-by-case basis, based upon the facts of each case. Therefore, the outcome in any given case can be hard to predict.

According to §107 of the Copyright Act, the four factors to be reviewed in a fair use analysis are:

> [T]he fair use of a copyrighted work, including such use by reproduction in copies or phonorecords or by any other means specified by that section, for purposes such as criticism, comment, news reporting, teaching (including multiple copies for classroom use), scholarship, or research, is not an infringement of copyright. In determining whether the use made of a work in any particular case is a fair use the factors to be considered shall include—
>
> - the purpose and character of the use, including whether such use is of a commercial nature or is for nonprofit educational purposes
> - the nature of the copyrighted work
> - the amount and substantiality of the portion used in relation to the copyrighted work as a whole
> - the effect of the use upon the potential market for or value of the copyrighted work.

Unfortunately, there is no clearly defined safe zone for what constitutes fair use—it will be determined on a case-by-case basis, with reference to important prior cases. The statute itself does give some guidance, however, through its four-pronged test.

First factor

The "purpose and character" prong clearly favors noncommercial use, and courts also favor uses that are for nonprofit or educational purposes, parody, criticism, commentary, or analysis.

Although transformative use is not a statutory category in and of itself, the courts analyze it as part of the first factor.[9] Recent case law created the concept of transformative use as significant. Courts look to see if the alleged infringement is transformative, that is, if it uses a source work in completely new or unexpected ways.

Second factor

The "nature of the work" prong tends to give less protection to works that are factual in nature because, as mentioned above, facts are not copyrightable. If a work is very factual, then society is improved if those facts and factual works can be freely discussed and circulated. On the other hand, if the original work is more imaginative, then this weighs against finding that the secondary use was fair, as opposed to an unauthorized derivative work.

Third factor

The "amount and substantiality" prong is tricky, as the emphasis is on the amount of the original work copied, and not the new work. Although courts look more kindly on an insubstantial or "de minimis" amount copied, there is no set length or amount that needs to be copied. The analysis is also qualitative, as taking a small piece can be significant, depending on that piece's importance to the original work. Courts look to whether the "heart of the work" is taken from the original.

Fourth factor

This prong is an economic analysis that looks at how the new work will impact the older work, and whether the new derivative work would be considered a "market substitute" for the older work. If there is little to no impact on the older work's market value, then this would weigh in favor of finding that the new work is a fair use. On the other

9 This was first raised in *Campbell v. Acuff-Rose Music*, 510 U.S. 569 (1994), a Supreme Court case in 1994.

hand, if the new work competes with and takes away sales from the original work, or simply permits the artist to avoid the need to obtain a license and pay royalties, then this weighs against finding a fair use.

TRADEMARK AND SERVICE MARK

A trademark or service mark is a word, phrase, symbol, or design, or a combination thereof, that identifies and distinguishes the source of the goods or services of one party from those of others. Federally registered trademarks and service marks are protected in the United States and are managed by the US Patent and Trademark Office ("USPTO"). Depending on the registration, a trademark or service mark may also be protected in other countries, pursuant to the Madrid Protocol, to which the United States is a signatory. Trademarks and service marks can also be protected by individual state laws and common law. They can be anything that serves as a source identifier, ranging from a name ("Disney"), to a symbol (Mickey Mouse's ears), to a color (the specific blue that represents a Tiffany's jewelry box), or a phrase ("Just do it" used to identify the Nike brand).

Most artists will have use for trademarks or service marks only if they want to protect a name or symbol for commercial use to identify themselves, their works, or their services. The decision to do so may be influenced by the artist's branding strategy (we discuss branding for artists in Chapter 11). As with the other forms of intellectual property protection, much of the reasoning behind the law tries to balance the economic protection of artists and the public.

One is not required to register a trademark or service mark with the USPTO in order to have a protectable interest in one's name or marketplace identifier. Instead, one can protect an interest in the mark by using it in commerce. However, registering a mark with the USPTO provides numerous advantages, including creating a legal presumption of ownership of the mark, and that the owner has the exclusive right to use the mark in connection with the specific goods and/or services listed in the registration. Two identical trademarks

can exist, if they are in different categories of goods or services, and there is no likelihood of source confusion of the goods and services being offered.

The decision to award a trademark or service mark is based on lack of confusion in the marketplace between the mark and another existing mark, and the USPTO reviews all applications for registration with that goal in mind. The most common reason for a rejection is that it would cause confusion with a mark already in existence, and the main criteria for confusion are: (1) that the mark (or phrase) itself is similar and (2) that the market is similar. There would be less conflict between a fashion designer's mark and an eye surgeon than there would be with two fashion designers. Before selecting and investing in a trademark or service mark, it is a good idea to search the USPTO's website's electronic database, which allows anyone to search all registered trademarks and service marks in the United States, or have a commercial database search conducted.[10]

There are also other reasons why a mark may be rejected. The USPTO lists four common reasons; the proposed mark is:

- Descriptive for the goods/services
- A geographic term
- A surname
- Ornamental as applied to the goods

For example, a generic business description, like "Graphic Designer" or "Dramatic Actor," cannot be registered, because one cannot monopolize such a common descriptive name. Once a trademark or service mark is registered, it can be renewed perpetually (with periodic required updates to certify that the mark is still in use).

10 https:// http://tess2.uspto.gov/. For a basic primer, see the USPTO's "Trademark Basics" at
 https://www.uspto.gov/trademarks-getting-started/trademark-basics.

PATENT

Patent protection is an extremely powerful form of protection that is available to inventors. As it is rarely applicable to artists, this chapter touches on it briefly. The USPTO defines patents as follows:

> A patent is an intellectual property right granted by the Government of the United States of America to an inventor "to exclude others from making, using, offering for sale, or selling the invention throughout the United States or importing the invention into the United States" for a limited time in exchange for public disclosure of the invention when the patent is granted.

There are two main types of patents: utility patents and design patents. Utility patents cover "any new and useful process, machine, article of manufacture, compositions of matter, or any new useful improvement thereof." Design patents, on the other hand, can be granted "to anyone who invents a new, original, and ornamental design for an article of manufacture." Design patents can be thought of as protection for artistic but functional works, whereas copyright covers nonfunctional artistic works.

Securing a patent is a time-consuming and often an expensive process, frequently requiring the services of an attorney. Once secured, the owner of a patent has what is sometimes referred to as a "limited monopoly" on the new invention. The patent owner has the sole right to use the invention, but it is time limited (a utility patent lasts for twenty years and a design patent lasts for fourteen years). The rationale behind patents very clearly shows the balancing act between the interests of society and that of the inventor (creator). The "bargain" in exchange for a patent is complete disclosure, so that society may benefit from the knowledge or discovery. In return, inventors get complete control over their product for a limited time.

TRADE SECRETS

Finally, one other method of protection, although not commonly used among artists, is through trade secrets. Trade secrets protect economically valuable information that companies want to keep secret, such as formulas, patterns, devices, methods, techniques, or processes that do not enjoy the same kinds of protections provided by intellectual property laws. They can be protected through federal and state statutes and state common law. A classic example of a trade secret is the recipe for Coca-Cola. A recipe is a good candidate for trade secret protection, because it is extremely hard to reverse engineer and cannot, on its own, be protected by copyright, trademark, or patent law.

Other examples include a painter who has a special way of mixing paints to produce a particular texture, or a singer who has a way of breathing that allows him or her to sing with a unique tone. It is unlikely that either of these would be good candidates for protection under intellectual property laws. However, if the artists in question want to try and keep their techniques from becoming widely used, they have two options: 1) never to disclose (and maintain the secrets forever) or 2) involve others in the process. If the latter is chosen, then it is important for an artist to have the others sign well-drafted confidentiality agreements, which will add a level of enforcement protection.

CONCLUSION

Artists need to be aware of the various intellectual property laws, and to navigate them appropriately. The informed artist will know that it may be important to consult with a reputable attorney who is knowledgeable in these fields. Good counsel should enable an artist to do that which he or she does best, which is to concentrate on creative output. Familiarity with intellectual property laws will also empower artists to be able to collaborate, create original and derivative works, and understand their rights.

Contracts

Contracts are road maps to relationships. A contract requires a meeting of the minds and occurs when two or more parties come together and commemorate an agreement that maps out their obligations to each other. A contract contains valuable information, such as who is entering into an agreement, for what purpose, who is responsible to the other for certain defined tasks, what is being given in exchange for the tasks, the duration of the relationship regarding those tasks, who owns the resulting physical and/or intellectual property, and other important issues. They can define roles and obligations and offer remedies if parties breach their defined and agreed-upon promises. Contracts that are not egregious or illegal are legally binding and enforceable in a court of law.

A contract can be written or verbal, formal or informal; even agreements written on cocktail napkins may be considered as valid in courts of law in certain instances. For legal and business purposes, however, it is advisable to have a formal, written agreement that clearly states the terms of a relationship.

STATUTE OF FRAUDS

Without a written agreement, it can be difficult to determine or prove the exact agreed-upon terms. While verbal contracts are sometimes valid and enforceable, there are several types of contracts that

must be in writing. These contracts are governed by the "Statute of Frauds."

Some of the contracts that must be in writing include rules related to executors of estates, a promise conditioned on marriage, and any agreement that cannot be performed and completed within one year. Furthermore, the purchase or sale of real estate requires a written contract (this does not include a lease, unless the lease is for more than one year), as does the sale of goods worth $500 or more. Suretyship agreements must also be in writing. A "surety" is one who promises to pay another's debts. In addition, work-made-for-hire relationships must be memorialized. For more on the concept of work made for hire, see Chapter 3.

COMPETENCY, CONSENT, AND LEGALITY

Each party to a contract must have the legal capacity to enter into that contract. Minors under the age of eighteen cannot enter into contracts (with certain limited exceptions). Neither can a person who is declared mentally incompetent by a court of law; however, a guardian can enter into a contract on that person's behalf. Furthermore, people who are intoxicated by drugs or alcohol are not considered to be legally competent. If one who does not have the legal capacity to enter into a contract does so, such contract can be rescinded or voided by a court.

In addition to capacity, a party to a contract must consent to the terms. Signing an agreement signifies that one is legally presumed to have consented to the terms. It is advisable to consult with an attorney when presented with a contract, to ensure full knowledge and understanding of all terms.

OFFER AND ACCEPTANCE

A contract begins with offer and acceptance. One party proposes certain terms to another, which is the initial offer. An offer should identify and define the scope of the agreement. Once an offer is

proffered, the other party may accept the terms of the offer, modify the terms and make a counteroffer, or reject the offer. This can be accomplished verbally or in writing, although it is always prudent to memorialize negotiations in writing. A writing can include formal or informal letters, emails, texts, and handwritten notes.

Counteroffer

A counteroffer occurs when, instead of accepting any or all terms of an offer, changes are made, which are then offered back to the original party. The counteroffer may be accepted or rejected by that party. This process continues back and forth until all of the terms are agreed upon, or the negotiations are unsuccessful.

Once both sides to a contract agree to all the terms, then the contract can be drafted to formalize the agreement.

COMMON CLAUSES IN CONTRACTS

The clauses in a contract outline the terms governing the agreement. The rights and responsibilities outlined in any agreement will be unique to that particular agreement. However, there are several clauses that appear in most contracts. These include:

- Introduction
- Consideration
- Grant of Rights
- Term, Termination
- Deliverables
- Merger and Integration
- Indemnification ("Hold Harmless"), Representation and Warranty
- Nonwaiver
- Alternative Dispute Resolution (Mediation and/or Arbitration)
- Attorneys' Fees

- Choice of Law and Choice of Forum
- Severability
- Force Majeure
- Counterparts
- Prior Understandings

Introduction

Contracts usually begin with the names and addresses of the parties, followed by "Whereas," "Recitals," or language briefly describing the purpose of the agreement. For example, a Commission Agreement between a theater company and a playwright may start like this: "Whereas the theater company intends to commission a play about star-crossed lovers, and whereas the playwright agrees to write a play about star-crossed lovers, Now therefore, the theater company and the playwright agree as follows . . ."

Consideration

Consideration is something of adequate value that is given by one party in the contract to another in return for the other party's performance. It is the bargained-for exchange between the parties, and a requirement in any contract.

Consideration may take the form of money, property, services, or in-kind value. Adequate value does not necessarily mean fair market value, and if there is a legal dispute, a court would look to the time the contract was signed.

Grant of Rights

This clause defines what rights are granted in exchange for the consideration. It is important to define the grant of rights, so that there is no confusion during and after the performance of the contract. In contracts involving real property, such as a painting, it is important to define that the right to the physical painting is conveyed, and to specify whether the intellectual property in the painting is assigned and transferred as well, or whether the intellectual property is

retained by the artist. For more information, see Chapter 3 on intellectual property.

When granting rights, one should consider defining the time period and geographical area of the grant, whether it is exclusive or nonexclusive, and what rights (if any) are reserved by the artist. Where relevant, it is also important to consider whether an employee or independent contractor relationship exists, as the rights granted may automatically become the property of the employer or company hiring the independent contractor (depending on whether the agreement contains work-made-for-hire language).

Term, Termination

A contract must specify the duration of time that the agreement is in effect. It should also contain termination language, which enables the parties to end the agreement prior to its term's end, whether for cause or without cause, and includes any notice requirements or remedies that may be available to a nonterminating party, if the termination is based on the default of the other party.

Deliverables

Many contracts contain deliverables. These expressly describe who, what, when, and where the agreed-upon work is to be done or performed.

Merger and Integration

Merger and Integration clauses prevent the parties from later claiming that the contract does not reflect their complete understanding of the agreement. Once the parties enter into a contract, this clause prevents them from altering or adding to it with later, outside, or unwritten agreements. The Merger and Integration clause also prevents a party from claiming that the agreement is not consistent with prior agreements. It will usually contain a declaration that the signed agreement constitutes the entire agreement between the parties.

Indemnification and Hold Harmless

Indemnification means that one party will pay for losses suffered by the other party resulting from the first party's actions, omissions, or assurances. This clause transfers liability (legal financial responsibility) from one party to another. It can also be called a Hold Harmless clause. Usually, a party agrees to pay money; for example, a party may indemnify another party for attorney's fees, judgments, and settlements. Indemnification does not extend to acts of fraud or criminal activity.

Representations and Warranties

In this clause, the parties are promising that whatever is represented to be true or accurate is in fact true or accurate.

Nonwaiver

Nonwaiver clauses provide that any default excused by the nondefaulting party will not constitute a waiver of any other defaults. Such a clause might read: "The failure by one party to require performance of any provision shall not affect that party's right to require performance at any time thereafter, nor shall a waiver of any breach or default of this contract constitute a waiver of any subsequent breach or default or a waiver of the provision itself."

Alternative Dispute Resolution (Mediation and/or Arbitration)

Many contracts include clauses that enable parties to solve legal disputes without resorting to litigation. These Alternative Dispute Resolutions are often less expensive and time-consuming than lawsuits.

Mediation is a nonbinding negotiation process that is facilitated by a neutral third-party mediator. The mediator does not decide the outcome; rather, he or she tries to help the parties come to a resolution.

Arbitration is a way for parties to settle their matter privately and out of court if they cannot settle the matter themselves or through mediation. In an arbitration, each party has its own legal counsel, both parties contribute to the administration costs, and the discovery

process (the process of gathering evidence) is considerably shorter than if the parties litigated in court.

Attorneys' Fees

Many contracts have a clause specifically stating that in the event of litigation or arbitration, the losing party will pay the winning party's attorneys' fees.

Choice of Law and Choice of Forum

These clauses specifically identify the law under which a court would interpret the meaning of the contract, or where any lawsuit based on the contract must be filed. The contract might state: "This contract will be governed by the laws of the State of New York." In that case, New York law will be used by whatever court hears the case, even if that court is not in New York, and the underlying events did not take place in New York. These clauses may also designate a specific forum where any litigation or arbitration must take place in the event of a dispute (such as "the Federal and State courts in New York County, New York").

Severability

Without a Severability Clause, if one provision of a contract is declared by a court to be invalid, that court may, without such a clause, rule that the entire contract is invalid. This clause is important to a contract because it "saves" all other provisions of a contract, even if one of the provisions is deemed invalid or illegal. Such a clause might read: "If any provision of the Agreement is held unenforceable, then such provision will be modified, and all remaining provisions of this contract shall remain in full force and effect."

CONCLUSION

The purpose of this chapter was to provide basic knowledge about contracts, both on how they are formed, and the kinds of common

terms you might see in them. It is by no means a comprehensive study in contract law and does not delve into the kinds of sophisticated contracts that creators in the arts and entertainment businesses encounter. It is advisable to consult with an attorney who can protect one's interests in contract drafting and negotiations.

Business Entities

INTRODUCTION

The previous two chapters covered contracts and intellectual property and dealt with the law as it applies in the contexts of both art and business. In this chapter, we're using the term "business law" more specifically to refer to the business structures that are used to run businesses, and how your choice of legal structure will determine many aspects of your business—interactions with the government, tax obligations, and even relationships with customers and other businesses. And as we will explain shortly, you are likely already considered to be a business in a legal sense, so choosing a structure simply gives you more control to do what is best for you and your practice.

The idea of starting a company can certainly be more intimidating than just using business strategies in your operations. We begin this chapter by explaining what having a "business structure" means in both legal and practical terms. In particular, we'll discuss the factors you should carefully consider before deciding which structure is right for you. Then we review the different business structures, the steps involved in forming a company under each option, and what ongoing legal obligations come with each option.

Before we dive in, please keep in mind that the types of business structures and their exact details vary from state to state. If you work in more than one state, or live and work in different states, you'll want

to compare the options in each state to determine if establishing your company in one state is better for you than the other. We'll provide the general legal framework for your consideration, but this cannot replace a personal consultation with an attorney familiar with your state or other professionals, like accountants, who can help you in assessing what is most appropriate for your specific needs. We just want to start you thinking about the different options and relevant considerations.

What Is a Business Structure?

Your business structure is not dependent on whether you work out of an office, your home, or a studio. Rather, business structure refers to the entity that is legally responsible for your business activities. This is true even if you haven't taken any formal steps. If you're only working for yourself—for example, selling pieces of art directly to buyers or providing art services—you already have a business structure in place called a sole proprietorship. Although there are no formal requirements for setting up a sole proprietorship, there are rules that apply to how you do business. (More on this a little later.) Even if you've already taken formal steps to form a company—most likely a limited liability company (LLC) or corporation—there are important rules that apply to the ongoing operations of that business entity.

Considerations in Selecting Your Business Structure

There are several important and very practical factors to consider before you take on the time and expense of forming a new entity. This isn't an exhaustive list, but it covers the most important and most common concerns.

LIABILITY

For many, the question of liability will be the most important factor because you need to consider the worst-case scenario of getting sued by an individual or another business. Most people are familiar with

the term "liability," which refers to how legally responsible you are if something goes wrong and how much that responsibility might cost you. For example, suppose a potential buyer visits your studio, trips over a canvas that you left on the floor, and breaks her hip. In addition to negatively impacting your reputation and sales with bad reviews or public comments, she could sue you for her medical expenses and other damages (obviously it is more complicated than that, and many other conditions apply, but that is the basic concept). Similarly, you might be liable for failing to meet a contractual obligation, like delivering the correct work by an agreed deadline or making payments.

When you're choosing among business structures, keep an eye on what type of liability accompanies that structure. It will either be personal liability or limited liability, and the difference is very important.

With personal liability, the responsibility sticks with you as an individual. Put simply, that means if you're sued and lose, a court could ultimately order your personal assets, such as your property and personal bank accounts, seized in order to "satisfy" the judgment.

Many of the business structure options we discuss below offer "limited liability." In basic terms, limited liability shields your personal assets from a business suit. In that case, if you're sued and lose, only business assets (funds in business bank accounts, property owned by the business) are vulnerable in the event of a judgment against you. To be clear, this protection is very useful, but it comes with additional responsibilities that must be satisfied, or you risk losing your limited liability protection just when you most need it. These responsibilities include being very careful about separating business funds from your personal funds, and making sure you sign your contracts as a representative of your business rather than just your own name.

TAX CONSIDERATIONS

Depending on which business structure you choose, your tax-related responsibilities can vary significantly. With some options, you may

only have a little extra work in doing your taxes because you report business income and expenses on your individual income tax return. With other options, you'll have additional paperwork and forms to keep track of. You may even have to prepare and file a separate tax return for the business. In addition, with most business structures, you'll be responsible for withholding and paying income taxes throughout the year.

FORMATION AND START-UP COSTS

Finally, but certainly not least important, the costs associated with starting each business structure vary widely. The formation of most business structures requires some paperwork. Some of the initial paperwork needs to be filed with the state. This is usually handled by your state's Department of State or Division of Corporations; in some states, this is handled by a separate authority within your county. Other important paperwork needs to be created and maintained in your files but doesn't get filed with the state.

In addition to state filing fees, you should also be on the lookout for associated costs that may be required to complete formation. New York, for example, has a publication requirement for LLCs that surprises many first-time business owners. The state filing fees here are not unusual, but the steps required to satisfy the publication requirement for your newly formed LLC can cost several times more than the state filing fees themselves!

ONGOING RESPONSIBILITIES

Some of the business structures discussed below have additional responsibilities mandated by state law. Such formalities may relate to how you operate the business, such as requiring you to hold annual meetings and to record and store minutes of these meetings. That might be true even if you're the only one in your company. You may also be required to make certain annual or biannual filings with

the State. Because these requirements vary by state, it's especially important you check with your local authorities or consult a local lawyer.

We'll stress one more time the importance of confirming the specifics of each business structure you're considering within your state. While most states offer a similar range of business structures, the requirements and costs associated with each option can vary from state to state more than you might expect.

SOLE PROPRIETORSHIPS

You can think of sole proprietorship as the default business classification. As we mentioned above, sole proprietorship applies to any individual who makes sales or provides services to other individuals or businesses. If you've ever sold something (such as a work of art) or been paid for providing a service (such as performing as a freelance musician or making a commissioned painting), the law considers you a Sole Proprietor. This is true even if you've never thought of yourself as a business or taken any formal steps toward formalizing your business structure. The determining factor here is your business activity—are you making sales or providing services—rather than any paperwork you may have filed. Unlike most of the other options we'll be discussing, within a sole proprietorship, the person and the legal entity are one and the same.

Liability

Without exaggeration, liability is the most important consideration in operating as a sole proprietor. Anyone choosing to work as a sole proprietor must consider how completely they are exposed. As a sole proprietor, your personal liability is unrestricted. That means that in the event something goes wrong (for example, losing a suit, or failing to pay a debt), it is not just the assets used for business purposes or the revenues earned through that business's activities that are susceptible. Any and all personal assets you own will also be on the line.

For all intents and purposes, nothing that you have of value is out of reach. That includes real estate, your car, personal bank accounts, and investments.

Tax Considerations

One of the benefits of operating as a sole proprietor is that you have the simplest tax-reporting responsibilities. All revenues, expenses, and other financial details related to your business activities are reported on your personal income tax return. This could result in little to no additional paperwork on your tax return. However, this doesn't relieve you of your record-keeping responsibilities. You should be diligent about keeping track of your business activities apart from your personal accounting. You may be required to support the business revenues and deductions you report with an audit.

Another important responsibility is paying income taxes on the revenues you earn. Federal income tax is technically a pay-as-you-go obligation. Put another way, you should be paying your taxes as you receive income throughout the year. For many, this is handled by paying quarterly estimated taxes. You are strongly urged to discuss your specific situation with an accountant or contact the IRS directly to confirm your obligations.

If you're going to be paying others to do work for you, either as contractors or employees, it would be a good idea to get an Employer Identification Number ("EIN") assigned for your business activities. The EIN is also referred to as a tax ID or tax identification number. The EIN can be secured in just a few minutes using the IRS's website. There is no fee for getting an EIN.

Formation and Start-Up Costs

In addition to being the simplest business structure to use, sole proprietorships are also the cheapest to get started. In most states, there are no forms, special legal requirements, or fees to start doing business.

However, there is one important exception to this ease. If you're operating under a business name that is not your true personal

name, many states require you to register the business name you'll be using. This is usually referred to as a fictitious or assumed name. For example, if Jane Smith is a photographer who only uses her own name to sell her photographs and services, she can likely proceed without hesitation. However, if she adds even one word to her business name—for example, Jane Smith Photography—or if she operates under an invented business name—for example, Urban Luxe Photography—she will probably be required to register this name with her local authorities.

In some states, you register your fictitious name with a state office while in other states you file with your local county clerk. Depending on your location, the registration form you use might be called a Business Certificate, a Certificate of Assumed Name, Fictitious Name, "Doing Business As" or "D/B/A" form, or Trade Name form. Whatever name you use, it's important that you also acknowledge it on all government forms moving forward, including your state and federal tax filings.

Ongoing Responsibilities

Beyond your tax payment and filing obligations, Sole Proprietorships normally don't have any additional ongoing responsibilities as is the case with many of the other business structures.

PARTNERSHIPS

Just as sole proprietorships apply to individuals, partnerships apply to two or more people engaging in business pursuits together. For example, a graphic artist and web developer might join forces to serve clients. As we saw with sole proprietorships, determining whether a partnership has been formed depends on the actions and intents of the individuals working together rather than on any paperwork that has been prepared or filed. As long as two or more of you have agreed to work together, have agreed to each contribute money, property, or time to the business, and are each sharing in the business's profits

and losses, you will have created a separate legal entity—a partnership—under the law and you will be considered partners.

Another corollary to the sole proprietor is the liability you're exposed to in a partnership. There are three standard forms of partnerships, and the extent of your liability will depend on the partnership type:

1. A "**General Partnership**" is what's created when you start working together in the absence of any agreements or additional paperwork between you. In a general partnership, all the partners share in running the partnership and any liabilities that arise, including liability for other partners' actions. Additionally, each partner can act on behalf of the partnership as a whole, including taking on contractual obligations and debt, even if the other partners were not made aware of the action.

2. A "**Limited Partnership**" (LP) is usually created by written agreement and requires filing with your state authority. In a limited partnership, there are two types of partners with different responsibilities and liabilities. There must be at least one general partner and at least one limited partner. General partners manage the business's operation, have a say in decision making, and have full liability for the partnership actions. Limited partners, on the other hand, have invested funds or assets in the business but are not involved in managing operations and are not personally liable for the partnership or any other partners' conduct.

3. "**Limited Liability Partnerships**" (LLPs) are not recognized in all states, and in some states they're restricted to certain professions, like doctors and lawyers. Where they are an option, the extent and types of liability the partners face vary. For this reason, LLPs are not common options for artistic pursuits.

It's probably a good idea to take a moment to acknowledge that the terms "partner" and "partnership" are frequently used much more colloquially than in the legal sense we use here. You'll often hear people refer to their partners when they are developing new works, collaborating on a single project, producing an event, or serving different aspects of a client's needs. Using the word "partner" can be a very convenient shorthand and, by itself, is not sufficient to form a legal partnership. However, there may be situations where casual wording combined with your actions and other facts and circumstances could risk the creation of a legal partnership. It's for this reason we stress that your collaborations should be defined in written contracts that include provisions explicitly stating no partnership is formed unless that is your intent (for more on contracts, please refer back to Chapter 4).

Finally, although general partnerships are tempting as a relatively easy option for going into business with others, we would encourage you to carefully consider the personal liability you're exposed to in a partnership. It's one thing to accept such personal liability as a sole proprietor when it's based only on your actions and you're intimately aware of all the facts and risks to be weighed in making your business decisions. When you're dealing with partners, you could find yourself taking on not only risks, but also significant obligations, without your input or choice.

Liability

General partnership

Like sole proprietors, partners are exposed to full personal liability for the partnership's debts and obligations. Even more so, as a partner, you are also fully responsible for the actions your partners take on behalf of the partnership. In the event of a lawsuit or debt, each partner's personal assets are vulnerable when it comes to satisfying that obligation, including those you may not have been aware of.

LP

Remember that LPs have two types of partners. General partners are fully liable for the LP's obligations. Limited partners enjoy limited liability. That means they have no personal liability when it comes to satisfying the LP's obligations. Only funds or assets the limited partner previously put into the LP or any profits due to that partner would be vulnerable.

LLP

The partners in an LLP have some form of limited liability, but the extent of this protection varies from state to state. An LLP may protect each partner's personal assets from liability for other partners' individual conduct or from the debts and obligations of the partnership as a whole.

Tax Considerations

Generally, tax reporting for partnerships is only a little more complicated than it is for sole proprietors. Partnerships are subject to pass-through taxation. Partnerships don't file their own tax returns. Rather, partnership profits and losses are passed through to the partners and reported on the partners' individual returns. The partnership's profits, losses, and other relevant details are included on IRS Form 1065, which is referred to as an informational return. Each partner also receives an individual Schedule K-1 that indicates that partner's share of that activity. The partnership is responsible for providing these to the partners each year.

Formation and Start-Up Costs

General partnership

There are no formal requirements for creating a general partnership. Although not required, the importance of having a written partnership agreement cannot be stressed enough. If you intend to give the partnership a business name under which you'll operate, you'll need

to register that name. Find more details on this in the discussion of sole proprietorship formation requirements earlier in this chapter.

LP

To form an LP, the partners will first draft and sign a partnership agreement that will define the differing rights, responsibilities, and relationships of the general and limited partners. Next, you'll be required to register the LP with your state authority by filing a Certificate of Limited Partnership or similar form and to pay the respective filing fees. This certificate usually includes the name of the LP, contact details, and the names of all general partners. Limited partners don't need to be identified. In most states, you will be required to include some form of "LP" or "Limited Partnership" in the partnership's name. The certificate is usually signed by all the general partners.

LLP

To form an LLP, you'll be required to register with your state authority by filing a Certificate of Limited Liability Partnership, Certificate of Registration, or similar form and to pay the respective filing fees. In most states, you will be required to include some form of "LLP" or "Limited Liability Partnership" in the partnership's name.

The fees for filing LPs and LLPs are often in line with the fees for filing corporations and limited liability companies. However, in some states, you'll run up against additional costs before your registration is truly complete. For example, in New York, there is a publication requirement that involves incurring costs after your initial filing as well as a subsequent filing fee to confirm you've satisfied this publication requirement. This can significantly increase your costs of formation.

Ongoing Responsibilities

Your state may require certain types of partnerships to periodically make a filing that confirm the partnership's activity and contact details. In New York, there is no such requirement for LPs, while LLPs must file a statement every five years.

CORPORATIONS

Corporations have long been a popular business structure for both small and large endeavors. For many, the primary appeal of forming a corporation is the limited liability it gives all of its owners, who are referred to as shareholders. For others, an important benefit of the corporation is that it's the business structure that makes it easiest to take on additional investors. There are a slew of other advantages that come with corporations, including benefits related to how you pay yourself, health insurance, and retirement plans, which are beyond the scope of this chapter but provide very good reasons to consult an attorney or accountant before deciding which business structure would be most advantageous under your circumstances.

There are, in fact, two versions of the corporation to consider:

C Corporation or "C Corp"—This is the corporate form most people think of, and it's the type of corporation created when you file with your local state authority.

S Corporation or "S Corp"—S Corps are not formed by a separate process. Instead, in order to become an S Corp, a recently created C Corp files an extra form with the IRS that lets it be treated as a partnership for taxation purposes. Essentially, this makes the S Corp an important hybrid—S Corp shareholders enjoy the benefits of both the limited liability of a typical corporation and the easier pass-through taxation of a typical partnership. However, S Corps are only available under certain conditions discussed below.

A corporation is considered its own legal person separate from its shareholders. As such, corporations are required to follow certain formalities in order to maintain their separate status and to continue

to provide the protections of limited liability for their shareholders. These formalities include having a board of directors that is responsible for governing the corporation, holding meetings at least annually for the board of directors and the shareholders, and maintaining accurate minutes of these meetings.

While these formalities are understandably intimidating at first glance, it helps to interpret them in the situation you're likely to face as an individual artist. It's perfectly acceptable for one person to start their own corporation. In that scenario, you would create the corporation with just one initial shareholder—yourself. As the sole shareholder, you could appoint yourself as the only director on the board of directors and as the chief executive officer. There's nothing wrong with an individual starting a corporation. However, despite being the sole shareholder and sole director, you would still be responsible for holding annual meetings, taking minutes of any decisions you make at those meetings, and keeping a record of those minutes. This responsibility should not be shrugged off, especially taking notes and keeping a copy of the minutes. Don't let the idea of keeping minutes intimidate you. The minutes can be kept fairly general. But failing to follow these formalities could be a basis for losing the limited liability protection that was probably so important in choosing the corporation as your business structure.

Liability

Both C Corps and S Corps protect their shareholders with limited liability. This means that only the corporation's funds and assets can be used to satisfy the corporation's obligations or debts. Each shareholder's personal assets remain protected. However, this protection relies on you following the corporate formalities discussed throughout this section. If you fail to follow these formalities, it's possible that a judge could find that you've lost the benefit of limited liability, making your personal assets vulnerable. You may have heard this situation referred to as "piercing the corporate veil."

Tax Considerations

C Corps

C Corps pay corporate income taxes and are required to file their own corporate tax returns. This creates a situation called "double taxation," meaning corporations first pay corporate taxes on their profits, then when any remaining profits are paid to shareholders as dividends. Then, the shareholders also pay income tax on those dividends. Note how this is different from the sole proprietorships, partnerships, and limited liability companies discussed elsewhere in this chapter, where profits are only taxed when they are passed through and reported on individuals' tax returns.

S Corps

S Corps do not pay corporate income tax or file their own tax returns. Instead, the S Corp's profits are treated just like those in a partnership and pass through to the individuals to be included in their individual income tax returns. This eliminates the double taxation of profits we discussed for C Corps. Each year, the S Corp prepares IRS Form 1120S describing all of its financial activity and provides each shareholder with a Schedule K-1 that indicates that shareholder's share of that activity.

Formation and Start-Up Costs

C Corp

The formation of a corporation, referred to as incorporation, starts by preparing and filing a Certificate of Incorporation or Articles of Incorporation with your state authority. This initial filing includes details such as the corporation's name, purposes, and the types and numbers of shares that may be issued. In most states, you will be required to include some form of "Corporation," "Corp.," "Incorporated," or "Inc." in the corporation's name. This will require a filing fee that is usually similar to the fees for filing partnerships or limited liability companies. Once formed, the corporation will be required

to issue shares of its stock to shareholders and approve by-laws that include the rules by which the corporation will be governed.

S Corp

An S Corp is created by following all of the steps in forming a C Corp. Only one additional step is required—filing Form 2553 with the IRS. The form must be signed by all shareholders. Submitting this form is referred to as "making an election to be an S corporation." So while the corporation is really created at the state level, it only becomes an S Corp after taking an additional step at the federal level. Nonetheless, you may also have to make a similar election at the state level to get pass-through treatment for state taxes. It's important to note that not all C Corps can become S Corps. To be eligible for the S Corp election, the corporation must be a domestic (not foreign-owned) corporation, with only one class of stock and no more than one hundred shareholders who are all US citizens or legal residents.

Once a corporation is formed, it's considered a separate legal person and can exist in perpetuity, even if its founders have died or are no longer shareholders.

Ongoing Responsibilities

As mentioned earlier, corporations are legally required to follow certain ongoing formalities. These include holding annual board and shareholder meetings and keeping minutes of these meetings. Many states also require corporations to make periodic filings to confirm contact details, the name of their chief executive officer, and other details. In New York, these Biennial Statements are due every two years.

LIMITED LIABILITY COMPANIES

Limited liability companies (LLCs) are a relatively newer business structure option that have grown in popularity since the 1990s. Like the S Corps discussed above, they are hybrids that combine the pass-through taxation characteristics of a partnership with the limited

liability protections of a corporation. LLCs have some added advantages. Unlike corporations, an LLC's limited liability is not dependent on potentially burdensome formalities such as having boards, holding annual meetings or keeping meeting minutes. Additionally, LLCs can be owned by non-US citizens.

The owners of an LLC are called members. It's possible to file an LLC with just one owner, resulting in a single-member LLC.

Liability

The limited liability granted to LLC members is the same as the limited liability we've already covered. While this doesn't rely on any corporate formalities, you're still required to operate the LLC as a separate entity from its individual members. In particular, this means being diligent about keeping LLC funds and expenses separate from your personal finances. For example, if you're operating as an LLC and sell some art pieces, the payment for those pieces must first be deposited into your LLC bank account. Once the funds clear, you can then pay yourself from the LLC bank account. Payments to the LLC should never be deposited into your personal bank account.

Tax Considerations

For tax purposes, single-member LLCs are treated like sole proprietorships, and LLCs with two or more members are treated as partnerships. It is possible for an LLC to elect to be treated as a corporation, but this option should only be used after consulting with an accountant or attorney. In some states, LLCs may be responsible for a separate franchise tax. Like the partnerships discussed above, the LLC will give each member a Schedule K-1 indicating their proportion of the LLC's profits and other financial activity. The member would then file the K-1 with their individual tax return.

Formation and Start-Up Costs

LLCs are formed by filing Articles of Organization with your state authority. The Articles contain basic information about the LLC and

may contain restrictions about its operations. The filing fees here are often similar to those for filing a corporation. However, be aware that your state might have additional requirements to complete formation that may mean additional costs for you. In some cases, these additional costs can be significant. Be sure to check with an attorney or your local state authority to confirm all costs before starting the process.

Once the Articles have been filed, the members must draft and sign an Operating Agreement. The Operating Agreement defines the relationship among the members, how profits and losses are shared, and how decisions are made. The operating agreement doesn't get filed with the state but should be kept secure in the LLC's files.

Ongoing Responsibilities

Some states have periodic filing requirements for LLCs. Unlike corporations, LLCs do not exist in perpetuity. The death or withdrawal of a member can potentially lead to the LLC's dissolution. The Operating Agreement can be drafted to mitigate the effects of these events.

SOCIAL ENTERPRISES: BENEFIT CORPORATIONS AND LOW-PROFIT LIMITED LIABILITY COMPANIES

Broadly, social enterprises refer to for-profit businesses that have committed to addressing social or environmental needs. Since 2010, more than thirty states have authorized some form of new business structure that facilitates social enterprise. By far the most common of these is the Benefit Corporation, sometimes called Public Benefit Corporation. Another form authorized by just a handful of states so far is the Low-profit Limited Liability Company (L3C). These new options make for-profit entities eligible for financial support that was previously restricted to nonprofit organizations. In particular, many foundations are now able to invest directly in these social enterprises to satisfy their annual spending requirements. Artists who are already

involved in public art projects or social causes should consider the opportunities these new options provide.

Liability

Both Benefit Corporations and L3Cs provide their owners with the same limited liability found in their traditional counterparts. And as with their traditional counterparts, the formalities or practices discussed in the respective sections above must be followed to maintain limited liability.

Tax Considerations

Tax treatment is similar to that found in the traditional counterparts discussed above. Benefit Corporations based on C Corps face double taxation, while those based on S Corps use pass-through tax treatment. L3Cs get the pass-through tax treatment of typical LLCs.

Formation and Start-Up Costs

A new corporation can be formed as a Benefit Corporation, or an existing corporation can amend its certificate of incorporation to become a Benefit Corporation. Either way, the certificate of incorporation must include a statement on the Benefit Corporation's intent to create a public benefit. An L3C is formed by filing Articles of Organization that define its socially beneficial mission. Because each state varies, it's very important that you consult with your state authority or a local attorney familiar with these new structures to ensure that the language in your formational document complies with your state's requirements. The filing fees for forming Benefit Corporations and L3Cs may be cheaper than their traditional counterparts.

Ongoing Responsibilities

In addition to the ongoing formalities addressed above for corporations, Benefit Corporations are required to produce some material positive impact on society and the environment. Every year, this

impact must be measured against a third party standard and documented in an annual benefit report. The annual benefit report typically gets filed with your state authority, along with a filing fee.

NOT-FOR-PROFIT CORPORATIONS

Not-for-profit corporations (NFPs) are among the most misunderstood entities. Even the name causes confusion, as some states choose to call them not-for-profits, while others call them nonprofits. There are plenty of myths floating around that inaccurately discourage or encourage the use of nonprofits. Where appropriate, nonprofits can be an excellent option for structuring a project. But under some circumstances, the overhead, formalities, and compliance requirements simply outweigh the benefits.

In most states, NFPs are special types of corporations. In some states, nonprofits are not limited to corporations. The common thread is that they are formed for charitable purposes, which are defined broadly to include religious, scientific, public safety, literary, and educational purposes, as well as fostering amateur sports and preventing cruelty to children and animals. Unlike all the other business structures discussed in this chapter, nonprofits have no owners. Instead, a board of directors governs the NFP, but the directors do not receive compensation in the same way that shareholders would. While nonprofits are formed at the state level, many of the benefits commonly associated with them don't take effect until your organization applies to the IRS for federal tax-exempt status.

Each NFP is governed by a board of directors. Depending on the size of the NFP, the board may responsible for daily operations, or there may be separate staff appointed by the board to handle running the organization. Contrary to common misconceptions, NFPs may in fact make a profit in the form of revenues from programs or contributions. However, as an NFP has no owners, any profits realized must be reapplied toward furthering the organization's charitable purposes.

Liability

Liability in the nonprofit context is different from in the other business structures. The board of directors has various fiduciary duties to the organization, but the individual directors do not have personal liability for its obligations and debts. Generally, directors are granted broad discretion in making decisions they believe are in the best interest of the NFP. However, directors who inappropriately take advantage of their role in the NFP for their own benefit can be held accountable.

Tax Considerations

In most states, the state tax exemptions associated with NFPs are not automatic. Unless an NFP applies for state and federal tax exemptions, it will be responsible for corporate income taxes. Tax-exempt status has numerous benefits. First, once the exemption is confirmed, the organization will no longer be responsible for paying federal or state corporate income taxes. For NFPs that plan on owning real estate, you may also be exempt from paying property taxes. Second, as a tax-exempt entity, donations to the organization will be tax-deductible for donors. These are all benefits that can result in more funds to be applied toward the NFP's mission.

To be clear, these exemptions only apply to incomes related to the organization's tax-exempt purposes. NFPs are permitted to generate income from activities that are unrelated to any tax-exempt purposes (for example, renting excess office space to another business). However, those incomes will be subject to taxation. Similarly, the exemptions do not extend to its employees' incomes. Employees remain responsible for paying income tax on their own salaries, and the NFP may be responsible for withholding and paying taxes on behalf of those employees.

Formation and Start-Up Costs

NFPs in most states are formed by filing a certificate of incorporation with the state. The certificate includes the NFP's name, purpose(s), and the names of the initial board members. It also typically includes

a range of provisions intended to satisfy the IRS's exemption require-ments. Filing fees for an NFP are usually less expensive than for a for-profit corporation.

In many states, NFPs also need to register with a separate state authority that oversees NFPs and fundraising activities. In New York, that's the Attorney General's Charities Bureau.

Applying for tax-exempt status involves submitting an application to the IRS and can be a more complicated and more expensive process than the initial state filing. There are multiple versions of the Form 1023 application. NFPs with low projected annual budgets are eligible for a simpler online version (Form 1023EZ) and a lower filing fee of $275. As of 2017, the annual budget threshold for this cheaper, simpler application is $50,000. For NFPs with larger projected budgets, completing the application will be a much more involved process with a filing fee of $850.

Ongoing Responsibilities

Like their for-profit counterparts, NFPs have many ongoing responsi-bilities, but it's important to avoid assuming that their obligations are too similar. NFPs are responsible for numerous annual filings. NFPs with federal tax-exempt status must file an annual IRS Form 990, which informs the IRS about your financial activities. There are multiple versions of this form based on your organization's annual budget. The smaller your budget, the simpler the Form 990 is to complete. In most states, there is also an annual filing with the state authority that over-sees NFPs and fundraising activities. Unlike for-profit corporations, all of these annual filings are subject to public review. If your NFP receives large grants, you will also likely be required to report how those funds were applied and their effects.

At a governance level, the board of directors is required to meet at least annually to fill any board seats that are empty or expiring, to elect officers, and appoint any committees. The board must also annually review and comply with its conflict-of-interest policy, as well as other such policies that may apply. While annual meetings

satisfy statutory requirements, it is best practice for boards to meet more frequently throughout the year.

CONCLUSION

This chapter was intended to give you a basic understanding of the business entities we covered and to start you on the path to determining which is the best option for your arts-related business. There are many practical, financial, and legal considerations to weigh in making your choice. Because of the enduring legal and financial consequences, this is a decision that is best made in consultation with an attorney and accountant in your state who are familiar with both the field you're working in and the types of structures you're considering. Also, please see figure 6 ("Most Common Business Structures for Artists") for a quick overview of the structures discussed in this chapter.

	Sole Proprietorship	General Partnership	Limited Liability Company	Corporation	Not-for-Profit Corporation
Difficulty and cost of formation	Low	Low to Moderate	High	Moderate	Low
Difficulty and cost to maintain	Low	Moderate	Moderate	High	Moderate
Structural Formality	Low	Moderate	Moderate	High	High
Difficulty of tax preparation	Low	Moderate	Moderate	High	High
Flexibility of adding owner	None	High	Mid	High	N/A
Formation documents	n/a, Assumed Name if applicable	Partnership Agreement	Articles of Organization	Certificate of Incorporation	Certificate of Incorporation
Formation authority & filing fee	County; no formation fee; low Assumed Name fee	State; no formation fee; low Assumed Name fee	State; Moderate filing fee	State; Moderate filing fee	State; low filing fee
Periodic filings	no	no	yes	yes	yes
Ongoing governance	no	no	no	Annual Board meetings	Annual Board meetings
Flow through taxation	yes	yes	yes, unless elect to be taxed as corp	Only if S Corp	n/a
Limited liability	no	no	yes	yes	yes

Figure 6. Most Common Business Structures for Artists, courtesy of Zak Shusterman

MANAGING FINANCE

Introduction

It takes as much energy to wish as it does to plan.

—Eleanor Roosevelt

Why spend time focusing on the financial details of your art career? Obviously money—or lack thereof—is an important issue for all of us, regardless of our profession. Furthermore, most of us believe that we understand something about our own financial picture. After all, we deal with it every day. At the same time, many people (not just artists) find financial matters intimidating, and sometimes clearly understanding your financial realities just creates more anxiety. Many people would rather ignore the numbers, just focusing instead on creating art.

As we will emphasize throughout this book, a little planning combined with a little extra knowledge can go a long way toward increasing your comfort level with your finances, and to positively impacting your own bottom line. The goal of this section is not to tell you how to do your taxes, pick stocks, or choose a specific accounting or budgeting system, because these are individual choices that you will need to make after carefully considering your options (and perhaps after consulting with experts, too). Instead, we will review some best practices in organizing your financial life through budgeting, define some basic financial and accounting terminology, and look at the essential elements of good financial health from a financial planning perspective.

Special thanks are in order to Rosalba Mazzola and Julian Schubach, who drafted the chapters on Budgeting and Terminology, and Financial Planning, respectively. Also, a note of caution—nothing in this book should be construed as giving tax or financial planning advice. If you have any specific questions about your own financial situation, it is always highly recommended that you obtain your financial advice from a qualified financial planner, and that you seek any accounting and tax advice from an accountant or tax professional.

MEET SOFIA GARCIA

Because there are so many aspects to our financial lives, and because many artists have varied and complex sources of income, we are going to work with one example through this section, a fictional "composite sketch" of one artist who faces many of the same issues that the rest of us do. We won't focus on her exclusively, but often when we use samples and examples throughout this section, we'll refer back to her so there's some consistency in building out a complete financial picture. So, let's meet Sofia!

Sofia Garcia is a professional set designer and photographer, and very well respected in both fields. She earns money in a variety of ways. First, she is frequently hired by larger production companies to do set-design work. These jobs typically last for several weeks at a time and are quite time-intensive. When she does this kind of work she is treated as a "W-2" employee by the companies for which she works, meaning that they deduct payroll taxes from her paycheck and treat her as an employee. Separately, she owns Sofia's Design, LLC, a company under which she conducts classes and workshops, sells photography works (often online), and does freelance and other "gig" work. As part of that practice, she rents a studio space where she physically makes work and runs classes and workshops, and sometimes even runs shows. Finally, she applies for grant funding frequently and is occasionally successful, though that is not usually a regular part of her income.

Sofia is very organized and keeps excellent records, and she typically handles her finances on her own. She has never needed to seek professional help from either an accountant or a financial adviser and, given that money is often tight, never considered it worth the expense even when she did have questions. Also, each year Sofia completes her personal tax return, which consists of both 1099 and W-2 income. And other than having separate checking and savings accounts, she does not engage in many other savings strategies—though she does diligently manage to put away a little each month for retirement.

In 2017, Sofia made $83,000, which was significantly more than she earns in a typical year. A total of $27,000 came from three separate W-2 jobs doing set design. Also, through Sofia's Design, LLC, she earned $5,000 teaching, $1,500 from conducting workshops, $2,500 in smaller freelance projects, and $12,000 from the sale of her work on Shutterstock .com. However, she was also successful with two grant applications and received $10,000 from one and $25,000 from the other. This additional $35,000 made her far more profitable than usual.

After taking possession of the grant money, Sofia deposited the full $35,000 in her savings account. Over the course of the year, Sofia used the grant money to fully fund several new projects and exhibitions, including some ambitious ideas that she had held off on in the past due to limited funds. She also made sure to compensate all of her collaborators and independent contractors at very good rates, in part to thank them for working with her in the past on a more limited budget. She was thrilled that she could develop her art at such a high level without incurring any debt.

However, in the spring, when Sofia began to work on her tax return for the previous year, she was taken aback when she realized the tax implications of taking possession of the grant money, and how much was owed in taxes. Confronted with this troublesome tax bill, she decided it was time to employ the services of a skilled accountant and financial adviser to provide financial education and management of her budget and income to avoid any problems in the years to come. The information that appears in the following chapters will

help artists like Sofia (and you) to learn more about how to budget, save, and report income and expenses, as well as how to work with qualified professionals to maximize how well she does in these areas.

Budgets

Budgets ... who needs them? What kind of budgets are needed—project-based, annual, or both? When are they appropriate? How do you create them? Why are they so important?

These are some of the many questions that artists have about budgeting. And let's face it—very few people get excited about preparing budgets, yet using them can have life- and career-altering effects. Furthermore, stalling on diving into your finances can lead to larger undetected issues. It's time to coach your money to do what it's supposed to do: work for you, not against you or your future.

So how do we learn to enjoy the budgeting process so that it can help us to succeed? Let's start by breaking it down into a few simple steps and mastering each one separately. Much like choreographing a great dance piece, once it comes together, it can be a masterpiece!

WHO NEEDS A BUDGET?

All businesses, large or small, benefit from budgeting their finances. The perception among many is that budgeting is more meaningful for big companies, when in fact a small, one-person company might benefit the most! It is when resources are limited that accounting for every penny counts. It can make the difference between losing or gaining profit.

WHAT KINDS OF BUDGETS ARE NEEDED?

Budgets can be confusing because there are many different types that account for different items, leading you to different results. It's important to know the various types of budgets you might need or want to create, how each works, and why each is important. You may have three or four different budgets for your work. The two most basic types of budgets are project-based budgets and annual budgets. The **project budget** represents every stage of a project, including development, production, and postproduction (if applicable). Whether you are applying for grant funding, seeking investment, or explaining a project to a collaborator or employee, you may need to produce a project budget (we will discuss budgeting in the context of grant applications in Chapter 16). It can cover any amount of time the project needs, from weeks to years. It is important to make clear how much time you are accounting for, either in the proposal or in the budget itself. The **annual budget** outlines your income from all sources and lists a complete summary of all costs associated for the year.

WHEN ARE BUDGETS APPROPRIATE?

In Chapter 1, we discussed setting goals and planning for the future. Some of the goals you have may be financial goals. To achieve these goals, you will want to plan for future expenses. For example, you may be considering taking a part-time job or some additional contract work in order to save money for a show you want to produce. How much money would you need to earn—and save—in order to cover the production expenses? One way to find the answer to this would be to prepare a budget. The budget would illustrate an estimate of the expenses associated with the project, such as fees to performers, travel, meals, music, costumes, props, etc. In addition, you should factor in your living expenses such as food, rent, personal care, entertainment, and anything else associated with your usual life activities. After the project begins, you can then use the budget as a guide for

spending during the year, evaluating whether a particular expense is necessary, and why.

A budget is utilized in business in a similar fashion. For an example, let's look at Sofia's Design, LLC, the company owned and operated by Sofia Garcia. Sofia's Design offers a variety of workshops and classes at the studio and also displays various works of art for sale, both in the studio itself and at periodic exhibitions around the city where Sofia lives. Sofia uses a budget to plan off-site events as well as to manage the operational costs at the studio. These include expenses associated with the instructor fees, supplies, maintenance of space, and rent.

In figure 7, you can see that Sofia has prepared a budget for 2018 that outlines her projected income from classes and workshops. This budget also includes the related costs of the classes and workshops. The income and expenses here are added to her overall budget for the year, which illustrates her income from all sources for the year, as well as her total costs. The budget thus provides Sofia with a game plan for the year. It is not a perfect science, admittedly, but is a useful tool for her financial planning needs, and to help control her cash inflows and outflows.

Budgets play a vital role for businesses of all sizes and types, as well as individuals. Sofia built her budget by referring to her prior year financial data, using what was reported on her tax return as a guide, and then estimating increases and/or decreases for the following year. You will notice that while the budget shows surplus of roughly $54,000, her actual take-home pay was $43,700 due to taxes for which she had to account. Usually she is not this profitable, but due to the grant income she received (totaling $35,000 from the two grants), her checkbook balance is higher than normal. However, since most of that grant money will most likely be allocated to future artistic projects, she will need to manage the money in the short term and plan carefully as to how and where she will use it in the interim. In addition, she may consider putting some money away for retirement as she has never been able to do in years past. We will address putting away money for retirement in Chapter 8.

THE PROFITABLE ARTIST

BUDGET

Name: SOFIA GARCIA		YEAR:	2018
DBA: SOFIA'S DESIGN, LLC			

PROJECTED INCOME	AMOUNT	Description
TYPE:		Source of Income
W-2 Income Job 1	12,000	Universal Studios
W-2 Income Job 2	6,000	Talent Partners
W-2 Income Job 3	9,000	Cast & Crew Productions
Grant Income	25,000	Creative Capital
Grant Income	10,000	Doris Duke
Freelance Income (no 1099s expected)	5,000	Checks, cash and Paypal payments from students
Gig Income (No 1099)	2,500	Various Weekend Jobs
Class/Workshop Fees	1,500	Various Weekend Jobs
Other (please list):		
1099 Income	14,000	Shutterstock
TOTAL GROSS INCOME	$ 85,000	

PROJECTED EXPENSES*	AMOUNT	Description
Fees		List fees paid to individuals in relation to your project: i.e. dancers, cheorographer, videographer, photograher, sound tech, programmer, app developers, etc.
Fees to Other Artists	12,500	Joe, Adam, Eric ($3,000), Sean, Anthony, Louis ($4,500), 10 crew members ($500 each)
Workshop/Class Instructor Fees	500	ABC Studio
Consultant Fees	1,000	RM Consulting LLC
Other Contracted Service (please list):	-	None
Subtotal Fees	14,000	
Administrative/Production		Indicate detailed costs here: e.g., travel for 2 dancers x 2 weeks at $400.
Equipment Rental or Purchase	1,750	
Studio/Rehearsal Space Rental	4,800	
Performance Space Rental	600	
Production Costs	1,200	
Travel	3,250	
Local Transportation	400	
Office Supplies	600	
Internet/Phone Service	400	
Software	1,000	
Subtotal Admin/Production	14,000	
Promotion/Marketing		Describe each, eg., 2 classes; print run 500 cards; 10 student tickets
Free Tickets	120	
Sessions/Forums	480	
Workshops/Classes	1,300	
Website hosting	120	
Printing	240	
Ads (print, online, other)	360	
Postage	80	
Mailings	150	
Other Promotion/Marketing (please list):		
Subtotal Promotion/Marketing	2,850	
Other Expenses: please list		
Subtotal Other	0	
TOTAL PROJECTED EXPENSES	$ 30,850	
TOTAL PROJECTED SURPLUS*	$ 54,150	

*Budget Notes

* Please note this figure is before consideration of taxes

Figure 7. Sofia's Design Studio, LLC, Budget for 2018, courtesy of Rosalba Mazzola

HOW DO YOU CREATE A BUDGET?

So, how do you actually create a budget? There's no scarcity of financial advice and sample budgets and templates available on the Internet, in books, or on TV shows. But how do you decipher what is right, and will work for your situation? It's easier than you might think. There are three fundamental concepts for any budget that are pretty consistent, no matter the context for which you are creating one. These are income, expenses, and assessment. There is an art to it all, and how detailed you make it is up to you.

The first step—income—is about knowing how much money you have coming in. This may be a paycheck from an employer or two, income from an investment, grant income, or sporadic gig income.

The next step is a bit more complicated, but not less significant, and that is to identify expenses (where your money is going). This means listing out your rent or mortgage payments, telephone bills, payments to credit cards, student loans, metro card or other travel expenses (taxi rides, trains, buses, car rentals, etc.), groceries, and other miscellaneous costs. Basically, anything that you pay out each month is an expense.

The final step is the assessment, and it's debatably the hardest one. This is the part when you must examine your expenses and determine whether your money is being spent wisely. But it can also be a very empowering and valuable process, as you might identify habits you want to change, or you might discover ways to save money that are virtually pain-free (for example, noticing that you buy certain materials for your art on a regular basis, which you could pay less for by buying in bulk).

Furthermore, once you've completed your initial budget and are aware of how much you've got, you can then go ahead with optimizing your budget to achieve your goals. In Chapter 1, we looked at strategic planning and SMART goal setting, and budgeting offers an important way to actualize your goals, structuring your finances so that you have the cash available to make them happen. Also, you

might have specific financial goals that are unrelated to your artistic work and goals. Is it a dream vacation you want to save up for? Perhaps it's just to start a savings account or retirement account? Or if debt is a problem, you can add eliminating debt to the list. Add your specific financial goals to your list of general goals, subject them to a SMART analysis, and budget for them accordingly.

As we all have different goals, income, and expenses, this is where your creativity and personal ideas will have to come into play. Looking for money to achieve your goals is another form of art. You could take on a part-time job to bring in extra income (thus raising your income), or search for a cheaper cell phone plan or switch cable companies (thus lowering your expenses). Either option will leave you with more money to put toward your goal(s). You can choose whichever option or combination works best for you, but the important point to remember is that without identifying your income, expenses, and potential options, your decisions may not be based on the complete financial picture. That is the power of making a budget.

Preparing a simple budget isn't a difficult task, particularly with budgeting software. By using the most advanced products the market has to offer, you can keep track of account balances, pay bills, transfer money to savings or retirement accounts, and see the whole picture in one spot. There are a number of very functional free options, as well. As of this writing, Mint.com has lots of ways to help you manage your money. From a simple, no-frills budget to a plan that sees years into the future, all you need to get started is to open a free account. And if you would rather not use budgeting software, you can always use something as simple as Microsoft Excel (or Google Sheets) instead.

WHY ARE BUDGETS IMPORTANT FOR ARTISTS?

Budgets represent your work in numbers. They indicate how you value aspects of your work in financial terms. However, some artists avoid preparing budgets because they are afraid to know the true cost of their work. Another stumbling block is that many artists are

their own biggest supporters, especially from a labor standpoint, as they might spend many hours of their own time and labor creating a work of art, rather than hiring someone else to do it. This makes it extremely difficult to put a dollar amount on what it takes to produce their work. Difficult doesn't mean impossible, however. Keeping track of your time on projects can be a very helpful place to start. Make a list of the hours you spend on various aspects of your work and apply an hourly rate to them.

Budgeting plays an important role in fundraising, as well. Funders want to see that you will spend their money appropriately and responsibly and usually require a budget submission. It is hard to determine how much money you need to raise if you don't lay out all your costs first. We will discuss setting budgets for fundraising purposes in greater depth in Chapter 16, including compensating yourself, but a general tip is to start with what it really costs you to make your work, not what you think it should cost. This forces you to crunch real numbers and provide funders with data that support your monetary request. And while many artists are used to working on a scarcity model, grantors want to see you represent your expenses with complete accuracy and transparency. If you know you can create a work for $1,000, but only because you received in-kind contributions and didn't pay yourself or your collaborators, the true cost of that work is higher than $1,000, and your grant budget should reflect that (including fair market value costs for any items you get free or discounted).

Many donors will want to know precisely how their money will be used, or what percentage of your budget they are being asked to fund. This is very common with traditional grant makers, but other kinds of donors may want to know as well, for example, a prop store donating props for a performance.

Finally, most institutional funders want to see a budget that breaks even, in other words, where the income equals the expenses. They want you to list realistic expenses as well as possible ways of meeting those expenses. You want to be able to show that you've thoroughly considered every potential cost in your project.

We have now looked at what budgets are, why they are necessary and in what contexts, how to construct them, and how to extract greater insights about your project and career from them. The following chapters will explore financial terminology as well as issues of personal finance, so as you gain additional information, you can incorporate that into your budgeting. And as you learn more about savings and other kinds of financial goals, revisit your budget again. Like any kind of skill (or art form), it requires practice but, over time, can deliver meaningful results.

Financial Terminology

As we stated at the beginning of this section, any specific questions about your personal financial and tax situations should be addressed to a qualified professional. However, it is very important that you familiarize yourself with a few basic accounting and tax terms, as they come up frequently in a business context and will help you to further professionalize your project or practice. The definitions outlined in this chapter will do just that. And as we describe these concepts, we will demonstrate how they might apply specifically to artists.

To begin, it is important to highlight that there are three types of businesses from an accounting perspective: Service, Manufacturing, and Merchandising. Each of these types of businesses operates differently, and therefore the accounting for them is not the same. Financial Statements and related terms vary based on the type of business you are. Typically, performing artists are considered a services-based business. Oftentimes you are being paid for your time on a project, as is the case for actors, dancers, musicians, etc. If you are a studio artist, you will most likely be manufacturing art to be sold. Most galleries would fall into the category of merchandising, which would mean you are buying art and then reselling as a retailer to others. Obviously, your specific practice may have elements of all three.

As an artist, you can operate as a sole proprietor (doing business as yourself), as a single-member limited liability company (LLC), a corporation or S-Corporation, or as a partnership if you are working

with one or more individuals. Regardless of your business entity structure, it is important that you maintain separate books and records. In other words, your personal finances should never be commingled with those of your business. Best practices dictate that you open and use a bank account that is separate from the one used for your personal finances. If you are self-employed, this can sometimes be challenging, but as long as you deposit all self-employed/freelance income into the business account, it is fairly easy to transfer funds as needed to your personal account to pay for non-business-related items. While you can record your income and expenses by hand in a ledger book, it is strongly recommended that you use a computerized accounting software. There are many free and affordable options available on the market. This will make it faster, and easier for you to maintain your financial data. It will also allow you to obtain and review summarized, year-to-date information as needed.

We will now review the three most common financial concepts that you will need to deal with as a business owner: the income statement, the balance sheet, and income tax issues.

INCOME STATEMENT

The income statement (also known as the profit and loss statement) is a financial statement that summarizes a company's income less its total expenses in order to determine whether it operated at a net income or loss over a specific period of time. This is typically a twelve-month period and usually a calendar year, January through December. This financial statement is one of the most widely used by businesses. It is often requested by banks and other lenders when applying for a loan, and it is used as a primary source of information for income tax filing purposes. Sole proprietors are only required to report income and expenses on a separate form, Schedule C, as part of one's personal income tax form 1040.

The information contained on an income statement is a very important source for artists. They can understand the profitability of

their business over a given time period (usually over a year), although it could be applied to a specific project, such as a tour, exhibition, or print run. It allows you to see what expenditures you have incurred in direct relation to the income earned for that same period. It can be prepared at the year's end or periodically throughout the year (quarterly or semiannually). Reviewing this statement throughout the year will help you get a better handle on whether you can spend more if needed on your practice, or if you need to cut back on certain expenses to manage your losses. For example, Sofia's income statement for Sofia's Design, LLC, is shown in figure 8 (see page 112). With net income of $21,000 and net expenses of $20,430, Sofia's business is profitable with a net income of $570. Analyzing her income statement might help her to make different spending choices for the following year, which in turn could increase her profitability. For example, she spent $2,000 on out-of-town travel alone. She might look into how much income that travel generated for her, as cutting back there even by 50 percent could almost triple her profits. One technique she might consider is to prepare a six-month income statement, which would allow her to take stock of where her income and expenses were midway through the year, which could give her time to correct any problematic trends, or to continue doing what is working.

Sometimes losses are inevitable, especially in the beginning years of a business. However, you need to be aware that losses occurring more than three years in a row can be an indicator for taxing authorities that your business should be considered a "hobby" rather than a for-profit entity. This could result in significant tax consequences, as all the deductions you used to offset your income can be subsequently disallowed, resulting in additional tax liabilities. Therefore, while losses are customary for many businesses, they should be monitored closely and managed. By using a computerized accounting software, an income statement can easily be printed and reviewed by you and/or your accountant at any point in time with just a few simple clicks of a button.

SOFIA'S DESIGN STUDIO LLC
INCOME STATEMENT
FOR THE YEAR ENDED 12/31/17

Income			
Workshop Income	$	1,500	
Teaching Income		5,000	
Freelance Income		2,500	
Shutterstock Income		12,000	
Total Income			**$ 21,000**
Expenses			
Advertising	$	480	
Business Equipment		1,100	
Local Travel		200	
Meals		1,800	*
Office		300	
Rent Space		3,000	
Research/Seminars		800	
Fees to Artists		9,500	
Supplies/Props		650	
Travel-Out of Town		2,000	
Telephone		400	
Internet		200	
Total Expenses			**$ 20,430**
Net Income/(Loss)			**$ 570**

*Meals are only 50% deductible for income tax purposes so if you were using the above financial information for tax planning purposes your net profit would be $1,470

Figure 8. Sofia's Design Studio, LLC, Income Statement, courtesy of Rosalba Mazzola.

Income/Revenue

Income refers to money received for work or through investments over a particular period of time. For an individual, this means employment and investments, and for a company, this means total revenue from selling goods or services minus the cost of operations and taxes. Revenue is comprised of the total amount of gain from the sale of goods or services, and sometimes from interest, dividends, rents, and royalties. For nonprofit organizations, revenue is often generated through donations, sponsorship, earned income (membership dues or ticket sales, for example), and fundraising activities.

For an artist, revenue can come from a variety of sources. In the case of a musician, revenue might be generated by ticket and album sales or from giving music lessons to students. From the perspective of a music business for which you are the sole proprietor, income is derived from ticket and album sales minus the cost of the venue, the cost of the equipment, and the expenses incurred recording the album. For a literary artist, income might be from book sales, or stipends for readings, or perhaps teaching, as well. And in the case of studio artist like Sofia Garcia, revenue could similarly come from sales of work, and also teaching. In Sofia's case, for example, she receives revenues from a variety of sources, starting with her three sources of W-2 income, as well as the freelance work she does, and then the revenues earned through her LLC, which include both the sale of works as well as teaching and workshop fees.

Expenses

Business expenses are the costs of operating a company necessary to generate future income. For a visual artist, these might include the monthly rent on a studio or the cost of consumable supplies like wood, paper, paint, or darkroom chemicals. Business expenses can also be the cost of shipping artwork from one location to another for a sale or for a show. For an opera singer, business expenses would more likely be the cost of voice lessons, transportation to and from auditions, and rehearsal space rentals. The most important thing to remember about business expenses is that you must keep track of them—with receipts, copies of debit and/or credit card statements, cash journals, etc. Whether you are reporting these expenses on your taxes or just keeping records of how much you spend for management purposes, it is important to maintain accurate records of your business expenses. These accurate records are the only way you really know how much you spend, and therefore how much you need, in order to keep your artistic practice going. We have listed examples of typical artist expenses that you should be tracking whenever applicable, as this will ultimately be useful for tax purposes (though we

remind you that any references to deductions here are simply very general rules, and that you should seek qualified advice regarding your own tax situation).

Overnight travel expenses

Airfares, Trains, Taxis, Meals (only 50 percent deductible for tax purposes). Please note IRS allows daily per diem meal allowance depending on location of city or state. Typically, if per diem is given, receipts for these meals are not required as long as the business trip itself can be substantiated. We highly recommend keeping a detailed calendar.

Local travel expenses

Commuting to and from a regular job is not a tax-deductible item. However, travel expenses from your main job to a second job are deductible, as is travel to auditions. If you are self-employed and your home is your primary place of business, then all travel expenses to work sites are deductible.

Business meals (50 percent deductible)

Any lunch or dinner meeting with agent, fellow artist, director, producer, lawyer, or accountant can be considered a business meal. It is imperative that you keep an appointment book and log who was present and the nature and topic of the discussion, and that you keep a copy of the person's business card along with a receipt.

Vehicle expenses (mileage or actual)

There are currently two methods of calculating vehicle expenses: (1) Standard mileage rate per business mile driven (refer to IRS code for annual rate, as it changes each year), plus any parking and tolls, **or** (2) Actual Vehicle Expenses such as gas, insurance, or repairs. In many cases, you can compute it both ways and choose the higher of the two.

Equipment purchases and depreciation

Depreciation represents the annual cost allocation of an asset. Every asset has a specific useful life. You compute depreciation by taking the purchase price of an asset, less any residual value and divided by its useful life. For example, suppose that a computer purchased for $2,000 has a five-year life (sometimes called a "useful life"). In this case, it has depreciation expenses of $400 per year, assuming a straight-line depreciation method (one of the most standard ways of calculating depreciation). There are also other, accelerated depreciation methods. The types of equipment that are typically depreciated include—but are not limited to—computers, tablets, mobile phones, musical instruments, and video equipment.

Home office or studio rentals

If you work primarily from home and have dedicated work space, you can deduct a portion of your home expenses as a home office. If you rent, this would be a percentage of your rent and utilities. If you own, it would be a percentage of your mortgage interest and real estate taxes and utilities. Years ago, the concept of a home office was highly scrutinized by taxing authorities, but with the rise of telecommuting becoming such a mainstream practice, home offices have become more accepted. Currently, there are two methods allowed by the IRS. These are the **simplified method** and the **traditional method**. The simplified method allows for only up to 300 square feet at a standard rate of $5 per square foot (a maximum $1,500 deduction). Using the traditional method, on the other hand, you can allocate a percentage of your home or apartment expenses as a home office expense. For example, if your rent is $15,000 per year and only 30 percent of your home is used for business, you can deduct $5,000 as business use of home. Please note that regardless of which method you choose, the home office deduction cannot result in your business incurring a loss. You can deduct only up to the amount of profit.

Other Industry Specific Costs include, but are not limited to, the following:

- Studio Rental Fees
- Professional Clothing: Costumes or Dancewear (non-street wearable)
- Agent and Managers Fees
- Union Dues
- Accountant or Attorney Fee
- Professional Development (Research)
- Coaching and Professional Training
- Storage of Business Equipment (i.e., Instruments)

Profit

Profit refers to the difference between revenues and the related expenses incurred in producing those revenues. It is calculated as follows:

$$Profit = Total\ Revenue - Total\ Expenses$$

You should be mindful of this formula when pricing your work. For example, sculptures, paintings, albums, and performances all have costs associated with creating them (in addition to your labor) that should be factored into your price. Please refer to Chapter 13 for more tips on pricing your work.

Surplus versus loss or deficit

A surplus is when revenue exceeds expenditures, and a loss or deficit is when expenditures exceed revenue. Whether your arts business is operating at a surplus or a deficit, be cautious of the amount and of any fluctuations from year to year. Becoming intimate with your financial information will allow you to make informed financial and tax planning decisions, which can have a direct impact on your personal bottom line.

Invoice

While invoices are not part of an income statement, we discuss them here as a reminder of how important it is that you get paid for your work. Most are fairly simple, and they can be easily created in Microsoft Word or Excel using templates, but you can also use the invoicing feature included in computerized accounting software. More often than not, however, it isn't so much that we don't know how to invoice, but that we don't set aside the time to follow up, generate, and send one. This delays an artist's ability to collect money for their hard-earned work or services. Ensuring that you get paid for your work is as important as every other aspect of your practice. And while some people prefer to be paid in cash in order to avoid any forms or records, we remind you that it is illegal not to report all income that you receive.

Good business practices mandate that you generate and remit invoices to your clients or patrons. An invoice is simply a bill for goods or services. Its main function is for record keeping and notification—it allows your client to have a record of what you are charging, breaking the charges up into specific categories (quantity of items sold, price per item, number of hours worked, rate per hour, etc.). If you are dealing with an established business or institution, most of them will require you to submit an invoice before they will issue payment. Sometimes invoices are issued before anything is performed or delivered, giving the purchaser a chance to review what you will deliver. Not only does this prevent misunderstandings, but it creates a "paper trail" that can be used should a dispute arise in the future.

Many artists are providing or selling something similar on a regular basis, so you can design a basic invoice and adapt it as necessary (a painter will usually be billing for a painting, a dancer for hours worked, etc.). You will want to include certain basic information on any invoice:

- Names—your name (or that of your business), and the client/ purchaser.
- Dates—the date the invoice is issued, and the date payment is due.
- Addresses—your business address, and the client's address.
- Descriptions—describe the activities or services performed, the goods provided, the units (hours, quantity, etc.), and the dates on which these were completed.
- Prices—itemize the costs of every good or service and, most importantly, include the final price.

SOFIA'S DESIGNS LLC

1000 BROADWAY
NY 10036
Phone: (907) 000-0000

INVOICE

INVOICE #	DATE
1	11/28/17

BILL TO	SHIP TO
ABC FOUNDATION 4500 BROADWAY NEW YORK, NY 10033	

P.O. NUMBER	TERMS	REP	SHIP	VIA	F.O.B	PROJECT

QUANTITY	ITEM CODE	DESCRIPTION	PRICE EACH	AMOUNT
	SET DESIGN	SERVICES RENDERED FOR UPCOMING EVENT	275.00	275.00

Thank you for your business!

| TOTAL | $ 275.00 |

Figure 9. Sofia's Design Studio, LLC, Invoice, courtesy of Rosalba Mazzola.

Additionally, some clients may require you to provide your Social Security or Employer Identification Number (EIN), and any other relevant business information (a vendor ID number, for example). Ultimately, how you present an invoice may be at the discretion of your client—they may have internal coding or other requirements, and if they need information presented a certain way, it's easy to just provide it to them.

There are hundreds of templates on the Internet. We have included a sample invoice used by Sofia Garcia here as figure 9.

BALANCE SHEET

A balance sheet is another important financial statement used in accounting. It is a statement that all businesses large or small should use and understand. A balance sheet should be thought of as a financial snapshot, as it summarizes the financial status of a company or an individual at a specific point in time, for example, December 31st. Depending on the size of a business and how detailed it needs its records to be, it will prepare a balance sheet on a monthly, quarterly, or annual basis. The famous accounting equation "Assets = Liabilities + Owner's Equity" is illustrated on a balance sheet, as this financial statement is comprised of these three elements. A company's assets are listed and totaled in one section and must equal the total debt and total equity in the business presented in the other two sections. Equity represents an owner's initial investment in the business plus (or minus) any net profit (or loss), and less any withdrawals throughout the year.

A balance sheet is more commonly used by corporations and businesses with large asset values, as it is required to be reported on businesses' income tax return. Sole proprietors or single-member LLCs are only required to report their income and expenses and therefore are not required to report a balance sheet. For this reason, they do not regularly need to prepare one. This report is still an extremely useful financial tool for owners to review and monitor, however. It is also

often requested by financial institutions when applying for a business loan or any other form of credit.

From the perspective of an artist who is seeking to get a better understanding of their finances, the balance sheet represents a good source of information containing basic business information of your resources and their valuation, and all company debt.

Assets

An asset is anything that has economic value. It is a resource of a company or individual. The key determining features of an asset are whether it is tangible or intangible and whether or not it can be converted into cash if necessary. Tangible assets can be further subdivided into current assets (cash and cash equivalents) and fixed assets (building, furniture, or equipment).

Many people find the concept of "current assets" versus "fixed assets" to be confusing, so let's look at some examples. Current assets are defined as the balance of all assets that can readily be converted into cash. This would include cash itself—quite literally the money you or your business has in the bank. It can also include any inventory that you are intending to sell. For example, Sofia Garcia has a checking account with $5,000 in it and six prints in her studio that are realistically worth $500 each (although she may hope to sell them for more). She therefore has $8,000 in current assets between the checking account and the prints.

Conversely, fixed assets are those assets that are not expected to be converted into cash in less than a year's time (or within the fiscal—or financial—year). A common example of a fixed asset is physical property, or certain financial instruments and investments. If Sofia owned a two-year CD (certificate of deposit) or if she owned the building that housed her studio rather than renting it, this would be a fixed asset, as she intends to continue producing work in the studio throughout the fiscal year, and money in CDs cannot be accessed until a later date. In certain cases at least, the distinction between current and fixed assets is conceptual as much as it is practical—it might be that the studio is

in a particularly desirable location and could be sold on short notice (certainly before the end of the fiscal year). For accounting purposes, she would still consider this as a fixed asset because she intends to use it throughout the fiscal year to produce work. CDs can also be cashed in early, but for a penalty if the two years have not elapsed, which reduces its short-term cash value.

Intangible assets are simply any nonphysical resources that can be used to the business or individual's economic advantage. These include most intellectual property such as copyrights, trademarks, and patents, or "goodwill," and brand recognition. It can be more difficult to place a value on these assets (less so with intellectual property), but they can be incredibly valuable. A set designer like Sofia Garcia who has been doing set design work for years with repeat clients has likely accumulated a lot of goodwill for her business. In other words, if another set designer charged comparable prices and had similar training, they might not be as successful attracting these clients, at least not at first. Brand recognition (which we will discuss in greater detail in Chapter 11) is similarly valuable. A film producer might want a famous actor to play a small role, or even a cameo, simply because that actor's name will attract a wider audience. Intangible assets are amortized similar to physical assets that are depreciated.

Accounts receivable

A receivable is an amount of money owed to an individual or a business for goods or services provided. It is classified on a balance sheet as a current asset because in general your customers pay you in less than one year. Preferably you are paid by a customer within 30 days, but sometimes it can take 60, 90 or, unfortunately, more than 90 days to get paid in certain cases. So if an artist working as an assistant on a photo shoot submits a bill for their services, until it is paid it is listed as an accounts receivable on their books.

If a customer does not have the ability to pay you within a year due to cash-flow reasons or because the project spans over twelve

months, then that accounts receivable is listed as a long-term asset on the balance sheet.

Liabilities

The term "liability" refers to an amount of money or a service that you owe to another individual (or business). A liability represents a debt of an individual or a company. Examples include accounts payable, loans, mortgages, taxes, or wages due. Accounts payable is listed as a current liability and it represents your vendors. In the example above with the photographer and their artist-assistant, the same bill for services that was a receivable for the assistant would be considered a liability for the photographer. Once it is paid, it is no longer a liability.

Like with fixed and current assets, liabilities can be further divided by how they need to be dealt with during the fiscal year. "Current liabilities" refers to debts to be paid within the course of one year, and "long-term liabilities" refers to debts paid over a long-term period. The term is often used in conjunction with assets because they figure so prominently in another area of accounting, the balance sheet. It is also worth noting that liability in the financial context has a somewhat different meaning from liability in the legal context (which we addressed in Chapter 5).

Equity

Equity is the owner's right to an asset or property. On a balance sheet, equity equals the sum of owner's contributions to the company, plus or minus profits from the business that have not been distributed to its owners yet, or losses. Equity can also describe the net worth of a company or an individual with the formula:

$$Equity = Assets - Liabilities$$

In real estate, equity refers to the value of a property minus outstanding debt (e.g., mortgage payments).

Capital

Capital is money invested in a business for the purpose of generating future revenues. Capital can also refer to the collective value (including money and property) of a business or an individual.

Cash Flow

Cash flow is the stream of cash revenues or expenses in a business over a period of time. If the closing balance is higher than the beginning balance, the cash flow is "positive." If not, the cash flow is "negative." A positive cash flow is crucial to the survival of a business. Even if a business generates profits, a negative or small cash flow can lead to insolvency, which is a technical way of saying that you no longer have enough money available to pay your bills.

For example, Sofia Garcia likely has a substantial amount of money tied up in long-term assets, mainly her unsold work in her studio space, but she might still have trouble paying her current bills if she cannot quickly or easily sell that work and her cash flow is negative. On the other hand, a musician with a smaller net worth but with steady gigs that pay directly after the performance might have a positive cash flow and could face fewer financial problems in the present.

TAXES

The following list of terms relate to taxes that most small businesses encounter, including forms you will need to file, specific terms you will see on those forms, and common vehicles for tax deferral.

Independent Contractor

For the purposes of financial accounting and taxation, an independent contractor is someone who is self-employed, but who is then paid by another business or individual to provide services or goods. From a tax standpoint, the hiring party does not withhold income or Social Security taxes on the independent contractor's behalf. Independent contractors are responsible for paying both halves of Social

Security tax in addition to income tax on the net income produced from the freelance jobs. They must report their income and expenses on a Schedule C as part of the Form 1040 tax return.

An independent contractor is a person who contracts to do work for another person according to the independent contractor's discretion—the contractor is not subject to another's control except for what is specified and mutually agreed upon for a specific job. While almost anyone can be an independent contractor, a typical independent contractor is someone with a specialized skill who is retained for a fairly limited function (either in terms of the scope of the work they will do or for the duration of the project). The photographer's assistant referenced above is also a photographer, for example. This is a common arrangement for artists who work both as, and with, independent contractors. For example, writers may write reviews for several websites and be paid by the submission—they are working as independent contractors.

Conversely, writers may hire a graphic artist to design the covers of their books. They have now hired an independent contractor. Independent contractors can be appealing to the hiring party because there is much less responsibility and administrative work than with an employee. And many artists find that the lifestyle of an independent contractor suits them because they have more flexibility with work hours and no permanent supervisor.

It is worth noting that, especially for artists, a person's status as an independent contractor as opposed to an employee has significant tax and legal implications. We addressed the legal implications in greater detail in Chapter 3, and keep in mind that the ownership of intellectual property can often hinge on whether the creator is an employee or an independent contractor, also known as "work for hire." There are also differences in (legal) liability.

W-2

A W-2 is a tax form prepared by the employer that declares an employee's wages and taxes withheld (including Social Security tax

information) over the course of a calendar year. In turn, employees are responsible for reporting information from the W-2 form when they file a Form 1040 tax return. You should expect to receive a W-2 from a company you worked for during the year no later than January 31st of the following year. As you'll recall, Sofia Garcia received several W-2s for her work for various employers in 2017.

W-4

Form W-4, the Employee's Withholding Allowance Certificate, is a tax form provided by employers to their employees typically when they start a new job. This form allows the payroll department to deduct an estimate of your federal income taxes. It can be updated at any time during the year as your needs or tax status changes. It is important to contact your tax adviser to ensure that you choose the proper exemptions. While the form on its face appears simple, completing it incorrectly can have significant tax implications. Withholding too little may result in a large tax liability at tax filing time for which you did not budget! And while erring in the other direction of withholding too much (resulting in a large refund) may sound like a better strategy, in many cases you will need the money throughout the year to pay your rent, or food, or other important expenses. Therefore, your goal should be to withhold just the right amount to fulfill your tax obligation, while retaining the greatest amount of money in your wallet (or bank account) throughout the year. It is a delicate balance—the number of exemptions you list on the W-4 should be measured closely with a tax adviser. Please pay special attention to your marital status on this form. If you are single, mark the "single" box, and if you are married and your spouse does not work, then mark the "married" box; but if you are married and your spouse works, mark the box that states "married but withhold at the higher single rate." This will help avoid owing more taxes at year's end.

W-9

A W-9 is an IRS form that employers are required to distribute to any freelance or independent contractors. It requests the name, address,

and Social Security number for an individual, or the taxpayer identification number for a business and its certification. These individuals (or businesses) are required to furnish information on the W-9 to their employers, who will use the form to later issue you a 1099 and file with the IRS. As many artists are self-employed and work as consultants or independent contractors, this is a form that they will fill out frequently depending on the number of different people or companies to whom they provide services. Fortunately, it is one of the simpler IRS tax forms to fill out.

1099

There are actually a number of tax forms that fall under the 1099 "series," i.e., the 1099-INT, 1099-DIV, and 1099-MISC, but when people refer to a 1099 they usually mean the 1099-MISC. This is the form that employers must fill out for independent contractors who earned more than $600 and whose earnings, referred to as *nonemployee compensation,* are not reported on a Form W-2. The 1099s are also used for interest, dividends, payouts, broker transactions, and barter exchanges, among other types of income. The form varies depending on the type of income that it reports, but most artists will receive them for services they provided to a company or individual. 1099 forms are one way that the IRS helps to track freelancer income, so all 1099 income must be reported and filed with taxes, regardless of whether or not you received one from an employer. As a self-employed freelance artist you are required to keep track of your income, so telling the IRS you did not report a 1099 because you did not receive one is not considered a valid excuse.

Deductions

A deduction is an amount subtracted from total income to reduce the amount of income subject to tax. Deductions include expenses incurred by a business or an individual in order to generate income. Receipts should be kept and filed for every deduction declared to the IRS. Credit card statements and debit card statements are also valid substantiation.

Artists who deduct business expenses on their income taxes need to keep meticulous records of those expenses and maintain a file for their receipts. While artists should deduct all business expenses on their taxes, they need to keep in mind that they have to prove to the IRS that they are, in fact, a business and therefore generate some income from their art-making. Because determining which expenses you can write off and whether or not you even qualify as a business are difficult questions, you might want to consult an accountant or a tax expert, ideally one with experience dealing with artists and not-for-profits.

Schedule C Form

A Schedule C, "Profit and Loss from Business," is the IRS form that you must submit, along with the Form 1040, which details the profit and loss generated by your business each tax year if you are a sole proprietor or single-member LLC. The Schedule C is the form used to report your "business expenses." Accountants typically recommend that you retain any receipts related to expenses claimed on your Schedule C for seven years.

CONCLUSION

This list of terms is by no means exhaustive. But having a working understanding of which documents are used to show the financial situation of your business will help you to communicate important information to collaborators, investors, and financial professionals who can help you. Similarly, understanding which tax forms are needed for various work arrangements, and having a basic sense of how these can be structured to your advantage, will at the very least help you to track and prepare the necessary information to work effectively with a tax professional. And again, should you have any specific questions about your financial situation, we strongly encourage you to seek help from a qualified professional!

Personal Finance and Savings

This chapter will focus mainly on savings and general financial health, with an emphasis on personal finances. Given that many artists work as sole proprietors or "moonlight" while working jobs in other industries, it is often impractical to only address the business side of finance. Here we will address the different types of accounts that you can use to hold money and save for retirement, and the concept of the time-value of money. We will also present you with a tool to help survey your overall financial situation (the "X-ray") and provide an overview on a number of important concepts in personal finance. A special thank you to Julian Schubach, Financial Advisor from Odin Financial, for authoring this chapter.

SAVINGS VEHICLES: SAVINGS AND CHECKING ACCOUNTS

Most everyone who is generating income or has any expenses has a savings and/or a checking account at a local bank or credit union. There are differences between these two accounts, and it is important to understand those differences.

A checking account is a deposit account that allows the owner to make deposits and withdrawals. You may sometimes see a checking account referred to as a "demand account." Checking accounts allow the owner to withdraw funds from ATM machines and write

checks. Checking accounts do not limit the frequency of deposits or withdrawals. Because checking accounts may have ATM cards or checkbooks linked to the account, there is the potential for account breaches. It is important to regularly check your account balance and statements to ensure there have been no fraudulent withdrawals in the case that someone has accessed your ATM card or checkbook. Generally, checking accounts pay little to no interest on your balance.

A savings account is another form of a deposit account at your financial institution. Savings accounts will pay higher interest than checking accounts. There may be minimum balance requirements for a savings account depending on the individual account rules at your bank. In most cases, banks will not provide checkbooks for savings accounts.

Because a checking account has ATM cards and checkbooks associated with it, and therefore is more susceptible to fraud, it is wise to keep only enough in the account to cover your short-term expenses. As the account continues to grow, be sure to move money out of the account and into your savings account.

It is important to understand the different types of registrations for bank accounts that include individual accounts, joint accounts, business accounts, and trust accounts. There are various types of trust accounts, business accounts, and joint accounts depending on your marital status, the form of trust established, and the type of business that is holding the bank account.

Individual accounts are titled to one person only. If you get married or take on a partner in a project, it is important to retitle your accounts as joint accounts if you want your spouse or partner to have access to them.

Joint accounts can be titled "tenants in common" or "rights of survivorship." Tenants-in-common accounts pass through probate if the primary owner passes away. Accounts with rights of survivorship allow for the full balance of the account to be transferred to the joint owner in the case of the other person passing away. These accounts avoid probate.

Business accounts can be owned by corporations, sole proprietors, or partnerships. In the case of corporations and partnerships, the financial institution will require a copy of the corporate resolution or partnership agreement. Similarly, trust accounts require a copy of the trust document. In the following chapter, we will discuss investment accounts and alternative savings vehicles.

It is never too early or too late to begin saving. Like any task, getting started is the toughest part, but once you see the results of your hard work, you will be genuinely pleased with your success. As we discussed in Chapter 6 on Budgeting, one practice that many people find useful is setting a goal each year for the amount of money you want to save, which can be allocated in different ways. Examples are emergency savings, personal savings, business savings, and even travel savings. You can use your budget as a way in which to help you allocate money for savings.

Emergency savings are vital. Generally, it is wise to set aside enough money to cover six to nine months of expenses in the case of loss of employment, injury, or any other event that may limit your ability to generate income. Emergency savings can be amassed in your savings account at your financial institution, which provides you liquidity and easy access to the funds if and when you need them.

RETIREMENT VEHICLES: IRA, ROTH IRA, SEP-IRA, INDIVIDUAL (SOLO), AND CORPORATE PLANS

IRA

This stands for Individual Retirement Account. Contributions to a traditional IRA are tax-deferred, as are all the gains in value they earn. "Tax-deferred" means that no current income tax has to be paid on any contribution to, or for any gains in the amount invested in, the account until it is removed and paid (or "distributed") to the account holder. It allows individuals to set aside money they have earned in

their job or their business over the year. Making contributions to your IRA allows you to take a tax deduction each year, reducing your taxable income. It is important to note that you cannot contribute to any type of IRA unless you have a profit from your business or wages from an employer. You must wait until you are 59½ to begin making withdrawals or face a 10 percent penalty. Last, you may contribute to an IRA no matter how low or high your income may be.

Roth IRA

Unlike the Traditional IRA, a Roth IRA allows individuals to contribute money that has already been taxed so that earnings and withdrawals from the account are ultimately tax-free. It's important to realize that you will not be able to deduct contributions to a Roth IRA, as you can with a traditional IRA, but the "payoff" is that you are not taxed when you withdraw the money you contributed, or any earnings on that money. The best way to compare a Traditional and a Roth IRA is as follows: with a Traditional IRA, you receive a tax deduction and defer taxes until retirement. With a Roth IRA, you do not receive a tax deduction, but the contributions grow tax-free. Unlike a Traditional IRA, there are phaseouts for Roth accounts. In 2017, if you made more than $133,000 as an individual filer or $196,000 as a married filer, you could not make contributions to a Roth account.

Deciding whether to contribute to a Traditional or Roth IRA is a personal decision. If you have 1099 income and are expecting a hefty income tax bill, a Traditional IRA may be best, because it reduces your tax burden. If you are in a low tax bracket and believe your tax rates will rise in the future, you may be more inclined to participate in a Roth IRA. Your accountant or financial adviser can help you navigate this decision when you are ready to open an account and begin making contributions.

SEP-IRA

SEP-IRAs are retirement plans established by employers, including self-employed individuals. The SEP-IRA allows employers to make

tax-deductible contributions on behalf of eligible employees, including the business owner. The employer is allowed a tax deduction for plan contributions, which are made to each eligible employee's SEP-IRA.

As with a Traditional IRA, employees do not pay taxes on SEP-IRA contributions until retirement. A SEP-IRA has similar rules to a Traditional IRA, in that withdrawals made prior to age 59½ face a 10 percent penalty. A major benefit of a SEP-IRA versus a Traditional IRA is the amount you may contribute each year. In 2017, the maximum contribution to a SEP-IRA was 25 percent of income, up to $54,000. The maximum contribution for an IRA in 2017 was $5,500 plus an additional $1,000 for account owners over the age of 50.

Individual (Solo): 401(k)

If you are a sole proprietor or are running a small business, you might consider an individual (solo) 401(k) plan. In 2017, individual 401(k) plan contributions were limited to $54,000. The individual 401(k) offers many of the same features as a SEP-IRA, but it can be cheaper to establish and maintain, and loans are often allowed, whereas no loans are allowed in SEP-IRAs, IRAs, or Roth IRAs. The major drawback to an individual 401(k) is that no outside employees can be hired.

Corporate Plans: 401(k) and 403(b)

A 401(k) or 403(b) plan offered by a company to its employees allows them to set aside income for retirement. The income and all the investment gains it accumulates are tax-deferred until withdrawal. Employers may choose to match a certain percentage of 401(k) or 403(b) contributions, as well. Generally, the individual contribution limit for these plans are $18,000/year as of 2017.

Because most people change jobs, the question many have is "What do I do with my 401(k)/403(b) when I separate from my employer?" Luckily, there are a few options.

Option 1: Keep your account at the old employer—An employee may keep their balance at the previous employer but not make any future

contributions. The account will continue to remain invested in the funds you selected previously, and you will continue to receive statements every quarter.

Option 2: Roll over your account to your new employer—If your new employer offers a retirement plan, you may roll over your balance from your previous employer to the new plan. When you roll over the balance to the new plan, it will be invested in the funds you select in the new plan and is not eligible for any employer matching. There is no tax consequence for this transfer.

Option 3: Roll over your account to an IRA—The most popular option is to roll over your 401(k)/403(b) balance to your IRA. This will allow you to manage the retirement account yourself and make contributions moving forward. If you choose to roll over your balance to your IRA, please make sure that if you take possession of the funds after closing the 401(k)/403(b), you deposit them into your IRA within sixty days to avoid tax consequences. If that sixty-day rollover window closes, you will have to pay ordinary income taxes on the full withdrawal.

Last, if you are over fifty years old, you may also make a "catch-up" contribution to your retirement accounts. This is an incentive for those getting closer to retirement age to boost their retirement savings. Please check with your accountant or financial adviser to learn more about your catchup options for your specific retirement account.

PLANNING FOR NOW AND LATER: COMPOUND INTEREST AND TIME VALUE OF MONEY

If you had a penny and that penny doubled in value, every day, for a 30-day month, can you guess how much you would have at the end of the month? You will probably be shocked to learn that the answer is $5.36 million dollars! Think about it, you begin day one with 1 cent, day two, 2 cents, day three 4 cents, and on and on. This is the beauty

of compound interest. Now, let's get real, you will never grow your savings by 100 percent in a day, week, month, or year, but if you could earn 5 percent each year, over a period of 30 years, that is substantial growth. In its simplest form, compound interest can be defined as interest on interest.

If you have done any research into grants and awards, you have heard of some of the big ones like the Guggenheim Fellowship or the MacArthur "Genius" award. You might have imagined just what you could accomplish if you were to receive a large amount of money to devote to your art in any way you saw fit. What if you could guarantee yourself one, not immediately, but rather in ten years—what would that be worth to you? This is not a hypothetical question. For most artists, this is possible with a little saving and a concept known as compound interest. Let's look at a few examples.

If you could deposit $100 on the first day of the year into a bank account that paid an interest rate of 5 percent per year at the end of each year, but were unable to deposit any additional money for the next 5 years, how much money would you have in the account at the end of the fifth year? Well, using "simple" interest, you might expect the bank to pay you 5 percent of $100, or $5.00 per year, so you'd have a balance of $125 at that point.

Fortunately, because of compound interest, you'd do much better, because the 5 percent is calculated based on the new balance after adding each previous year's interest payment. So, if you just left the money in the account, in year 2 you'd be paid 5 percent of $105, or $5.25. In year 3, you'd receive 5 percent of $110.25, or $5.51. By year 4 you'd get $5.79, and when year 5 ended you'd receive $6.08 and have a total balance of $127.63, not just $125.00. Admittedly, the additional $2.63 isn't much these days, especially spread over 5 years, but it actually represents a significant gain in your return on the $100 you invested in the account, since you've now earned an effective annual gain of not just 5 percent, but almost 5.53 percent. And it's even better than our basic example shows, because many banks do the compounding calculations daily.

Now, what if you could set aside $20, $30, $50, or more each month in that account? After all, just by forgoing a "deposit" of $1.50 a day to the gourmet coffee "bank" by skipping a macchiato leaves you with $45 at month's end to deposit into your bank. That's $540 per year.

With the power of compound interest, it is never too early or too late to begin a savings program. No matter when you begin, your money will grow year over year, and no matter your time horizon, the growth of your account will help you take the steps to achieve your long-term planning goals.

Time Value of Money

The principle of time value of money is the notion that money received today is more valuable than the same sum of money received in the future. Why? Because the money earned today can grow with interest, thus having greater value than the amount you may receive in the future.

X-RAY

To make the best decisions about saving, budgeting, and debt management, it is important to understand your full financial picture. Often, people are quick to allocate money to areas they believe require immediate action, when they are in fact forgetting about other, more pressing needs.

A "Financial Planning X-ray" is a useful strategy to help you get a good understanding of what those pressing needs are and where you should focus on improving your finances. To start, look at any personal and financial goals that you have identified as taking place within the next three years through your SMART goal setting. Do you want to travel? Write a book? Produce a film? Teach at a university? Every year, revisit this document from a financial standpoint and update to help you stay on track and focus on what is important to you. These goals will help guide your budgeting, financial decisions, and managing your projects. The "Financial Planning X-ray" consists

Sample Financial Planning X-Ray		
SAVINGS	**OWNERSHIP**	**DEBT**
BANK ACCOUNTS		
Account Type Registration Balance	Type of Business Partnerships Ownership Percentage Income as Owner	Type of Debt Amount of Debt Interest Rate
		ESTATE PLANNING
INVESTMENT ACCOUNTS	**RETIREMENT**	
Account Type Registration Balance	Type of Account Custodian Balance	Will Health Care Proxy Durable Power of Attorney Trusts
GUARDIAN ACCOUNTS	**INSURANCE**	**REAL ESTATE**
		PRIMARY RESIDENCE
Account Type Registration Balance	Health Insurance Health Insurance Premiums	Own or Rent Rent/Mortgage per Month Value (if owned) Interest Rate (if owned)
INCOME	Life Insurance/DI/LTC Insurance Premiums Insurance Coverage Amount	
Employer Annual Income Additional Sources of Income Amount of Additional Income	P & C Insurance P & C Insurance Premiums P&C Insurance Coverage Amount	INVESTMENT PROPERTY Mortgage/Income Value Interest Rate

Figure 10. Financial Planning X-ray, courtesy of Julian Schubach.

of the following sections: Savings, Income, Ownership, Retirement, Insurance, Debt, Estate Planning, and Real Estate (see figure 10).

Savings

Bank account

As we discussed previously, it is important to properly register your accounts, which includes bank accounts such as checking and savings accounts. When completing your X-ray, be sure to indicate the registration for each of your accounts so you can decide if that registration is appropriate for you. In this section, list each account, along with balances. Remember, your savings account should generally have more money than your checking account. Your checking account should be used to pay your monthly expenses, and your savings should hold your "emergency funds."

Investment accounts

In this box, list all of your equity, bond, and alternative investments. Do not list your retirement accounts here, as that will come later in the X-ray. For each account, be sure to properly title the account, and list its registration and the balance.

Guardian accounts

If you have a child, the investments made for the benefit of your child will be listed in this section. Guardian accounts are managed by the guardian for the child until the child reaches the age of majority, which may range from ages 18 to 21 depending on the state in which you reside.

Income

Begin by listing your employer, and your partner's employer, along with your annual income. Indicate whether that is 1099 or W-2 income so you can plan for taxes as you browse through your X-ray before tax time. Also list any various sources of income from gigs, touring, art sales, or unearned income.

Ownership

Earlier in *The Profitable Artist*, you learned about the different business types and the benefits of each entity. In this section, list your different business entities, who the partner(s) is (are), and their ownership percentages. If you and your partner(s) are earning K-1 income, that should be disclosed in this section.

Retirement

In this box, you will list each of your retirement accounts. That includes IRAs, 401(k)s, 403(b)s, and any other retirement account you may have money in. List the type of account, the custodian or institution that manages the savings, and the balance of the accounts. All retirement accounts are registered to the owner, and these accounts can never be registered any other way.

Insurance

As an artist, there are various types of insurance you may have: health insurance, disability insurance, long-term-care insurance, life insurance, and various policies for your instruments, art, or touring/production company.

Health insurance

If you work for a company and earn W-2 income as a full-time employee, you will most likely be offered health insurance through your employer. If you do not have insurance through your employer, you may purchase health insurance as an individual. Based on your income each year, you may be eligible for a government subsidy, which provides assistance purchasing insurance. It is important to understand your coverage, deductibles, and copays for your policy.

Life insurance

Life insurance comes in all different shapes and sizes. Some insurance, called term insurance, provides low-cost life insurance for a set amount of years. This policy only provides your beneficiaries with a benefit upon the death of the insured during those years of coverage. Another type of insurance is called permanent insurance. Many permanent insurance products generate cash within the policies. There are many different forms of permanent life insurance, which may last all the way to age 120! Permanent insurance generally will cost more money than term insurance, but the added benefits sometimes make the investment a worthy one.

Disability insurance

Commonly referred to as "DI," disability insurance will provide you income in case you cannot work because of an injury. Disability policies are structured around your income and the length of time you would need to earn a replacement for your income in case you cannot work for reasons that meet the requirements set out by your policy.

Long-term-care insurance

Anyone who is reading this book has most likely known someone who needed skilled nursing, assisted living, or a home health aide later in life. The costs of these services are extraordinarily high and are continuing to increase. Long-term-care insurance is a policy that can be purchased before these services are needed and provides a daily or monthly benefit to the owner of the policy, which can be applied to the costs of these services. To learn more about long-term-care insurance, or any of the other insurance policies previously mentioned, please speak with your insurance broker or financial adviser.

Property and casualty insurance

Property insurance protects items you own (artwork, instruments, sculptures, etc.). Casualty insurance protects you financially if someone sues you. The two are often referred to collectively as "property and casualty." There are various policies that fall under this coverage.

Debt

There are many types of debt, some of which is considered good and some bad. Some of the most common debts we manage are credit card debt, student loans, car loans, and mortgages. In all debt scenarios, one of the most important items to understand and manage is the interest rate applied. Interest rate is the amount charged, expressed as a percentage of principal, by a lender to a borrower for the use of assets. Interest rates are typically noted on an annual basis. When managing debt and paying down your obligations, it is important to pay off the debt with the highest interest rates first. Generally, credit cards carry the highest interest rates, as much as 30 percent each year. For instance, if you currently have $10,000 in credit card debt, with a 30 percent interest, each year, the amount you owe can grow by as much as $3,000! It is important to work with an accountant or financial adviser if you have debt with high interest to build a plan for repaying it.

Estate Planning

Estate planning is a term we use to describe various documents that protect our assets. The three main documents that are vital to everyone are health-care proxies, durable power of attorney documents, and wills.

Health-care proxy

This document allows you to appoint a person you trust to make health-care decisions for you under two different circumstances. The appointed person may act on your behalf when you have the temporary inability to make decisions, or a permanent inability to make decisions, regarding your health care.

Durable power of attorney

A durable power of attorney enables you to appoint an "agent," such as a trusted relative or friend, to handle specific health, legal, and financial responsibilities in the event you cannot do so yourself. The agent has the ability to sign your legal documents on your behalf.

Will

There are various types of wills that can be drafted. A will or testament is a legal document by which a person expresses their wishes as to how their property is to be distributed at death. To draft a will, health-care proxy, or durable power of attorney, it is wise to find an estate-planning attorney to assist you. The cost of preparing these documents as a group may range from $500 to $15,000, depending on the complexity of the planning required.

We previously learned about Sofia's income, grant money, and LLC in the accounting section. In the X-ray below, we have inserted Sofia's financial information so you can see how the X-ray works in a real-world example, in figure 11.

Sofia Garcia Financial Planning X-Ray		
SAVINGS	**OWNERSHIP**	**DEBT**
BANK ACCOUNTS	Sofia's Studio - LLC	Student Loans - $65,000.00
Checking Account		Income-Based Repayment
Registration: Individual	**RETIREMENT**	$400.00/Month
$5,000.00		4.57% Interest Rate
	IRA - Vanguard - $15,000.00	
Savings Account		**ESTATE PLANNING**
Registration: Individual	**INSURANCE**	
$10,000.00		Completed Will, HCP, and DPA
	Health Insurance	With an Attorney
INVESTMENT ACCOUNTS	Purchased on Exchange	
	$450.00/Month	**REAL ESTATE**
Brokerage Account		PRIMARY RESIDENCE
Registration: Individual	No Additional Insurance Coverage	
$12,000.00		Rent
		$1,500.00/Month
GUARDIAN ACCOUNTS		
		INVESTMENT PROPERTY
N/A		
		N/A
INCOME		
W-2 Income - $27,000.00		
Grant Income - $35,000.00		
Freelance Income - $7,500.00		
1099 Shutterstock Income - $14,000.00		

Figure 11. Sofia Garcia Financial Planning X-ray, courtesy of Julian Schubach.

Managing Your Money for the Future

Following her success receiving the two grants worth $35,000—and the resulting tax ramifications—Sofia Garcia sat down with an accountant to better structure her finances. The accountant helped her to understand the importance of saving for retirement, deducting expenses, and reducing her tax burden. As you can see from Sofia's "X-ray" in the previous chapter (figure 11), she has a checking account with $5,000, a savings account with $10,000, and an investment account valued at $12,000. She also has $15,000 in a retirement account, and with the grant money coming in, the chance to build up her savings more. She scheduled a meeting with a financial planner who showed her that her accounts were stagnant, growing each year only by the amount of her contribution. While her accountant had made good recommendations about her beginning to save and reduce her taxes, she had not yet received any advice about how to invest in each of her accounts so that she could maximize her savings. As we travel through this section, we will go over what Sofia learned during her meeting with the financial planner: the importance of meeting or exceeding inflation each year, risk tolerance, types of investments and asset classes, and the importance of building a team to help guide you through financial, accounting, and legal matters you may not know.

INVESTING BASICS AND PRINCIPLES

Inflation

While Sofia was able to begin building her savings, she was actually losing buying power each year by not having her money invested advantageously. Inflation can be defined as increases in prices and decreases in her purchasing power. In times of economic growth, the cost of consumer goods and services increases each year. Recently, inflation has been between 2 and 4 percent annually. This means that every year, the cost of buying a set of items will increase by that percentage. While it doesn't seem like much, we learned about compound interest in the previous section and how a 2-to-4 percent increase in costs over a period of time quickly adds up to a big number. Let's say for example you have $1 today. That $1 today can buy you a can of soda. You take that $1 and place it in your savings account, where you earn little or no interest. Twenty years pass, and in that twentieth year, because you earned so little in your savings account, you now have $1.20. Unfortunately, a can of Pepsi now costs $2. While your dollar grew over twenty years, it did not keep pace with inflation, and your buying power declined. The value of your original $1 actually decreased over twenty years.

It is important to invest your savings across a spectrum of asset classes to not only meet or exceed inflation, but to provide diversification in your holdings. We often hear that we shouldn't put all of our eggs in one basket, and that holds true in investing, as well.

Diversification

Diversification is a technique that mixes a variety of investments within your portfolio, in turn reducing the risk. Generally, a portfolio constructed of different investments may, on average, produce higher returns while limiting risk, compared to having all of your money in a single investment. Diversification is a strategy that Sofia never employed in her portfolio. As it turns out, Sofia's savings across her bank and retirement accounts were all in cash, so she could not keep pace with inflation and had no diversification in her portfolio.

Diversification, as previously mentioned, also helps to reduce risk in your portfolio. Oftentimes, when we meet an artist for the first time, their first question is how to choose appropriate investments and where they can look to accomplish that task.

Another important factor to consider when investing your savings is risk and risk tolerance. Every investor is different. Some people are naturally risk averse, and some are willing to invest in more risky asset classes (such as international developing markets). Generally, for retirement accounts, the younger a person is, the more risk they can take on in their portfolio, and the older a person, the more conservative they are. The reason behind this is simple. A young person has many years to recover losses they may sustain in market downturns, whereas older investors have less recovery time if they are approaching retirement. While this is a general rule, there are plenty of young investors who prefer to invest conservatively despite their time horizon, and there are older investors who wish to remain aggressive despite the risks associated with their investments choices.

It is important to differentiate your risk tolerance for qualified and nonqualified investments. Qualified investments are retirement accounts, which as we learned earlier provide tax-deferred savings. Qualified accounts carry a 10 percent penalty for withdrawals prior to age 59½. Because of this, you must take the time horizon into account when considering the risk you are willing to take in your portfolio. This is money you most likely will not touch until age 59½, and, because you won't be using it for living expenses or emergencies, you might be more willing to take on additional risk in an attempt to attain larger growth opportunities in the long term.

Nonqualified accounts are accounts on which you have already paid taxes. Think of a nonqualified account as your savings and checking accounts at your bank or credit union. This is money you use each month for expenses, emergencies, and large purchases like a car, a vacation, or a home. Nonqualified accounts contain savings a person needs in the short term and therefore usually are invested more conservatively. We will cover this in greater detail later in this

section. If you are interested, you can visit https://personal.vanguard .com/us/FundsInvQuestionnaire to complete your own risk tolerance questionnaire.

Below is a chart of the S&P 500 performance since 1959 (figure 12). The Standard & Poor's 500 is a stock market index based on the market capitalizations of the common stock of 500 large companies. This index is considered a leading indicator of equities and the general condition of the stock market.

Figure 12. Standard and Poor's 500 Index History, 1960–2015, courtesy of Julian Schubach.

The most common questions new investors have are in regard to timing the market and the volatility of their portfolios. Before someone invests their money for the first time, whether it be for a retirement account or a taxable account, it is important to understand that any money exposed to the market may increase or decrease in value. The best way to control the degree of fluctuation in your account is to build a portfolio that matches the tolerance you have for risk. The more conservative an account, the less it will fluctuate, and vice versa for more aggressive accounts. Let's say the S&P 500 grows by 15 percent in your first year exposed to the market. If you were invested in a conservative portfolio (less equities and more fixed income), your balance may only grow by 5 percent. Conversely, if the S&P 500 were to decrease by 15 percent, you may only lose 5 percent.

Keep in mind that these are theoretical numbers, and, based on the underlying holdings in your portfolio, the returns will track the market differently.

It is impossible to know when the stock market will increase or decrease in value. Investors who attempt to "'time" the market are generally unsuccessful. By having your money invested and exposed to the market, your account(s) will increase and decrease in value in any given year. It is difficult to predict how the market will perform over the short term, but over long periods of time, the market provides favorable returns. As you will see in the chart below, the longer your time horizon for your investment, the more likely you are to have a positive return (figure 13).

Standard and Poor's 500 1926–2015		
Time Frame	Positive Return	Negative Return
5 Years	86%	14%
10 Years	94%	6%
20 Years	100%	0%

Data Source: Returns 2.0

Figure 13. Chart of Standard and Poor's 500 Performance: 1926–2015, courtesy of Julian Schubach.

Common Types of Assets for Your Portfolio

Stocks

A stock is a share in the ownership of a company. As you purchase more shares of a company's stock, your ownership stake in that company becomes greater. Indexes like the S&P 500 are a collection of stocks, which fluctuate in price. Fluctuations are caused by a number of different influences, like regulations, positive or negative news, changes within an organization, and consumer demand. An investor can buy and sell stocks of both domestic and international public companies.

Bonds

A bond is a debt investment in which an investor loans money to a corporation or government for a specified amount of time and in turn, the investor receives either a fixed or variable interest rate. When a company or government needs to raise money to finance a project, they may issue bonds directly to investors. The price of a bond depends on various factors, including the credit quality of the issuer and the length of time until expiration.

ETFs

An ETF (exchange-traded fund) tracks an index and contains a collection of assets. ETFs are traded like a common stock on an exchange. Think of an ETF as a basket, and within that basket there are various holdings, such as bonds and stocks.

Mutual funds

Like ETFs, Mutual Funds are baskets comprising underlying holdings. Mutual funds are run by money managers, who invest the capital and attempt to produce capital gains and income for investors. A mutual fund's portfolio is structured to match the objectives listed in the prospectus. For more information about stocks, bonds, ETFs, and mutual funds, please visit www.investopedia.com, which is a wonderful resource.

Building a Portfolio

Now that you have a basic understanding of stock, bonds, ETFs, and mutual funds, the question becomes how do you construct a portfolio that not only provides diversification, but also matches your tolerance for risk and time horizon?

There are a few different ways an investor can learn how to construct a portfolio. For investors looking to manage their account themselves, start by visiting the website for an online brokerage company. Some brokers you may have heard of include TD Ameritrade and E-Trade. These companies allow you to open various

accounts including IRAs, Roth IRAs, SEP-IRAs, and nonqualified accounts. Once you have opened and funded the account(s), you can construct your own portfolio on their platform.

The second option is to work with an online adviser. Commonly called Robo-Advisers, these firms provide web-based portfolio management and digital finance advice with minimal human intervention and for low fees. Two popular Robo-Advisers are Betterment (www.Betterment.com) and Personal Capital (www.PersonalCapital .com).

Last, some investors choose to work with financial advisers. A financial adviser will help you assess your tolerance for risk, build portfolios, and act as a quarterback for your financial life.

There is no right or wrong way of managing your money; the best choice is the option you feel most comfortable with. An important factor to keep in mind is the costs associated with various investments and portfolio management services. Fees vary based upon the level of service provided and the type of funds or portfolios you invest in.

BUILDING A TEAM

Sofia was wise to enlist the help of an accountant but might consider adding more members to her professional support team. Depending on the stage of your career, there are different professionals to add to your team to help you manage your taxes, legal issues, finances, production, insurance, and payroll. Think of the various professionals you work with as cogs in a wheel. It is important for you to not only have a good relationship with each of the members of your professional team, but also for them to work with one another, as well. If, for instance, your accountant recommends you fund an IRA, it is more efficient for the accountant to know your financial adviser and work with them to open an IRA and build a portfolio in line with your goals. Building a strong team will help you manage your planning needs in the short and long term.

Accountants and Business Managers

The main focus of an accountant is to prepare and manage financial records for you and your business. Accountants make sure that records and filings are accurate and taxes are paid properly and on time. Additionally, accountants may oversee financial operations of a business to ensure it runs efficiently. Because many artists have fluctuating incomes, and may earn both 1099 and W-2 income, it is wise to find an accountant who is familiar with the specific issues you may face. Speak with other artists and interview two to three accountants before hiring someone with whom you will build a relationship. Remember, the accountant you hire will be an integral part of your business and financial life.

Business managers perform accounting services and also typically offer bill payments and management, cash flow management, insurance administration, contract administration, and back-office services. Artists who employ business managers generally are earning a steady income and have a need for a "concierge." Business management firms typically work with artists in mid-to-late stages of their career when their earnings are at their peak.

Attorney

There are many different needs an attorney can assist an artist with, including estate planning and document management, contracts, legal documents for selling or touring, and creating and managing trusts. There are attorneys who work specifically with artists and understand your unique needs.

Financial Adviser

A financial adviser helps you manage your savings, investments, and retirement accounts. Think of a financial adviser as the quarterback of your finances. A good adviser will work behind the scenes with your account/business manager and attorney to fund and manage retirement accounts (which allow the accountant to reduce your taxes each year), fund trusts (which attorneys will draft and manage), and build insurance coverage options for your business and your art.

As with accountants and attorneys, it is wise to choose an adviser who has worked with artists in the past so they understand the intricacies of managing items such as restricted and unrestricted grants you may receive. Some advisers sell products, on which they earn a commission, and some advisers charge a flat fee for managing assets and providing financial planning services.

Agent

An artist agent is a professional who works on your behalf to represent, promote, and sell your work. Agents represent your business interests by pursuing individual sales, licensing, publicity, teaching opportunities, events, or commissions.

Fiscal Administration and Sponsorship

Fiscal sponsorship allows individual artists and emerging arts organizations (in all artistic disciplines) the ability to raise funds using the fiscal sponsor's tax-exempt status as a 501(c)(3)-classified organization. The artist applies to (or requests money from) the donor, who in turn makes a grant or contribution to the sponsoring organization. The sponsor then makes the funds available to the artist, typically taking a small percentage of the funds as a service fee.

Each sponsoring organization has different rules and conditions for accepting artists into the sponsorship program. At a minimum, the sponsoring organization will want to ensure that the project aligns with its mission. For that reason, sponsorship is usually most appropriate for projects with a public benefit component. We will cover fiscal sponsorship in depth in Chapter 14.

THE LINK BETWEEN YOUR ART AND YOUR LIFE

We cannot overemphasize how important it is for artists to understand their complete financial picture. Are you supporting or supplementing your art practice with another source of income? Do you have to support other people aside from yourself? Do you have credit

card debt, student loans, a car loan, or a mortgage? If so, your time and funds for your art may well be tied to factors that have nothing to do with your sales. An arts practice that is profitable, in the sense that it earns more than it loses, may still not be viable in the context of your overall life if it keeps you from meeting your other financial obligations.

None of these potential obstacles is a reason to get discouraged. In fact, many circumstances that initially appear to be obstacles can be turned into opportunities with a little planning and creativity—an inherent artistic strength. And it's far better to anticipate the obstacles ahead of time to give you the greatest number of options. So as you learn to evaluate the costs associated with your projects, practice, and time, you should extend that same analysis to your life as a whole.

TAKE CHARGE OF YOUR FINANCIAL PRESENT AND FUTURE

This section is all about learning or reviewing a very basic "language" that you need to put and keep your financial house in order. We've all heard people speak about "assets" and "liabilities," "budgets" and "savings," but too many of us don't get much further than hoping that the check we wrote to pay the monthly interest and principal on the credit card bill doesn't bounce. This, as countless studies have shown, is a very stressful way to live and counterproductive to having a successful career. We want the profitable artist to be conversant in the language of finance—it really is quite basic and manageable—so that they can take charge of this fundamental part of their lives. Learn the language; use it to deal with financial realities; use budgeting as part of the planning process you have embraced to empower your life and artistic practice. After you have answered many of the same questions we ask in other sections—who, what, when, where, why, how—this time in numbers instead of words, you can tackle the planning X-ray, armed with a new language and rich information with which you can shape and control your financial future.

Emergency Preparedness

One of this book's most important themes is that of awareness. Whether it's choosing the proper business entity to limit your liability, budgeting for the future, or organizing your fundraising efforts into a time line, we want artists to take the necessary steps to put their projects and practices in the best position to succeed. Sometimes, part of preparing for success is guarding against disasters, especially those that are beyond your control. Recent history has shown us that natural disasters—from Hurricane Katrina to Superstorm Sandy to wildfires in California—can have a devastating impact on artists' livelihoods, for several reasons. While artists are vulnerable to the same kinds of personal physical and economic dangers as everyone else, artists are also likely to have both inventory and production facilities in their homes (or nearby) that can be destroyed simultaneously. It is bad enough to lose one's home, but even worse to lose one's business at the same time.

While these are unpleasant and scary things to think about, the good news is that there are ways to both mitigate and prevent the risk, and many resources to help you do so. In order to address some of the resources and areas to consider for preparation purposes, we will look at the following topics: Location, Record Keeping, Insurance, and Emergency Grants.

LOCATION

Preparation begins with assessing the risks to your local environment. Do you live in a part of the world that is known to experience certain kinds of natural disasters? For example, people living in the southeastern part of the United States, as well as the Gulf Coast, have been particularly vulnerable to hurricanes over the years. People in California face the risk of wildfires, those living in the Midwest experience tornadoes at a higher rate than in other parts of the country, and people living in island or coastal areas in the Pacific Ocean face a higher tsunami risk. And risks aren't limited to large-scale, infrequent disasters. Drought and even localized flooding can happen with regularity in many areas.

While it's impossible to predict when and how a disaster will strike, you can investigate the kinds of risks most likely to occur where you live and work. If you are living in a region that is particularly vulnerable to a certain kind of natural disaster, there is a good chance that local authorities have already developed action plans and recommended responses. Make sure to familiarize yourself with these, as they can help you learn about warnings earlier and will have suggestions on evacuation routes and home care, as well. Any suggestions on home care (for example, how to protect windows against high winds) will likely apply to a studio or rehearsal space, as well. If the local home care guides do not address storage, make your own plan about how to store and care for your art, taking into account the risk in question. If you live in an area at risk for hurricanes and flooding, avoid storing work in basements. If the risk is wind or earthquake, keep it away from things that could fall. If you can fireproof the storage area, even better.

And while the focus of this chapter is on emergency and disaster preparedness, it's worth taking time out to assess your studio or workspace for more everyday risks, as well. Electrical issues are one of the most common causes of fires, so have your wiring examined by a professional, especially if you are located in an older building. Look for areas where you might have overburdened electrical outlets or fraying cords and keep any kinds of flammable materials away from both. If

you are working with hazardous materials, these can be a risk to your health as well as a fire hazard, so research what the safest and most recommended ways to deal with these materials are. Preparedness does not stop at your studio—if you are in a shared space or building, your neighbors can pose a risk even if you are very cautious. Think about what precautions can be taken to mitigate those risks, and communicating with your studio mates or neighbors is the best-case scenario.

RECORD KEEPING

One of the most important things you can do for emergency preparedness is to protect your records. This is true on both a business level and an artistic level. On a business level, consider storing your receipts, contracts, grant award letters, and any other tax or legal documentation. These kinds of records can be very costly to replace, at least in terms of the amount of time you would need to spend doing so. And perhaps more important, losing documents like these could result in missed business opportunities, as you may miss key deadlines for grantors, clients, and collaborators. Most of this information can be stored digitally, especially if you have a scanner or take photos, but it's always good to have hard copies of the essentials. Invest in some waterproof and fireproof boxes in which to store these essential documents.

On an artistic level, you will want to preserve those things that will allow you to resume work as quickly as possible after a disruption. Make sure to document and protect all the resources you can, including anything related to your ongoing work such as prototypes or drafts, as well as collaborator contact information. On a related note, this can also be an excellent opportunity to create an archive for yourself. The Joan Mitchell Foundation has published a free and very thorough document on how to build an archive for visual artists who have never done so, as part of the organization's "Creating A Living Legacy (CALL)" initiative.[11]

11 http://joanmitchellfoundation.org/uploads/pdf/CALL-Workbook-Dec2013.pdf.

INSURANCE

While we discussed a variety of types of insurance in Chapter 8, we want to pay specific attention to it here. The first thing to do is to check if any of your existing insurance policies (assuming that you have any) extend to your artwork. This is especially important with either homeowners or renters insurance. If these policies do not cover your work, you will need to look into other sources. Many types of homeowners insurance place restrictions on covering art and other valuable items, so read the fine print and contact the insurance company in advance for specific questions. Furthermore, you'll want to check to see whether your existing policies cover all kinds of disasters, especially those that happen frequently in your local area. For example, many typical homeowners insurances specifically do not cover flooding, so if you are at risk of that, you might consider a separate policy. You can search for Insurance on NYFA Source by searching Services → Insurance. This is available at source.nyfa.org.

Regardless of which type of insurance you obtain, make sure to create an inventory of any work that you have or are storing. If you put together an archive, the inventory list can be made coextensively and is a useful exercise in and of itself. An inventory that lists works specifically and establishes values will be extremely helpful when making an insurance claim, as well as for certain kinds of recovery grants.

EMERGENCY GRANTS

No matter how well you plan, it's almost impossible to anticipate everything that can go wrong. Despite your own plans for mitigating damage and acquiring comprehensive insurance coverage, you may still need additional support in the event of a disaster. A good place to start is NYFA's own NYFA Source, which has a dedicated section entitled "Emergency Resources." It lists the first lines of government disaster response units for every US state and territory and, where applicable, specific grants that are targeted toward artists. In general,

freelancers and artists can face challenges in finding disaster relief funding that applies to them specifically. When a large-scale, localized disaster occurs, organizations sometimes launch short-term initiatives to aid artists in recovery (either by themselves or as part of a larger coalition). NYFA did this in 2012 following Superstorm Sandy, in partnership with the Warhol, Lambent, and Rauschenberg Foundations. In the wake of Hurricane Harvey in 2017, a number of Houston-area arts organizations came together to form the Harvey Arts Recovery, a coalition that amalgamated arts-related disaster recovery resources. Be sure to look out for updates from arts service organizations in your area following any kind of large disaster, as onetime opportunities for support may arise.

However, there are a number of organizations that offer emergency assistance on a regular basis. The Actors Fund offers emergency assistance for those working in the entertainment industry, with both targeted financial support for victims of specific disasters and general information on disaster planning and relief.[12] MusiCares provides emergency assistance for those in the music industry on a case-by-case basis.[13] Craft Emergency Relief Fund + Artists Emergency Resources (CERF+) provides information on disaster preparedness as well as emergency grants to studio artists.[14] The Adolph and Esther Gottlieb Foundation[15] and the Joan Mitchell Foundation[16] both provide emergency grants for visual artists. And The Artists' Fellowship, Inc., is a charitable foundation that assists professional fine artists (painters, graphic artists, printmakers, sculptors) and their families in times of emergency, disability, or bereavement.

12 http://www.actorsfund.org/services-and-programs.
13 https://www.grammy.com/musicares/about/who-we-are-contact-information.
14 https://cerfplus.org/about-us/what-we-do/.
15 https://www.gottliebfoundation.org/emergency-grant/.
16 http://joanmitchellfoundation.org/.

SECTION IV MARKETING

Introduction

Marketing is one of the most important activities that any business or organization can undertake. It is a chance to shape the narrative about who you are and what you do, to create relationships with the public, and to bring in new customers and stakeholders. For an artist, this is equally important, if not more so. Ultimately, it is about sharing your work with a larger audience, and about starting a conversation (either online or in person) that can lead to exchanges, collaborations, and many other enhanced opportunities.

For many artists (and many businesses in other industries), marketing is also a question of resources. How, where, and when do you allocate time, money, and expertise so as to use those resources most effectively? Can you utilize existing resources to engage your audience, stakeholders, and the wider public? We will focus primarily on tools that are accessible to all.

We'll begin by looking at understanding your work and your place in the market. Next, we'll discuss understanding your audience. We'll continue with establishing short- and long-term goals and then examine branding as a concept for artists. We will focus time on breaking down the tools at your disposal, both digital and nondigital. Finally, we will close by looking at creating a marketing budget.

Marketing Principles and Strategies

UNDERSTANDING YOUR WORK AND YOUR PLACE IN THE MARKET

One of the first steps that you need to take in order to construct your marketing plan is to understand your work and its (your) place in the market. Let's begin with understanding your work.

At the most basic level, what do you do? Are you a painter, a sculptor, a filmmaker, a composer, a playwright, or a mixed media artist? Don't stop with those most basic categorizations, but look at what makes your art uniquely yours. Do you work with a certain kind of material (ceramics, acrylics), play a specific instrument, or write fiction, poetry, or nonfiction? What other distinguishing features are there about your work, such as size, temporality, or geographic and environmental conditions necessary to sustain it?

Also think about the subject matter you work with, both generally and in the specific work or project that you are trying to market. Are you photographing particular regions or populations? Do you play the music associated with a particular time and place, like French Baroque or Klezmer? Are you trying to bring an awareness to social inequities via the stage or a mural?

Think about how works similar to yours are consumed. Are they displayed in places specifically dedicated to art, like museums or galleries, or do they interact with people in public spaces? Do people

purchase tickets to hear or see your work? If applicable, can people buy your work? If so, how does that take place? Some artists may be creating works of which there is only one version, or perhaps a very limited number of copies. This is particularly true of the visual arts. Conversely, musical, literary, and sometimes media artists create works that are designed for, and well suited to, large-scale consumption. Taken collectively, all of these factors help determine your place in the market.

Let's return to the importance of understanding your place in "the market." For starters, the word "market" can have multiple definitions and connotations. A brief Internet search of major online dictionaries yielded ten different definitions on English Oxford Dictionaries, and nineteen on Dictionary.com. In the context in which we're using the term market, however, the following is a good summation: "In marketing, the term market refers to the group of consumers or organizations that is interested in the product [or service], has the resources to purchase the product [or service], and is permitted by law and other regulations to acquire the product [or service]."[17]

Marketers tend to define a market by the product itself (for example, the corn market) but sometimes look at larger groupings (the entire agriculture market). And while it is easiest to identify and study markets for products that are very similar or interchangeable, you can still group and analyze markets for products that are highly variable and unique, such as the "art market" and the "luxury market."

Why study these markets? Understanding what market you are in can provide you with a lot of useful information. There is sometimes available (and publicly accessible) data on the consumers in a given market, including demographic and psychographic information, or how these consumers respond to different factors like price. Furthermore, you can examine the different parts of a given market to understand where your position is. For example, in the market for cars,

17 "Market Definition," NetMBA, accessed November 15, 2017, www.netmba.com/marketing /market/definition/.

you can identify distinct areas based on price (both high and low), safety, fuel efficiency/environmental sustainability, physical size, recreational capabilities, and aesthetics. Building a marketing plan for a sport utility vehicle will be different from that for a self-driving car, even though both are technically automobiles. Marketers apply the data available about the larger market to construct a message and strategy that fits the market for the particular product for which they are trying to generate interest and enthusiasm.

The same holds true for markets in the arts. While broad demographics and trends may not be available for every market within the arts—and may not even be all that relevant for an individual artist—it can help you to better understand the environment in which you operate. Think back to Chapter 1, where we discussed "Environmental Scanning." Understanding the market you are in and what is your place is in that market is extremely important for setting strategies of all kinds. In particular, it can help you to identify what those artists who are in the same market segment are doing, to whom they are selling, and what marketing techniques they are using. Are you creating wearable art that can also be considered fashion? You may find useful reference points in both the fashion and luxury markets as well as the art market. Are you a musician who performs at weddings? Researching the wedding industry may be a good investment of your time.

UNDERSTANDING YOUR AUDIENCE

If understanding your work and its place in the market is the first step toward creating a marketing plan, especially at a very high (or conceptual) level, then understanding your audience is where you get into the specifics of who actually consumes your work. At the most basic level, understanding your audience is about focusing on a given individual who has attended your show, read your book, watched your movie, or, most important, bought your work and asking the who, what, where, when, and why questions about that person. As a side note, while we will use the term "audience" member here, and

sometimes reference "attendance," we mean this to be completely interchangeable with someone who attends a gallery opening, or who purchases your work, or who participates or interacts with you and your artwork in any context, either in person or online.

When large companies approach marketing, a common approach is to create composite sketches of customers. This is something that we'll discuss and try in this section, but we would also note that many artists have more direct access to their customers (audience). Most artists begin with a smaller circle of supporters, fans, and clients, and that can be an advantage from a marketing standpoint, as it allows them to gather some very useful data. This approach is in fact quite similar to what was discussed in Chapter 2, covering the "Lean Startup" and customer discovery process. In fact, if you are trying out some of the tactics from the lean startup and are engaged in customer interviews, make note of the responses, as you can use the information you learn in multiple contexts.

For marketing purposes, you will initially be focusing on somewhat broader information than you might for customer discovery. You will want to know **who** the audience member is—what kind of demographic information distinguishes them? You will also want to know **what** they do. Do they work in an industry related to the arts, are they artists themselves, or something totally unrelated? Perhaps they are retired, or in school. **Where** is also extremely important to know. Do they live or work near you, or your studio, or the venue in which your artistic event takes place (if you are a touring artist, this could a broad category). **When** did they attend this event, or when did they initially learn of you or connect with you?

On a deeper level, you want to learn **why** they attended your event. Are they fans of the genre of which your art belongs? Was this part of a larger social gathering? Are they new to the area and looking for things to do? If your art deals with larger social or political themes, or if it involves historical figures, did they attend due to the subject matter, with your art being of secondary interest? Perhaps they stumbled across your event completely accidentally.

Finally, **how** did they learn about your event? From a planning perspective, this is essential information. Did a friend tell them, and if so, which friend and where did *they* learn about it? Did they see a listing in the paper, or on TV or the radio? Did they learn of it through the venue, or through a mailing list (email or regular mail)? You should pay particular attention to whether they learned about the event online, through social media, or otherwise. We will cover digital marketing in depth later in this section, as it is a particularly important tool for artists, both because of its ubiquitous nature and effectiveness, and because it is extremely cost-effective when compared to more traditional forms of communications. Did your audience member learn about this on Facebook, Instagram, Twitter, or somewhere else? If you undertook any paid advertising—in any context—try to find out of this reached your audience member (digital marketing also offers considerable options to track this).

As you learn about how this audience member learned of your event, try to dig deeper and learn about how they consume information generally, with a focus on their online activities. Many people prefer certain social media platforms, and others have trusted sources for cultural information and events. Learning this can provide deeper insights into whether they learned about your event by chance or as part of their regular activities, which in turn can help you make your future marketing more effective.

Repeat this process with other members of your audience. Obviously, most of these broad "who-what-where" categories are overly broad, and there is a lot of overlap between each. But taken collectively, this information can yield significant information that you can use to make larger decisions about a marketing strategy. And this also requires you to make informed and logical inferences about your audience based on that information you collect. For that reason, try to make your audience research as diverse as possible. Interview people from very different backgrounds, in different contexts (if your practice lends itself to holding multiple events or events in different geographic locations, take advantage of that), and in different categories, such as

people who attend one event, multiple events, those who purchase a single work versus repeat customers, and people who participate in online events.

Now let's try the exercise we discussed at the very beginning of this section. Take the information you have collected, and try to create a "composite sketch" of your audience member. Who is this person? What is their age, where do they live, what is their gender, where do they work and what do they do, how do they spend their free time, what do they care about, how do they use social media and what are their online habits generally, and anything else that helps bring this composite person to life. Take a few moments and sketch this out on a separate piece of paper.

You may have noticed several significant groupings within your audience, and if so, repeat this exercise until you have created composite sketches that adequately cover your audience. Once you have done so, you will use these composite audience members to help craft your marketing plan, choosing to spend your time and resources pursuing those people you believe most represent your audience, and in places that they are most likely to see and be receptive to it, online or otherwise. Bear in mind that this is merely an exercise. As you collect information on your audience, you may well observe patterns or common links (for example, everyone is a member of a particular local museum). Don't be afraid to account for these when setting your marketing

Figure 14. Maia Cruz Palileo (NYSCA/NYFA Fellow in Painting, Artist as Entrepreneur Boot Camp for Artists of Color Participant), *The Topless Ghost*, ink and gouache on paper, 44.5 x 30 inches, 2015.

plan, even if these patterns are not part of your composite sketch. Conversely, if you have noticed any broad patterns (for example, almost everyone in your audience reads a specific blog) that are not in your composite sketch, you may wish to revisit that.

ESTABLISHING SHORT- AND LONG-TERM GOALS

One of the most important functions of a marketing plan is to establish a clear set of objectives that you hope to achieve through your marketing efforts. These objectives should be both short term and long term. As you'll recall from our earlier discussion on goal setting in Chapter 1, applying the principles of SMART goal setting (Specific, Measurable, Attainable, Relevant, and Timely) will help you to articulate goals that are genuinely useful for planning purposes. Marketing is no exception!

Marketing Your Practice Generally

A threshold question before beginning is, are you trying to market a specific event, or your practice in general? While marketing an event is more straightforward from the standpoint of articulating goals and creating a time line, we will begin with marketing your practice generally, as your success in marketing an event will depend in large measure on how you have already raised awareness about your work overall. Marketing your practice generally as opposed to single event has a different set of challenges, as well as different opportunities. There is generally a different set of goals associated with it. Rather than trying to get your audience to do something specific, you are more likely looking to engage them, stay relevant to them (whatever relevant means for you in the context of your practice), communicate important moments in your career, or keep an ongoing dialogue with them.

So how do you actually do this, and how does that translate into a time line or calendar? Think back to the beginning of this section, where we discussed analyzing your work and its place in the market.

What insights did you gain from that? A long-term marketing plan for your practice can help to reinforce your role in the market to your audience by highlighting important aspects of your work. No matter what kind of art you make, it has some relation to outside events, which can be tied to your marketing strategy. Sometimes this connection is very easy to make, for example, your work is political in nature and provides a perspective on an upcoming election or campaign, or it deals with a geographic area that is in the news for some reason. However, some artists feel uncomfortable linking what they do to certain events, and there are indeed times when it might feel inappropriate to draw a connection (particularly with a tragedy, unless what you do is exactly on point or advocacy is a core part of your practice). Furthermore, it can be very challenging to create a calendar in advance that is based on newsworthy events.

Fortunately, there are plenty of more subtle options to connect your work to the broader world. The calendar is full of days, weeks, and months that have been designated to honor or celebrate various causes and segments of society. Perhaps there is a mathematical element to what you do, in which case timing a social media post with UNICEF's World Maths Day might be effective. Or you could honor the birthday of an artist who was a particularly strong influence on you. A simple web search will get you all the information you need about any given date, and with a little creativity you can find multiple things that relate to you or your work on a daily basis. That allows you to create a time line that surprises and enlightens your audience without having to be reactive or deal with events that might make you uncomfortable.

Other artists make teaching a core part of their marketing strategies. As an artist, you have likely spent much of your life refining a skill that very few people can do, and which many find inspiring. By offering insights into your work, you share that knowledge and wisdom with your audience, some of whom might be interested to learn those skills themselves, while others gain a deeper appreciation for what you do. This can be particularly effective for artists who make teaching a regular part of their practice.

Related to teaching is the strategy of sharing insights into the artist's life generally. Much of your audience might be unaware of what kinds of issues artists face, or how and where artists find inspiration. Many may not understand how best to interact with artists professionally (how to buy an artist's work, what are the expectations of a musician on a gig, and so on). You can provide valuable and interesting insight to your audience by sharing your experiences, and simultaneously build trust.

Finally, make sure to provide updates on events in your career, even if you are not marketing that event in particular. Examples could include attending a residency, serving on a panel, contributing an article to a publication, or a host of other happenings to which you might want to call attention. Not only does it keep your audience informed about your career and its continuing relevance, but it provides context for when you do market a specific event. Your audience will have a better understanding of why supporting a particular event is so vital to your career.

All of these strategies—connecting your work to current events of varying size and significance, teaching your audience, offering insights into your career and the arts generally—are just a few of innumerable possibilities you can use in marketing your practice. These examples offer one way to create a marketing time line that gives you sufficient material to plan ahead, so that your time line is a good fit with your audience and with your own voice. Which items you choose to highlight, how you highlight them, and in what order will be determined by your long-term goals, and by your understanding of what will resonate with your audience and help to achieve those goals. Much of this touches on the idea of your "brand," which we will now look at in more detail.

Marketing a Specific Event

If you are looking to market a specific event, like a concert or movie release or exhibition opening, the date of the event will dictate your time line. The next thing you will want to do is to identify your main

objective for marketing this event—what do you actually want your audience to *do*? Is it a ticketed event and you want them to purchase or reserve tickets, or at least to RSVP? Or is it a gallery exhibition where you are looking to bring as many visitors in as possible, even if no tickets are required? Any of these goals satisfy the "SMART" requirements, and whatever your goal is, try to structure it so that it frames your marketing campaign in a concrete way.

Once you've identified your main goal, think about what other goals you might have. These could be milestones that you need to achieve along the way (for example, an RSVP could be a preliminary step toward your goal of 80 percent attendance at your event), or they could be peripheral benefits (an increased "buzz" around what you are doing as an artist). Very often these will overlap.

Let's now take these goals and transfer them onto a time line or calendar. For the purpose of this exercise, assume that you have a ticketed performance coming up in three months. Your primary goal might be for your audience to purchase tickets and attend. In order to achieve this, you might plot out your objectives on your time line like this:

Create Awareness → Generate Enthusiasm and Buzz → Get Audience Members to Purchase Ticket(s) → Reminder → Documentation and Thank-You

There is no one-size-fits-all formula for creating a time line, but as you plot these various milestones on your time line, certainly be mindful of any external deadlines that your audience needs to know (for example, if online ticketing closes a day before the show). And as we noted before, there is a lot of overlap between categories here, as you could create awareness for your event while simultaneously generating enthusiasm and buzz and offering a chance to purchase tickets at the same time (many artists do). But conceptually, it will help you to schedule your marketing activities, perhaps beginning with a longer or more formal communication to introduce

the performance, followed by shorter "behind-the-scenes" video clips or quotes from collaborators posted on social media to build interest. Conversely, some artists will release more cryptic messages or images in order to pique the interest of their potential audience and wait until a later point to provide more complete information. Nor is there one right approach for how you communicate information—rather, it is about knowing your audience and the expectations of the market that you're in, which you have already researched and considered.

You'll notice that we have added thanking people for attending or contributing in some way onto the calendar, as well as documenting the event itself. These might not be related to achieving your stated goal of attendance for that specific event (unless it is thanking people who purchase tickets early in hopes of inspiring other purchasers, or documenting aspects of the work in progress that will intrigue your audience). However, it falls into the category of "best practices," and it makes sense to put it on the calendar, as it will help to grow and strengthen your network. We will discuss networking more thoroughly in the next section, but your online marketing efforts in particular are inextricably linked to networking.

Let's try an exercise now to practice creating a marketing time line for an event. In figure 15, we have a sample time line developed over three months (eleven weeks), leading up to a performance. In the left-most column there are dates, and in the center there are sample ideas. The far right column is blank, so take a few moments to think about how you would structure a similar time line. Then, adapt to any time line of dates that makes sense for you! This document is very simple to make and can be done in any spreadsheet program or by creating a table in a word document.

And it's worth noting that even if your event is coming up very soon, there is time to engage in some very effective marketing. Having more time is beneficial in many ways, particularly from a planning standpoint, but many potential audience members don't finalize their calendars until the last minute. There is still time to reach people.

Marketing Timeline Exercise:

TIME	EXAMPLE	YOUR CALENDAR
JANUARY		
WEEK 3	Behind-the-scenes Instagram post 1x wk	
WEEK 4	Behind-the-scenes Instagram post 1x wk	
FEBRUARY		
WEEK 5	Rehearsal Facebook Live video + Insta	
WEEK 6	Behind-the-scenes Instagram post 1x wk	
WEEK 7	Behind-the-scenes Instagram post 1x wk	
WEEK 8	1st email invite to performance	
MARCH		
WEEK 9	Instagram post incl. Call to Action to buy tickets	
WEEK 10	Rehearsal/costume post on Insta & FB	
WEEK 11	Reminder email invitation to all	
WEEK 12	**Performance!**	
WEEK 13	Thank-you posts & email	

Figure 15. Marketing Time Line, courtesy of Mara Vlatković (Campaign Specialist at The Juilliard School and Founder of Young Professionals in the Arts NYC).

BRANDING

As NYFA has presented the topic of branding to artists over the years, it has resonated with some, and not with others. We are presenting it here with both the "traditional" definition, and also what we have seen work for many artists. We invite you to consider whether any

of this material applies to you and to take whatever information and lessons can help you to raise awareness for your artistic practice. Branding is often a complex and controversial topic for artists. The American Marketing Association defines branding as follows:

> A brand is a customer experience represented by a collection of images and ideas; often, it refers to a symbol such as a name, logo, slogan, and design scheme. Brand recognition and other reactions are created by the accumulation of experiences with the specific product or service, both directly relating to its use, and through the influence of advertising, design, and media commentary.[18]

For many large companies, branding is a conscious, active, and heavily managed activity, designed to build consumer loyalty and trust. This in turn allows for the company to charge a premium for a product that has many substitutes in the market. For example, consumers routinely pay more for Advil than they do for ibuprofen, even though it's the exact same drug. However, effective marketing by Advil has created a sense of trust in the brand that can be powerful under the right circumstances. If you have ever been in a foreign country where you don't speak the language and you become ill, you might feel a greater sense of security purchasing Advil for pain relief even if it's more expensive.

While many factors go into building a brand in the corporate context, the name, logo, and package design are very important. Branding also has strong ties to trademark law, which was covered in Chapter 3. At more sophisticated levels, the language used to describe the product, the way in which it is pictured, and even the people and places associated with it are taken into consideration by marketers. Above all else, brands strive for *clarity* and *consistency*.

18 "Dictionary," American Marketing Association, accessed November 12, 2017, www.ama .org/resources/Pages/Dictionary.aspx?dLetter=B&dLetter=B.

For these reasons, many artists resist the idea that their art is a brand. After all, clarity may not be a concept that is ever considered when making art. In fact, many famous artists could care less about whether people "get" what they do. And the idea that their work needs to remain consistent can seem both overly restrictive and completely contrary to the creative spirit.

NYFA takes a different view of what branding means for artists. We approach branding as an exercise in authenticity. By authenticity we mean that every artist has their own unique story to tell, and their own way of telling it. How you communicate with your audience is simply another expression of that. Your art is already unique—unlike ibuprofen, it doesn't need to be differentiated from the exact same chemical compound through clever backstories or trademarked packaging and slogans. Instead, your challenge as an artist is to avoid getting caught up in trying to use language and communication styles that don't fit with who you are.

Ironically enough, this can include making too much of a conscious effort to brand yourself. There is nothing inherently wrong with creating a logo, or using the same kind of color scheme, font, and style each time that you send a communication—as long as that is part of your practice anyway. In his book titled *Making Your Life as an Artist*, Andrew Simonet made an excellent analogy when talking about careers:

> I think of careers [branding] like scaffolding, those metal and wood structures you put up when you are building a house. The scaffolding is important. Pay attention to it. But it is not the house. If you focus all your efforts on the scaffolding, you end up with a lovely scaffolding and nowhere to live.[19]

Substitute "career" for "brand," and you have an excellent approach for branding as an artist. And there is no question that many artists

19 Andrew Simonet, *Making Your Life as an Artist* (Self-published, 2014), p. 70.

do have definable brands, and that these artists can benefit from a business perspective. Famous artists who routinely sell work for a premium are benefiting from their brand. A well-known classical musician with a reputation for technical excellence can likely charge more for their performance of a Chopin piece than a musician who is a complete unknown, as their brand inspires trust in the audience. Directors may hire actors known for certain kinds of roles, as that can influence an audience's perception of the material. And people may pick up a new book by an author they trust because they believe it will make them feel good reading at night before they sleep. What branding experts try to achieve in the corporate world is alive and well in the arts world.

You likely already have a consistent and recognizable way of discussing and presenting your work and career. Don't be afraid to embrace that, and also to put your art front and center in any communication, as your art is the essence of your brand. But who you are informs how you approach the world and solve problems and make art, and you want to let that shine through without a filter. Those people that respond to your work will respond to an honest and sincere communication that discusses it, because that will reflect the artist who created it. This is not to say that you shouldn't pay close attention to the look and feel of your marketing materials, or the timing and content of communications with your audience, or that you shouldn't proofread emails and flyers. But it does mean trusting your instincts and personal style over trying to use language or visuals that you think carry more weight in the art world (or the business world).

Marketing Tools and Resources

MARKETING STRATEGY BREAKDOWN: TOOLS

Thus far, we've looked at many of the theoretical and philosophical components of marketing, from analyzing your audience and role in the market, to the timing and branding associated with your marketing efforts. Now, let's turn to some of the nuts and bolts associated with actually creating your marketing materials and getting them in front of your audience.

For years, artists (and for that matter, many small businesses) faced significant challenges marketing to a large audience due to cost. Simply put, there were very few available channels to reach a national audience, or even a regional one. Those few channels that did exist, mainly television, radio, and national print media, were cost-prohibitive for all but the biggest advertising budgets. International audiences were even more inaccessible, plus there was often a language gap. Within the past twenty years—and especially the last ten—all of that has changed. We live in a digital world with handheld Internet access, social media, and free and accurate auto-translate functions. An artist can literally connect to anyone in most places of the world, at any time, which has opened up amazing possibilities for marketing that cost nothing beyond an initial investment in a computer or smartphone. We'll start by examining the role of social media in artist marketing.

Figure 16. Performers Veena and Devesh Chandra (NYSCA/NYFA Artist as Entrepreneur Boot Camp Participants) enthrall audiences at the New York State Fairgrounds in Syracuse, NY, for the New York India Festival, September 2014. Photo by Mehul Joshi of M.A.R.S Fotographi.

Social Media

Social media has likely become the single most important tool for artists from a marketing standpoint. Artists now have the ability to share their work in a variety of formats (photos, videos, audio clips, text) instantly, and with an almost unlimited audience. With multiple platforms that have different styles and cultures, and vast amounts of subgroups on each platform, there is a place online for everyone. And most important, it is free. That said, with no real barriers to entry, there is also a tremendous amount of noise and competition for attention. Just because one million people could potentially see your work in an hour doesn't mean that they will, or that they are likely to do so. Making social media work for your practice and your marketing efforts can take a significant amount of time and effort. Still, the upside of social media relative to the cost makes that effort worthwhile for most artists. We'll review each of the major social

media platforms in turn. One caveat: the numbers and statistics cited here are taken from the Pew Research Center's 2016 study on social media unless otherwise noted.[20] These numbers will have changed by the time this version of the book is released. We encourage you to visit the Pew Center's website for the most updated numbers, as it is one of the most trusted sources for analysis in the field.

Facebook

Facebook is the largest social media platform. Some of the important numbers include 1.79 billion monthly active users, including 68 percent of all adults in the United States who are online. Some other significant demographics: 83 percent of female Internet users are on Facebook, 75 percent of all male Internet users are as well, and 88 percent of Internet users aged 18 to 29 are Facebook users, too (with older Internet users rapidly closing the gap). It's not hyperbole to say that much of the world is on Facebook.

There are pros and cons to marketing through Facebook. On the pro side, you potentially have access to an enormous audience. It is very easy to share content, whether text or video or images. You can also control who has access to your posts with a variety of controls and settings, and you can easily set up a public-facing fan page as well as a personal profile. You can also use your Facebook profile to comment on a variety of external websites and message boards, which can extend your social media "reach" even further beyond the platform itself. And Facebook has a large amount of features that can be used to support your marketing efforts, from paid advertising, boosted posts, the ability to create events and interest groups, check-ins at events and locations, and even livestreaming. You can become more active on Facebook by joining different groups and communities. These range from political interests to groups of musicians posting their renditions of particular songs, seeking feedback.

20 "Social Media Update 2016," *Pew Research Center* online, November 11, 2016, http://www
.pewinternet.org/2016/11/11/social-media-update-2016/.

On the con side, Facebook can be challenging to navigate due to its size and many features. The algorithms that govern where and when your posts appear in someone's news feeds do not always work in favor of smaller businesses or individuals. And Facebook makes frequent adjustments to its privacy policies, which you need to remain up to date with. This is particularly important from an intellectual property perspective—the user agreements that you sign can often grant Facebook pretty wide latitude to use your content however they see fit. And in general, anytime that you put your work online and accessible to the social media public, there is a risk of others taking that work illegally. Depending on your medium and artistic practice, you might want to consult with an attorney to make sure that you are protected (or that you understand exactly what you are signing).

One additional reminder with Facebook is that if you are using the platform for marketing and business purposes, you will want to use a Facebook business page. There are a number of reasons for that, including access to advanced analytics, no limits on followers (as opposed to personal profile friend limits), the ability to run contests, more options to include information on your main page, and differing levels of access for employees or team members. Setting up a Business page is very easy to do (just click on the "down arrow" on the right-hand corner of your screen, next to the "?" symbol, and select "create page." You'll have a variety of options for the kind of business you want to select, and there are plenty of options for both nonprofits and also for artists to create fan pages. You can also change the page name to be consistent with your other forms of social media.

Instagram

Instagram is one of the fastest-growing and most popular social media sites. Its 600 million users include 28 percent of all adults who are online in the US. Thirty-eight percent of all female Internet users are on Instagram, and 26 percent of male Internet users are, as well. From an age-range perspective, 59 percent of Internet users between the

ages of 18 to 29 are on Instagram, with the next highest age bracket being 30-to-49-year-olds at 33 percent.

Like Facebook, there are pros and cons, including the fact that it is connected to Facebook. This connection could be considered good or bad, depending on how you feel about Facebook, or how interconnected you want your social media accounts to be. In general, it allows for easy movement and some cross-posting between platforms, which can save time. Instagram is also notably user-friendly and has been introducing new features and functions that allow for posting video (and live video) and improved image editing and enhancements.

Instagram is focused on images, which means that artists in nonvisual media will need to find creative solutions to share their work as completely as they might do on a platform like Facebook, or they have to be very creative in their Instagram usage to do so. It is also geared for mobile devices rather than laptops and desktops, so even with its massive user base, there could be people in your audience who aren't well-served (or reached) by an exclusive focus on marketing through Instagram. There is also less flexibility in how you manage posts, as you can either set to "public" or "private," meaning only approved followers can see them.

Twitter

Twitter is another of the social media giants. It has 317 million active monthly users, and 21 percent of all adults in the US who are online are Twitter users. Demographically, 38 percent of female Internet users are on Twitter, and 26 percent of male Internet users. Thirty-six percent of Internet users between the ages of 18 to 29 use Twitter, followed by 23 percent of those in the age 30-to-49 bracket, and 21 percent of those between the ages of 50 to 64.

Twitter is known for its brief, text-based updates and has a different look and feel from Facebook and Instagram (and is not connected to either platform). It too has pros and cons. The pros include its brevity—due to character restrictions, information needs to be communicated as efficiently as possible. And as the platform has grown, there have

been developments in the way users can include images, links, and tagging functions so that it is a more dynamic experience. Twitter moves at incredible speed and is one of the fastest ways to stay on top of current events. It is also an effective way to reach the press and journalists, so if your practice is related to current events, Twitter might be a very effective platform for you.

There are downsides to Twitter, as well. Cons include a fairly specialized set of language and terms that other Twitter users use in order to work within the platform's limitations. If you are going to use Twitter as a marketing tool, you'll need to get familiar with them. Twitter is meant to be more for conversations and may serve artists in certain disciplines better than others (writers, for example). As it is also far more link- and text-based than it is image-based, visual artists may find it most useful if they are trying to position them- selves to be thought leaders, or if they are trying to align themselves with particular current events or issues. Given the speed and activity level at which Twitter operates, if you're not going to be very active on it, then it's unlikely to be an effective marketing tool for you.

LinkedIn

LinkedIn is a professional networking platform with 467 million users.[21] Approximately 25 percent of US adults are on LinkedIn, of which 28 percent are men and 23 percent are women. LinkedIn is unique in the sense that its profile is "professional" rather than "social." Many people who are reluctant to join social media will nevertheless have a LinkedIn account. Once thought to be primarily geared for more traditional industries, LinkedIn has long since expanded into the creative, part-time, and contract-based fields.

The pros to LinkedIn include the ability to put your résumé online in a way that is highly functional and connected to many of your past work experiences. You can document your professional life and also

21 "Numbers of LinkedIn members 2009–2016," *statista*, accessed November 15, 2017, https://www.statista.com/statistics/274050/quarterly-numbers-of-linkedin-members/.

receive quotes and endorsements from past coworkers and collaborators. LinkedIn also steers job opportunities your way, as well as professional news about people in your network. It is also an excellent research tool when you are looking at potential employees and partners.

The cons are that the platform is really not social, and depending on the kind of work you do, you may find your audience more reluctant to engage with you as openly as they would on other social media platforms. And despite offering some interesting opportunities for artists to connect with people outside their day-to-day network (and to tap into alumni networks, for example), it is not commonly used by artists for getting artistic opportunities. From a marketing standpoint, LinkedIn is more useful for making connections with specific individuals.

YouTube

YouTube is the largest video uploading site in the world, with an average of 100 hours' worth of video uploaded every minute.[22] Sixty-three percent of Internet users use YouTube in one form or another. YouTube is strictly video-based, and its opportunities for interaction are fewer and less sophisticated than a site like Facebook.

On the "pro" side, YouTube offers users a chance to make money based on the number of views their videos generate. At the highest levels of viewership, these can be significant sums of money. And perhaps more significantly, users with very high viewership (sometimes dubbed "YouTube stars") can become celebrities in their own right and can parlay that success into success in other arenas, especially the arts. There are a number of stories about musicians in particular who have turned "viral hits" (i.e., videos that generate hundreds of thousands, if not millions, of views) into record contracts. It is linked to Google as well, so you use the same Google account for YouTube that you would for all other Google services.

22 "5 Facts about Online Video, for YouTube's 10th Birthday," *Pew Research Center* online, February 12, 2015, http://www.pewresearch.org/fact-tank/2015/02/12/5-facts-about-online -video-for-YouTubes-10th-birthday/.

The "con" side is that the site is very focused on video, making it challenging for artists whose work does not translate well into that particular medium. And much of the sharing of videos needs to take place off the site, as there are limited opportunities to do so effectively within the platform. And some people consider YouTube's link to Google to be a negative as well, as you may wish to maintain a different kind of profile on YouTube from the one in your personal email. There are ways to have separate identities, but it takes some extra work and research.

General Strategies for Social Media

The list of social media platforms above is by no means exhaustive. There are others that are extremely popular (Snapchat, Tumblr), and many more will no doubt be created and grow in popularity in the coming years. Below are a few evergreen social media principles.

Target influencers

Influencers are people with many followers on social media who are trusted sources for their audience base. These can be celebrities or simply people who have expertise in a particular topic and have amassed an online following. Getting an influencer, or several, to promote your work in some way can translate into increased ticket or other sales, a growth in your online audience, and other metrics that reflect positively on your online marketing. As influencers are individuals (and sometimes people who are busy, or strongly opinionated, or both), there is no surefire way to get them to notice what you do or support it in some way. However, by making an effort to share their content, comment on their posts, or otherwise support and engage them online, you increase your chances of being noticed and earning a reciprocal action. It is best to try to target those with whom you align or respect. Not only is that consistent with your branding and authenticity as an artist, but alignment also increases the likelihood that a particular influencer will follow you back, or share your work.

Share the content of others

No matter what social media platform you are working on, maintaining a regular and frequent presence is a key ingredient for staying relevant and using it effectively. However, creating content can take time and energy, which deters some artists from taking advantage of the tool. Fortunately, you don't always have to create content in order to make a post. It is an excellent strategy to share the content of others, whether experts, fellow artists, or influencers. Not only does this keep your audience engaged and viewing you as a knowledgeable gatekeeper of information, but it can earn you gratitude from the person whose content you shared—which could lead to them sharing your content in the future.

Focus on what you do well

There are many choices for social media platforms, and trying to maintain a presence on all of them can be very time- and energy-consuming. Pick a particular platform—preferably one that you know your target market utilizes frequently—and learn to use it well, maintaining a consistent voice and approach that fits with the platform (for example, focusing on image- or text-based content as appropriate). It is better to use one platform effectively than to spread yourself too thin, or posting the same content across multiple platforms, or posting sporadically on each.

Analytics and Timing

People who use social media effectively for marketing don't just post at random. In addition to creating a time line and schedule for a marketing campaign, the timing of the posts themselves is important, too! When is your audience most likely to be using social media? You want to time your posts for the maximum exposure. As this is an issue for everyone, not just artists, there has been considerable research on this, and you can find a number of good articles analyzing social media traffic patterns (as with many aspects of social media, this can change quickly, so prioritize articles that are the most up-to-date). For example, there is currently agreement that nighttime (between 8

p.m. and 8 a.m.) has the least amount of traffic for Facebook, and that for Twitter you are more likely to reach businesses during the week, and individuals during the weekend. Some studies go deeper into the data, indicating that the greatest amount of Twitter traffic is on Wednesdays at noon and again between 5 and 6 p.m.[23] Some studies even show that you are most likely to get Facebook "likes" around 3 p.m., and "shares" around 1 p.m.

All of these studies come with a cautionary note—they are extremely general. Your own audience may have entirely different usage patterns. Fortunately, there are relatively simple and inexpensive ways to track this. Facebook and Twitter each have very powerful and user-friendly analytics tools built in. Facebook Insights (only available for business pages) and Twitter Analytics can provide information about who is liking your posts, what kind of content they like, when they are doing so, and demographic and geographic information on those engaging with your content. There are free third-party applications that allow you to do similar analyses for other social media platforms. With this information you can then determine when the best times are to post specific kinds of content. Like all data, the larger your audience, the easier it is to draw solid conclusions, but you can identify broad patterns with even a small following. As a side note—these analytical tools can help give more insight into your audience generally, which can support the research you are doing to understand your audience (see "Understanding Your Audience," above). Finally, remember time zones! If your audience is distributed over multiple time zones (including those that do not observe daylight savings time), take that into account when posting so that your research doesn't go to waste. As we mentioned earlier, there are apps that can monitor and automate that for you, which might save you time and effort, and peace of mind.

23 Nathan Ellering, "What 23 Studies Say about the Best Times to Post on Social Media," *CoSchedule* (blog), updated April 4, 2018, https://coschedule.com/blog/best-times-to-post -on-social-media/.

Hashtags

Hashtags are "a word or phrase preceded by the symbol # that classifies or categorizes the accompanying text (such as a tweet)." Most everyone on social media is familiar with hashtags at a broad level, as they help to tie together conversations on the same topic that are being held by different users. One of the most useful tools on social media, at various times hashtags have helped to spawn major political movements. While they were once predominantly used on Twitter to engage in a discussion on a particular topic, the other major platforms (Facebook, Instagram, and sites like Tumblr) have incorporated them, as well. You can use hashtags to your advantage by directing your posts to the appropriate topic area. Using general tags will get you a broader audience, but more specific ones that target a niche audience may well produce a better response rate, as your post will be in a less crowded space and in front of those who are seeking more specific information. As some people might be concerned about the aesthetics of including a large number of hashtags in a post, one strategy is to use a minimal number in the original post, then comment on that post and include the additional hashtags you want.

If you want to insert your post into a conversation that is particularly active or trending, many of the social media platforms have ways to search for trending conversations by hashtag (where you can see how many people are talking about that topic at the moment). There are also third-party sites that track trending conversations across major social media platforms. However, you should investigate the conversation somewhat to ensure that your content matches the tag, and that what you are posting is indeed relevant to that conversation. As we discussed earlier about authenticity in branding, you want your audience—and any potential new audience members who come across what you do by virtue of your participation in a trending conversation—to have trust and confidence in what you put in front of them.

Other Tools (Digital and Nondigital)

Websites

A website is an integral part of an artist's marketing strategy. It serves as your online home, the space that you can craft completely around your project or practice. As important as social media is, a website anchors your online persona. It can be a central hub for news about your work, a place for fans to purchase works, a repository of biographical information, and a gallery space all in one. It allows you to tell your story however you see fit, and with whatever elements. Finally, from a business perspective it can increase the sense of confidence that your customers have in you—if you were researching a new restaurant or contractor, you might notice if they did not have at least a functional website.

There are three basic necessities for a website. These are a domain name, a place to host the site, and some way to build the site (sometimes known as a website creation tool). Oftentimes, these can be combined by signing up through a service that provides them as a package—at the very least, domain names and hosting are usually offered in tandem. One of the most common website creation tools is Wordpress, which also powers many blogs and is relatively easy to use if you have some experience working with websites and computers. However, for those who prefer ready-made templates, there are a number of services and providers (Wix, Weebly, Other People's Pixels, Squarespace, and a host of others that were valid at the time this book was written), with average monthly prices ranging from $25 to free.

Ultimately, you will want to weigh a number of factors before choosing whether to build a site yourself or go with a template package. While much of this will be a matter of personal preference and comfort with technology, there are a few factors to consider. First, to what degree can you customize your template? Can you make sufficient changes, or is there a template that approximates or matches what you want to make your website look like? Your site will be one of

the best representations of your art and business online, and with so many options on the marketplace, you shouldn't have to compromise on the look and feel of it.

Second, how easy is it to optimize it for web searches? When template-based web hosts initially became popular, some of them experienced problems with Search Engine Optimization (SEO), meaning that they either did not come up very high in search engine search results or sometimes did not even come up at all. This has been less of an issue in recent years, as most hosting platforms have worked hard to correct the problems, but it is still something to research before committing to any particular service. SEO is an important aspect of any website—other than word of mouth and social media, search engines (particularly Google) will drive the majority of your web traffic. Therefore, building your site with SEO in mind can be a good strategy. While strategies on this can change, some very basic rules include making sure that your Meta title and Meta description are clear and concise (these are part of the HTML in your site and can be added via most template services, as well) and describe what you do. Other factors can include "bounce rate," meaning how quickly viewers come to your site and leave, and whether your site is mobile-friendly. All of these will influence how early on your site appears in a search-engine search.

Third, you'll want to consider the analytics—how well can you track the traffic on your website? For most, that means using Google Analytics, which is a (mainly) free analytics tool that yields an amazing amount of data for marketing purposes. A short list of what you can track includes the number of people viewing your site, which pages they spent the most time on, whether they clicked on any links you had, geographical distribution, times that they accessed the site, and how they got there. This kind of data can give you a great sense of what kind of material your audience responds to, what they find interesting, where they are, and when they like to access the site, which in turn can allow you to customize the site for better results. Most platforms either work with Google Analytics or have some tool

of their own, but you will want to investigate what the options and costs are associated with it, as website analytics are invaluable tools for building a marketing campaign. Piwik is another strong option and is open source (and of course free).

What about the content itself? What should your website feature? As we mentioned earlier, this is really the space for you to reflect your work, personality, and "brand" as an artist. And this is an area in which artists have a natural advantage over many other businesses when creating a website—a gifted and refined sense of aesthetics. The positioning of images, the color scheme, the font selection, and the words themselves are there to have you advance your own story. However, there are still some basic elements that you will want to consider including.

The first is a home page, which sets the tone for the site, provides links to other relevant pages, and often has some kind of representation of your work and who you are. You should also include a "biography" page if you're an individual artist focusing on your practice, or an "about" page if the site is focusing on a specific project. This gives context and background that your audience could find relevant. Many individual artists also include Artist Statements (if they have one) as a separate page.

You will want to feature your work, so having some kind of "Gallery" section (or "Selected Works," or "Work Samples") is important. It's one of the best ways to feature what you do, and to control the way in which your audience experiences it! We will discuss submitting work samples for grant purposes in Chapter 16, and many of the same principles apply here. You will want to make sure that you've documented your work in a way that it deserves.

If your work is visual and being represented by photographs, make sure that it's well lit, provides the proper perspective, and is taken by the highest quality camera available. For video and sound artists, make sure that there are no glitches in either the audio or video. Most important, consider the audience's experience with it. How long does it take to load? Are you using files that are supported

by all browsers? How does it look or sound on a mobile device? If your audience can't view or hear your work with ease, then they won't be able to appreciate the rest of the experience you've curated for them. But beyond the basics of ensuring that your work is represented functionally and with good quality, you want to think about the order in which your works are presented, which pieces or artistic periods you want to see represented, and any other significant statements your work makes. As we mentioned earlier, your website is your opportunity to tell your story, and your art may be the most important part in that story.

If any of the work you create is for sale, your website can be one of the best places to sell it! If you think back to the Business Model Canvas's box on "channels," you can assess how significant a part of your business model web sales will be. Some artists prefer to route much of what they do through an ecommerce platform like Amazon, for example. There is a variety of tools available for setting up sales options on your website. A very simple way is to create an account with a service like PayPal, then create a link on your site so that your viewers can use a credit card to purchase whatever you choose to sell.

Many artists also choose to add a "news" section to their site. This can be a place for you to feature any press that you have received, and also to put updates and announcements about upcoming events, but do not include this section if you aren't able to update it regularly. And finally, don't forget to include some way for your audience to reach you! Some people will list a direct contact, such as a phone number, mailing address, or email address, although you can put an "info@___" address if you want to keep some information private. Another option is to create a contact form, where you request that interested viewers enter some basic information like their name and email, and then you will contact them. It really depends on what level of privacy and contact you wish to have with your audience.

Finally, we want to emphasize that, all of this theory notwithstanding, it's important to have a clean website with basic contact information and information about your work rather than focusing on extra features

depending on the time you have. Voltaire once said, "The perfect is the enemy of the good," and that certainly applies here. Your audience will want to see you online, so make sure there is at least something there for them to visit. We would also invite you to read an excellent article on NYFA's Business of Arts section, titled "The Business of Art: Creating an Artist Website, or, The Art of Storytelling," by Toccarra Thomas. It discusses the basics of artists' websites very comprehensively.[24]

Blogs

Blogs basically function as online journals, though they've come a long way since their beginning when that's primarily what they were used for. Now, blogs have much of the same functionality as websites do and serve as influential thought leaders on a variety of topics, from politics to local events to art. It's not uncommon for a blog to feature multiple writers and contributors. Blogs support virtually all of the same applications that websites do (and are often built with the same underlying web-design programs), provide easy interface with social media, and can be updated and customized easily. In fact, some large news and popular culture websites once began as blogs that simply grew in popularity and contributors. Blogs can also be built into an existing website.

While some people question the relevance of blogs, for many artists they can be a way to connect with their audience on a regular basis but that is not through one of the large social media platforms. They can allow for more depth, with an emphasis on longer form, narrative content. As you can customize the user experience, they can be more personal for viewers than a social media post, and they can focus on your work without other distractions. And you can easily share posts on social media, so both can be part of your social media strategy.

In general, you don't want blog posts to go too long, even if you have the flexibility to do so. Digital marketing experts recommend

24 Toccarra Thomas, "The Business of Art: Creating an Artist Website, or, The Art of Storytelling," *NYFA Current*, March 28, 2013, current.nyfa.org/post/67602044737/creating -an-artist-website.

around five hundred words at most. And one of the most important things to keep in mind with blogs is that they can be a lot of work, as in order to stay relevant, you need to keep publishing new content. Otherwise, there's not much reason to have a blog, as it won't regularly attract and retain viewers. This is one reason why many theme-oriented blogs find other contributors, so as to balance the workload in addition to bringing in a fresh voice and perspective.

Email Campaigns

When it comes to online marketing, email is social media's older, more serious sibling. While social media seem exciting, ever-changing, and attractive, email is often considered the more boring and business-oriented communication tool. While social media use is at an all-time high, it still doesn't beat the use of email. Apart from its widespread use, another reason for delving into email marketing is that it has consistently been shown to have higher conversion rates, as well.[25] What are conversion rates and why should they matter to you? They are what indicates how much of your online audience takes action when they see online content from you, like clicking on a hyperlink, buying artwork, or getting tickets to your show or event.

An active mailing list is crucial to your communication with your audience, both to transmit more information about your current projects and get your audience to actively participate in them. If you don't have a mailing list yet, this might be your time to set one up. If you already have one—congratulations! You're well under way to engaging with your fans and supporters.

Email marketing software use

There are many reasons for using email marketing software instead of sending out emails from your personal account (Gmail, Yahoo, Mac, etc.). Here are the main four outlined below:

25 For more details on a social media versus email comparison, go to: https://www.mail munch.co/blog/email-marketing-vs-social-media/.

1. Give your audience the *possibility to unsubscribe*. This might sound counterintuitive to wanting to grow your contact list, but any mass emails sent out that have some commercial aspect to it must comply with the CAN-SPAM Act. We won't bore you with the details, but your contacts should know how to opt out from future emails. You comply by using email marketing software because an "unsubscribe" link is always automatically included in every email you send.[26]

2. Don't fret now if you're afraid of losing all your contacts to the unsubscribe button. The many additional features that you gain from using an email marketing software heavily outweigh any potential unsubscribes. You'll be able to test email subject lines, segment your contacts into different groups, and still make every email blast feel personal. Think of it as your personal email account but on steroids.

3. Email software also enables you to send well-designed emails. Especially if your practice is very visual, the strategic placement of images in your emails is very important. It also enables you to hyperlink all your images (email best practice!), include fancy features such as buttons, or personalize greetings to include the recipient's name. While it's important to include images, ensure that the language is clear with or without the image, as many mobile users will not be able to download your images.

4. It enables you to view analytics of your audience's engagement with your sent emails. Even the most basic and free software will give you access to open rates and clicks—how many of your contacts opened your emails and/or clicked on any of the links that you included in the content. This will provide you with essential insight about what content has been popular with your audience and whether people have opened and seen your emails, e-newsletters, or invitations.

26 See "CAN-SPAM Act: A Compliance Guide for Business," at www.ftc.gov.

Some commonly used email marketing software providers are TinyLetter, MailChimp, and Constant Contact. In case you're starting out, here are some email marketing software providers that are perfect for artists (please note that subscriber numbers and pricing are based on November 2017 information):

TinyLetter

This is an entirely free software product and lets you upload up to five thousand subscribers (contacts). You have the possibility to do basic design on your emails and receive open rates and click rates for any sent emails. This is a great platform to start with.

MailChimp

This is more powerful software than TinyLetter, and you can have up to two thousand subscribers for free on your list. If you have more contacts, their plans start at $10 a month. MailChimp gives you many more possibilities to design your emails and work more efficiently with your mailing list, such as divide them up in segments (e.g., collectors, buyers, family). It also provides you with more detailed analytics.

Constant Contact

This is very similar to the two software products above but is not free with any amount of contacts. Plans start from $20 per month based on how many subscribers you have. You have very similar powerful design features and insight into email analytics.

Press Releases and Media Relations

The media (whether print, online, or broadcast) can be very beneficial for marketing your work if you can find a way to connect with them. Finding ways to connect begins with researching which media outlets would be a good fit for your work, and beyond that, whether there are specific writers or journalists who have covered work similar to yours, or who write about themes that your work addresses. Look at the outlet's

editorial priorities to determine whether there is a good fit, as well. Developing good relations with the media can take time, and you should approach it like any other kind of relationship-building. If you receive coverage, you should follow up to thank the writer or media outlet, and if they decline to cover you, you should still follow up with a thank-you—they might cover the next event, or at least be inclined to do so.

A press release is one of the traditional methods for individuals (or entities) to interact with the media. This is a communication (typically written) that is designed for members of the news media. The objective is to make known some development that the author believes is newsworthy. While press releases can follow numerous formats, remember that your "audience" is first and foremost the news media, so you will need to present enough information for them to evaluate whether the event is newsworthy for their publication, and do so in a direct and concise way. Most press releases follow this format:

1. In bold at the top left of the page, you will type either "FOR IMMEDIATE RELEASE" if you want the story to be heard as soon as possible or "HOLD FOR RELEASE UNTIL" followed by a date if you are not yet ready for the details to be known.
2. A headline (one that will catch the attention of the media person reading it).
3. City, State where the events take place, just like in a newspaper article, indented with the first paragraph.
4. Start with the classic *Who, What, When, Where,* and *Why* and—in a few short paragraphs—tell your story exactly as you'd like it to be heard by the people you'd like to hear it and consider the "inverted pyramid" style of writing with the most important information first.
5. A paragraph or two of what makes the event/person newsworthy along with a quote from someone familiar with the work/person, and who has something positive and interesting to say; ideally, this quote will come from either the leader of the company or organization who created the release, or if it

is created by an individual artist, perhaps a key partner on the project (a curator, producer, prominent artist, critic, etc.), which will lend greater credibility to the topic.

6. Centered at the bottom of this text are three pound symbols (###) to indicate the end of the release. If your release goes beyond one page (this should only happen rarely), indicate so by typing "more" between hyphens ("-more-") at the bottom of the page.

7. Boilerplate. For artists, this might be your biography, mission statement, or artist statement.

8. Addresses and contact information. Sometimes CONTACT: is at the top of the page under FOR IMMEDIATE RELEASE:

Additionally, you should include your logo, if you have one, at the top of the page. If you have no logo, create an attractive letterhead on which to print your release.

Once you are finished, you want to find out how the media outlet prefers to receive press releases. This can be found out with a simple phone call or by following a "Contact" link found at the bottom of most webpages. If your release is picked up by a media outlet, you have essentially received free advertising. However, media representatives who receive press releases deal with dozens, hundreds, or more of these submissions if they work at a major media outlet. Try to keep their perspective in mind as you write—they are looking for *news*, so think about why a particular event is of interest to the public. If your release is simply a biography and a link to your website, chances are it won't end up in the media. Reporters or editors who review press releases will look at the submission from the public's perspective, not your perspective. Avoid hyperbole or other language that unreasonably exaggerates your importance or that of your project or event. The best press releases communicate the writer's message while still reading like a standard news story, and the most successful outreach typically reflects research on the part of the writer to ensure the release is sent to the most relevant contact. Following is an example of a press release layout:

FOR IMMEDIATE RELEASE:
Contact:
Contact Person
Telephone Number
Email Address
Website Address

Headline

City, State, Date—Opening Paragraph with *Who*, *What*, *When*, *Where*, *Why*.

The following two or so paragraphs will explain what makes your event or work unique and why people should be listening. Always include the "obligatory quote." That is, a quote from someone who knows you, your work, or something about the event and has something interesting and positive to say about it.

For additional information, please contact (name, contact info).

Artist bio, short summary of artist's history, an interesting fact or two (i.e., your boilerplate).

#

Flyers and In-Person Mailings

Finally, some of the more traditional forms of communication and marketing can still be extremely effective. Individual mailings, due to the proliferation of email and social media and their price and efficiency advantages, are often not part of an artist's marketing strategy. And this makes sense in many cases, as it can take a lot of time to put together a mailing and can be fairly expensive depending on printing and postage costs. However, if you have a smaller event that is particularly important for you, or you are trying get a select few people to attend, a personal note or nicely designed invitation can stand out

and make a positive impression. This can be a strategic expense in your marketing budget. And creating flyers for your event, especially if it's a local event, can also help to catch passersby who might not have heard. Many arts centers, city institutions, and public shopping facilities like supermarkets have bulletin board space, so take advantage of that, as well as posting flyers at the venue where you will hold your show/exhibition/performance.

CREATING A MARKETING BUDGET

In both Chapters 6 (in the Finance section) and 16 (in the Fundraising section), we discuss the mechanics of building a budget. Here, the question is more about allocating resources. More often than not, the question artists raise is, how much should I spend on marketing?

The answer to that really depends on you, and on your goals and resources. We have placed an emphasis in this section on free tools. In fact, every major tool we've discussed thus far could be done for free and potentially reach an unlimited number of people, from websites to social media to emails. The only investment is in equipment like a computer and Internet access, or a mobile device, which presumably you might invest in for other, nonmarketing purposes.

However, there are times when investing in marketing would make sense, particularly when your goal is to reach a large number of people and "convert" them into customers. Think back to the section on the Business Model Canvas and Lean Startup, and you'll recall how at the execution stage the goal becomes scaling up the number of customers or users, and that companies often invest heavily in marketing during that stage. In general, any time we make an investment in a business, it is because we believe that we will ultimately realize some kind of gain on that investment. If not, we would put our money elsewhere.

So the simplest calculation would be to look at how much you could earn from an event, project, or release and know that your marketing budget shouldn't exceed that. (Minus any other expenses,

of course.) If you can earn $1,000 in ticket sales from a theater performance, then spending $1,200 would seem to be a poor choice.

However, it's not always that simple. Investing in marketing yourself (or your brand) as an artist can ultimately have huge financial benefits further down the road. Perhaps this show referenced above is particularly unique, or newsworthy, or significant for your career. It might be that making people aware of what you're doing and gaining audience members and ticket buyers for the future could lead to future shows, longer runs, more expensive tickets, or any number of other positive outcomes. There is still an element of risk there, as there's no guarantee that your campaign will have that effect, but it is another way to calculate the benefits.

Mostly this will come down to resources. Start-ups that are deep into the customer acquisition process are likely to have investment backing that allows for these kinds of marketing expenditures. Our suggestion would be to evaluate your marketing plan as a whole, looking at your goals, your place in the market, your audience, and your time line, and then evaluate whether you can achieve these with the tools and skills that you have available, and with your current resources. Keep in mind that your time is a valuable resource, as well. If the only way you can reach your audience is through devoting the majority of your time to your marketing, it might be time to either reevaluate your plan or bring on someone to assist.

One major category of expenditures that artists or arts businesses make in marketing is in consulting expertise, to teach them how to use a tool, build a website, or design a campaign or to actually run a campaign. This is often a time consideration, as a professional can do something in two hours that could take someone else two weeks. But it can also be a question of skill—there are talented marketing experts who are excellent at helping you think through your message and your communications, particularly if this isn't a strong suit for you.

Other expenses in addition to, or in tandem with, consultant fees are advertising expenses. These can include boosted posts on social

media, AdWords on Google, or direct advertisements on another media platform.

For advertising on other platforms, these can include anything from traditional media, such as television, radio, and print, to advertising on the blog that targets a population you're trying to reach. For most of us, national TV, print, and radio are not considerations, but don't ignore local versions of each, such as public access channels and community papers. These can sometimes have a loyal viewership in an area you really want to target. Even if you don't (or can't) place a direct ad on one of these smaller platforms, consider becoming a sponsor in some way. Sponsoring local events, particularly in a genre similar to yours, can get your name in front of an audience that has already demonstrated interest in work like yours (it also has the benefit of helping other artists and building your network and goodwill). As we discussed in the section on targeting your audience, you want to put your marketing materials wherever your audience is. Targeting the entire country only makes sense if that is your audience.

Pricing Your Art

Setting a price or rate for your work or services can be an extremely challenging task for any artist. As a starting point, there is a cost to making your work. This includes the materials used to produce it, the tools required, and your time. Depending on what you are making, this can be quite costly (perhaps you work with metals, require heavy machinery, use cutting-edge technology, or need training to acquire a new skill). You can calculate these direct costs and set a baseline goal for what you would like to recoup. However, there are many other factors that go into pricing your work beyond the cost of raw materials, or even the time that you put into producing or preparing your art. This is one area of the arts in which your medium can make a big difference, as there tend to be norms within specific disciplines and industries. Still, artists should remember that the value of their work will be a function of (1) the market for their medium/discipline, and (2) their specific position in that market. The information gathered during your market research will help you to understand both (see Chapter 11).

There are also good reasons for determining your pricing structure beyond just making a sale. Having well-thought-out prices for your work demonstrates professionalism. It shows potential buyers that you understand the market for your art and gives them confidence that they are making a sound investment. Let's take a brief look at pricing practices by discipline.

PRICING FOR VISUAL ARTISTS

While there are many considerations that go into pricing a work of visual art, you should be aware of one major pitfall—once you have established a price, lowering it does not reflect well on your success as an artist. Those people who have already purchased your work at the original price may feel like they made a poor decision, and if they purchased your work as an investment, lowering the price may affect their financial interests. Furthermore, lowering your prices may compromise relationships with galleries if gallery representation is part of your business strategy.

As a general rule, galleries do not lower the list price of a work, though they often give discounts. For that reason, you will want to ensure that any agreement you have with the gallery (consignment or other contract) explicitly spells out which side will be reducing their commission in the event of a discount. In general, discounts up to 10 percent are shared equally between both the artist and the gallery, and greater than 10 percent will come out of the gallery's commission, unless there has been an agreement to handle it differently. For these reasons, you should think carefully about pricing your work realistically from the outset.

Establishing Prices for New Work

If you are an emerging artist without a well-defined sales history, your pricing strategy begins by analyzing work that is similar to yours. While you obviously will not find a work that is an exact match, try to look at a work that is similar in size and uses similar materials. Galleries are usually more familiar than artists on current prices, so if there is a gallery that deals in work similar to yours, visit them often and try to establish a relationship, as they may be a great source of information. You may want to start by browsing art fairs. If the prices for works are not listed, they are available upon request. And there are a number of online platforms devoted to art sales, which can provide even more data for your research.

When you are comparing other works, make sure to account for relevant factors beyond size and materials. In particular, look at the résumé of the artist who created the work. Is the artist well known, and how long has she been selling work? What awards has she won, or in which residencies has she participated? Has she exhibited in other galleries or museums? Has she received media attention? It takes most artists time to develop an audience and market for their work, and established artists will be able to charge more than emerging artists even where the works are the same size and materials. You need to compare prices with someone at a similar point in her career.

If you have an established sales history, you likely have a pricing structure. However, if you take a new direction with your work—perhaps using different materials—you may have to set new prices as your audience adjusts to the change. The pace at which you raise your prices may be faster than with an emerging artist, because you have already built a following through your other work—one prominent New York gallery owner spoke to us about an established artist who embarked on a new line of work and was able to raise his prices over 50 percent in a year. That is extremely unusual, and raising one's work when the work is already selling, by 10 percent over a one- or two-year period, is more typical.

For artists who exhibit and sell work in multiple countries, there are some additional factors to consider. For example, if you are working with different galleries, it is good strategy to put them in touch so that they can coordinate and discuss any kinds of relationship they need to establish. Also, as much as possible you want the prices to remain the same in both markets. If you are not represented by a gallery and are selling your work on your own, you'll want to continue to try to keep the prices for your work consistent. Especially in a time when so much information is so easily accessible, there is really no way to price your work differently in different markets without people becoming aware of that. However, as we will discuss in a moment, there are other options to sell less expensive pieces to different market segments. Finally, for your own calculations, remember that there

may be differences in currency exchange as well as import/export duties, sales taxes, and shipping, all of which will factor into your profit margin.

Other Pricing Considerations: Galleries and Series

Many visual artists opt to sell their work through galleries. This has a number of advantages, as the gallery will promote your work to their own clients, and the association can add some prestige to your career, much as signing with a record label does for a musician, or publishing a manuscript through a publishing house does for a writer. The trade-off is that the gallery needs to take a percentage of the sale—it is a business as well—and the industry standard is 50 percent, unless the work is a commissioned work, in which case artists often get 60 percent. Not-for-profit galleries tend to take smaller percentages, usually between 10 percent and 30 percent.

Furthermore, as previously discussed, galleries frequently agree to discounts for regular customers (10 percent is common), and museums may get as much as a 40 percent discount. As an artist, you should not be discouraged by your work selling at a discount—while you may make less on the sale, it means that someone has responded to your work and you are developing a market. And if that buyer is a significant collector, that will only enhance your status and exposure.

Another consideration is whether the work is a single work or one in an edition. The price of a print or photography in an edition of ten will generally be lower than that of a unique piece by the same artist. Also, if the edition size is larger, say twenty-five pieces, each print should be priced at a lower rate than if you printed only five pieces. The price of a work at the beginning of an edition will start lower and go up toward the end of the edition. This is partly a function of supply and demand, and partly a way to reward the first buyer for taking a chance on the work before its value has been "established." Furthermore, as potential buyers see the price rise as the edition sells out, the rising price may be an incentive to buy. As a reminder, set an edition number for photographs and prints or other editioned works—many

emerging artists don't think to do this, but it is an important factor to collectors and dealers. Some artists keep a print or two from each edition as an investment, assuming the price will go up. It's also a way of keeping some level of control of your work, as you will have a piece to use in the future for participating in a show, donating it to an important auction, or leaving it as part of your estate (this approach can apply to other media, as well).

Some Final Thoughts on Pricing for Visual Artists

Unfortunately, there is no simple formula that visual artists can use for pricing their works. Like many other aspects of being an artist in business, you will have to rely on your own creativity and diligence to find how similar works are priced. By understanding how the larger market is influenced by the interests of collectors and galleries, you can avoid mistakes like overpricing or underpricing your work that may harm your future sales. Finally, determining your prices can be a good opportunity to step back and reflect on your artistic career and ask realistic questions about the value of your work today.

PRICING FOR PERFORMING ARTISTS

Performing artists typically need to set prices for several different categories: physical products like CDs or films, large-scale productions like concerts and plays, and individual services such as serving as an ensemble member.

Performers tend to have an easier time than visual artists when it comes to setting prices. For starters, there is little risk of devaluing your work long term if you reduce your prices. Your audience is buying access to you for a few hours, or they are buying some manifestation of your intellectual property—a CD, DVD, or other recording of your film, music, or dance. Recordings are usually not intended for long-term use and do not appreciate in value unless they are antiques. The monetary value of a live performance ends with the performance. Furthermore, the market for recordings, films, or similar products

is pretty well established, in part because these products lend themselves easily to widespread distribution. Let's briefly examine each:

Products

When we discuss products created by performing artists, we refer to the physical means by which their art is distributed, not the underlying work or intellectual property. For a musician this could be a digital download or a CD, for a filmmaker a DVD or digital file, and for a dance or theater company some combination of the three.

Because the technology and materials involved are so inexpensive and so easy to reproduce, the market for these products is pretty well established. Furthermore, because these are designed to be sold in bulk, you are not trying to recoup your costs on any one individual sale. Most single CDs and DVDs sell for between $10 and $25, with direct digital downloads priced a few dollars less depending on the context (for example, a new release, a single song, or a compilation of sorts). Artists selling albums on iTunes, for example, will usually do so for around $9.99 (in 2017). And some artists create special packages with additional footage or multiple recordings, but the prices for those tend to go up proportionally with the amount of material included. As we will discuss in Chapter 15 on Crowdfunding, products like CDs, downloads, and DVDs can be part of a reward or "perk" system in a crowdfunding campaign, in which case the price structure could change depending on the specifics of that campaign, for example charging more to be given a production credit, or virtually given away as part of a larger package.

Where you should price your product within that range depends on your market and also on your sales philosophy. Some independent artists prefer to think of themselves as specialty items and thus price their work at the higher end of the spectrum. Their reasoning is that anyone who wants to purchase their work is not an impulse buyer, but rather a genuine fan who is willing to pay more for that particular work. Others, especially those who are seeking to build a following, will price their works more competitively to appeal to casual fans.

Productions

Productions can refer to a very wide range of activities for performing artists, but we use it for the "signature" performances in each performing discipline. For film, it would be the film itself, in theater a play or musical or other dramatic work, in dance a piece of choreography, and in music a concert (and there are many equivalent works in other disciplines, such as an opera, a reading, or a puppet show).

Pricing productions falls into two categories, the price an artist charges individual audience members, or ticket prices, and the price an artist charges the performance venue. Ticket prices vary by medium, but most general admission performances tend to range from $5 to $50 for independent or self-producing artists. Larger productions at well-known venues and featuring stars frequently charge more than $50, but these decisions are usually made by the venue itself rather than the artist.

When you sell your production to a particular venue, the price depends heavily on your individual market power, and on what kind of "draw," or audience support, the venue believes that you will generate. A live music venue might pay an established artist $2,500 for a Saturday-night show, but pay an emerging artist 50 percent of ticket sales for a Tuesday night—and that only after the first twenty tickets are sold. Certain disciplines have more established arrangements. For example, repertory theaters that show independent films will customarily offer the filmmaker $250 or 35 percent of the door. But the general rule is that the individual venue sets the parameters of the deal regardless of your discipline, and until you can demonstrate that you can bring in paying fans, you may have limited ability to negotiate.

Services

Many performing artists earn a living by performing complicated or specialized actions rather than creating new works. An opera singer, dancer, actor, or violinist would fit into that category (although they might be producing their own original works separately). These

artists typically earn money from their art by being paid to perform in productions.

Like productions, the pricing structure for performers varies greatly depending on their position in the market. If you are well known in your field, or you have an uncommon skill—perhaps you play an uncommon instrument or can mimic certain speech patterns—you can command a higher price. Ultimately, some fields offer stars the chance to make thousands of dollars for a single performance. Unionization has played a role in establishing more uniformity in pricing. Actors in particular have a strong union, so those actors who work on major shows and films can expect to be paid according to union rates (most of which are available online). In general, the larger and more commercial the production, the greater the chance that the performers from all disciplines will be compensated according to a union contract.

Many emerging performing artists will perform for little or no compensation just to get experience, making it difficult to determine a standard price for small productions and freelance work. Performers should speak to their peers to see what the community standard is for these smaller markets in their discipline. Our advice is to refer back to your market research and set a price for your time and services that reflects what your market will support. If you want to donate or barter your skills you can do so, but it is important to establish a value for your work. And unlike the visual arts, you have much more flexibility to adjust your prices if you initially misjudge the market.

PRICING FOR LITERARY ARTISTS

Literary artists either sell their products for mass consumption, or they sell their underlying work to a producer or publisher to turn into a book or production (an example of the latter would be when a playwright or screenwriter sells her scripts to a theater or film producer).

If you decide to self-publish, and that is an increasingly common route to take, you will have to set a price for your book. Just as

performing artists have limited flexibility in pricing CDs and DVDs due to the market for these products, literary artists face similar restrictions. While prices can vary according to the subcategory of the literary work, most have fairly well-established market values.

Some of the relevant subcategories include whether the book is fiction or nonfiction, for children or adults, hardcover or paperback, and if it is a textbook. Hardcover textbooks tend to command the highest prices, sometimes exceeding $100, whereas paperback romance novels can be priced as low as a few dollars. If you are selling your self-published book, it is unlikely that you will be doing so for more than $30 unless you are packaging it with another product.

If you sell your work to a publisher or producer, you have a different set of concerns. There are many excellent resources that discuss the process of getting a book deal, and we will not cover this process other than to note some basic elements. Many authors get a literary agent to represent them and handle the "selling" to the publishing company. The most important pricing issues that arise in publishing deals are the author's advance and the royalties. Royalties simply refer to the percentage of each sale that you will receive.

The same categories mentioned above (fiction versus nonfiction, children versus adults, and particular genres like history or mystery) may influence the type of deal offered to you. Many emerging authors do not receive any kind of advance, but if they do they are likely looking at advances of around $10,000—which may later be recouped from royalties—and royalties of between 5 percent to 10 percent for paperbacks and 10 percent to 15 percent for hardcover. Royalties for ebooks are often higher than royalties on traditional books, but the sales prices are often lower, so the author may not actually make more money per sale.

The size of an advance and royalty percentages are related, not surprisingly, to the author's market power. Publishers ultimately need to sell books, and if an author has an established track record and readership, or if the author is a celebrity or someone with unique

insight on an important topic, the publisher will be willing to invest more in that author's story.

For screenwriters and playwrights, especially at the level of independent films and shows, prices can vary widely. Often the producers are fellow artists with a very small budget, and the literary artist will enter into a partnership where she contributes the script and receives a percentage of the production's earnings.

Some Final Thoughts on Pricing in the Performing and Literary Arts

The common theme for setting prices in the performing and literary art worlds is market research and market power. If you are an artist in any of these fields and you are seeking to price your work for consumers, you will be working in a limited price range. Money is earned through selling in volume rather than selling several high-priced works, and you need to know what your target audience is prepared to pay. If you are selling your work services to a third-party producer, such as a concert venue, publisher, or movie studio, you may have the opportunity to earn significantly more on the initial sale. Still, this depends on your individual strength in the market and whether the producer believes your work or performance will attract a large audience.

Figure 17. JunYi Chow (Immigrant Artist Mentoring Program Alum), Rehearsal at *Stillness in Queens* Production, Flushing Town Hall, Queens, September 2017. Photo by Chang Yu Chuan.

SECTION V FUNDRAISING

Introduction

In this section of *The Profitable Artist*, we will focus on strategies and tactics that you can use to obtain resources for your project or practice. We will look at other artists who have successfully raised money for their projects, examine the perspectives of various kinds of funders, define some commonly used terms, and explore some useful tools.

Figure 18. Jonathan Ehrenberg (Artist as Entrepreneur Boot Camp Participant), *Ersatz 7*, dye sublimation print, detail (17 x 25 inches without the sculpted mount), 2016.

Before we do, however, we would like to invite you to pause for a moment, take a step back, and think about your project or practice as a whole (the work that you did in Chapter 1, with "environmental scanning," should help you here). How many relationships are associated with or connected to it or to you? Perhaps these relationships are very significant, such as a direct partner or an employee. But it could also include audience members, patrons, landlords, vendors, family members, mentors, students, and many, many more.

Which of these people might help you? Why would they, and how would they do so? Similarly, we would also ask you to think about all of the resources that are associated with your project. Many of these resources and relationships can ultimately be used in your fundraising efforts and lay the groundwork for sustained and continuing support in the future.

The Fundraising Landscape and Terminology

What is your fundraising landscape? In other words, what are the range of options that you have available to help fund your project? What specific combinations are best for you and your project, and what relationships and connections do you have—or could you establish—that can help you access the resources you need?

Every artist will have a fundraising landscape that is entirely unique to them, a mix of artistic discipline, personality, geography, and personal history. These strategies are:

> **Individual Giving**—This includes money that is raised through individual donors whom you know and/or cultivate and sometimes includes a tax benefit for the donor depending on your 501(c)(3) or fiscally sponsored status.

> **Crowdfunding**—This includes money raised through crowdfunding platforms like Kickstarter and Indiegogo and depends on the marketing skills and the reach of your network, as much as fundraising skills.

> **Special Events**—These include fundraising galas, benefits, or other special events put on for the purpose of raising money, either by charging for admission or by making pitches to those in attendance.

Corporate Sponsorship—This includes getting companies to financially support your project in exchange for promotional consideration or public acknowledgement.

Grant Making—This can include government funding, or funding through public and private foundations.

Earned Income—This includes money that is earned through sales, such as the sale of your artwork or the rental of your facility or your services. While this is not necessarily fundraising in the traditional sense, we include this here as a reminder that earned income can be used to support your projects and practice.

We will examine each of these strategies in detail in this chapter/ section. In many ways, an artist's fundraising landscape is as varied and individualized as their art. The strategies above can serve as the basis, or building blocks, of one's fundraising landscape. But we want to encourage you to think broadly and creatively about how to apply each to your practice, to build out your own funding landscape. The strategies are multifaceted, and the various strategies play off one another. Obtaining a small seed grant can lead to getting bigger grants, either for that specific project or for your career as a whole. Generating earned income through selling tickets to an event can reduce the amount of money that you need to raise through grants. But diversifying your funding streams like that can also lead to interlinked strategies—patrons to a ticketed event can be cultivated for individual donations at a later date, and a strong crowdfunding campaign with a broad range of support from different communities might help demonstrate impact and likelihood of success to an institutional funder. Being aware of all potential strategies and relationships, while remaining open-minded and creative, will help you develop your own, very effective, fundraising landscape.

SOME FURTHER DEFINITIONS

Before we go any further, let's take a moment to define some of the terms we'll be using throughout this section of the book. And a disclaimer as well—while these definitions are used by NYFA and many other funding organizations, you will likely encounter some funders who use different terminology (for example, some funders use "grant," "award," "support," and "fellowship" interchangeably). As always, you should check to see how the funder in question uses these terms, and adjust accordingly.

Project and Practice

Your "practice" refers to your entire career as an artist. It encompasses every aspect of your artistic life (including study and experimentation) and is constantly evolving. It has no fixed end date, though it may have different phases and periods. A "project" is a smaller, distinct piece of your practice. It is usually limited by time and has a definable or measurable outcome. Your artistic practice might be that of a filmmaker, and your project is a single documentary film. Or you may have a practice as a composer, but composing a series of works on a specific theme is your project.

Defining a project is a useful tool in fundraising and is the focus of this section. Most grants that are available to individual artists fund specific projects rather than their entire practice. And on a strategic level, it is often easier to rally support for initiatives like a crowdfunding campaign on behalf of a specific project.

Fellowship

A fellowship is generally some kind of benefit or honor conferred on an artist by an organization for a fixed period of time (a year is fairly common). This is frequently accompanied by some kind of financial benefit, either a cash gift or a set of services with a cash value, or both. It can also include access to facilities, and promotional considerations. Fellowships are given by a variety of different kinds of institutions, from 501(c)(3) nonprofit organizations, to universities,

to government institutions, and even research facilities. Fellowships may or may not require some kind of action on the part of the recipient, such as public presentations, teaching, or being accessible to the public at certain times. Fellowships often, though not always, support an artist's practice rather than a specific project.

Award

An award is usually a cash prize for which an artist applies and is usually based on a specific piece of work, or a body of work. There are usually no restrictions placed on how the funds can be spent.

Residency

A residency is typically when an organization grants an artist access to and dedicated time in the residency's facilities. Residencies tend to focus on the creation of work, and giving artists the time and space to create. They often include some kind of commitment to engage with the community (for example, conducting art education, service in schools, or holding open studios). In this way it can also be a great way to build community in service of your own goals professionally or for a specific project. Some residencies are residential, providing room and board for the artist, whereas others provide studio space. Times can vary from a week intensive where the artist spends all of their time working, to a year or more where the artist has access to space on a weekly basis. Some residencies charge to participate, and in any case a residency requires an investment of your time, so research first to make sure that residency is a good fit.

Grant

We use the term "grant" and "project grant" interchangeably in this book. A grant is typically a sum of money given by an institution, usually a foundation or government entity, to fund a specific activity or project. Grants are awarded following an application process, and the funds are considered "restricted" to the uses specified in the initial application, or agreed to in a contract signed by the funder and

grantee. The grantee usually has a limited period of time in which to complete the project, and the grant money is sometimes given in phases and conditioned on the successful completion of a prior phase. Most grants are given to achieve a purpose that advances the mission of the funder, and for the benefit of some population or geographic region that is encompassed by that mission. Grantees usually need to submit a written report at the end of the grant period.

Fiscal Sponsorship

Fiscal sponsorship is a tool that increases the fundraising opportunities for individual artists and emerging arts organizations by raising the number of grants to which they can apply and offering additional incentives to individual donors. Fiscal sponsorship is essentially a relationship between a 501(c)(3) not-for-profit organization ("the sponsor") and an artist or emerging organization ("the sponsored artist"), whereby the sponsor lends some of the benefits of its nonprofit status to the sponsored artist. Specifically, the sponsored artist can now apply for grants under the sponsor's nonprofit status. Furthermore, individual donors can give money to a fiscally sponsored artist's project and receive a tax benefit (at least so long as they would ordinarily otherwise qualify for a deduction).

How does this work, exactly? If you'll recall from our discussion of not-for-profit organizations in Chapter 5, these organizations can qualify for federal tax-exempt status, which means, among other things, that in certain circumstances individuals can receive tax deductions for making contributions to them. By entering into a fiscal sponsorship relationship, the sponsor agrees to receive contributions on behalf of the artist's project—usually less some percentage as a service fee—and the donor can receive a tax benefit just as if they had donated to the nonprofit sponsor. On the grant side of the equation, many foundations and government agencies will not make grants to individuals for policy reasons or other internal restrictions. When an artist applies through a fiscal sponsor, the funder can instead make the grant payment to the sponsor. This allows the funder to support

a project that the funder considers important while still adhering to its own policies.

Fiscal sponsorship is not appropriate for every project. While it is ultimately up to the sponsor whether or not to take on a particular artist's project, most fiscally sponsored projects have a "public benefit" component. This is because the sponsoring organization needs to ensure that it does not put its own 501(c)(3) status at risk and will want to ensure that each sponsored project is consistent with its mission, which will have a public service component of some kind. Artists can satisfy this in a number of ways—public lectures, exhibitions, screenings, or giving some kind of opportunity to an under-represented group. There is no fixed rule, and each fiscal sponsor will have its own screening process to determine whether a project is a good fit. But as a general rule, if a project's only purpose is to benefit the artist themselves, it is not a good candidate for fiscal sponsorship.

Thinking of starting your own nonprofit?

Another common use of fiscal sponsorship is when a not-for-profit organization has been approved at the state level (meaning that the state has determined that the organization has a charitable purpose) but has not yet received 501(c)(3) status. This is sometimes referred to as an "emerging organization," where the organization is acting as a nonprofit but is not yet tax-exempt at the federal level. As the process for 501(c)(3) approval can sometimes take a while to complete, and because it requires effort and expense to run a 501(c)(3) organization properly, some smaller organizations opt to find a fiscal sponsor while they await approval, or because they would rather spend their time and effort on executing their mission, as opposed to maintaining the requirements of a 501(c)(3). And of course, you will want to consult with the program officer(s) at a particular fiscal sponsor to get specifics on what that sponsor is looking for.

What should you consider when choosing a fiscal sponsor?

Choosing the right fiscal sponsor is something you should do carefully. Here are a few things to consider and evaluate:

Fees and Benefits—What percentage of the funds you raise does the fiscal sponsor take? Typically, fiscal sponsors charge between 6 percent and 10 percent, which helps to offset the administrative expense of sponsorship. A higher fee may mean that the sponsor provides more services, such as accounting or reviews of your grant applications, or other kinds of guidance and coaching. Conversely, make sure to check whether the sponsor has any "hidden" fees, such as a membership fee, or charging for application reviews, or even charging for an artist to apply for sponsorship.

Contract (and Intellectual Property)—All reputable fiscal sponsors will require that you sign a contract detailing the sponsorship arrangement, and most will have a generic one already developed. There are many important details there, and as we discussed in Chapter 4 on contracts, you should talk to a lawyer if you have questions. Pay particular attention to your intellectual property, to make sure that the sponsor does not somehow acquire any rights to it. Also look at any provisions around the use of each party's name and/or logo, and any other obligations that the sponsor asks of you.

Infrastructure—Does the sponsor have the infrastructure and capacity to run a fiscal sponsorship program and provide you with the service you need? Do they have enough staff and the requisite expertise to track and manage your funds safely, and to give you access to your money quickly? Technology may also be a factor in your decision. Does the

sponsor give you the ability to raise money online, either through its own platform or through a partnership with another platform? How many other artists do they sponsor— is this a regular part of their activities or just done on an ad hoc basis? Is there a track record of sponsoring artists?

Alignment—Do your own values and mission align with those of the sponsoring organization? Do they work with artists from your discipline, and do they work with a similar population to your audience? Perhaps more important, does the organization support programming that you support, and does it otherwise act in a way that makes you feel comfortable about being associated with it?

NYFA Fiscal Sponsorship

NYFA has one of the oldest artist sponsorship programs in the country. Over the past several decades, we have helped artists to raise over $30 million in funding. However, NYFA's Fiscal Sponsorship is more than a vehicle for artists to raise money—it is a partnership, and designed to ensure that we are actively helping artists regardless of whether or not they raise money. Every artist that engages with our Fiscal Sponsorship Team gets something from their interaction. We include free consultation services for each artist in the sponsorship program, and we review and give feedback to all grant applications that are submitted through NYFA. NYFA also provides considerable back-end financial assistance, including handling 1099s and other-wise accounting for independent contractors associated with your project who are paid by funds raised through NYFA. Our 8 percent administrative fee covers all services associated with our program, which means there are no hidden fees (for example, charging for application reviews or meetings).

In addition, all artists and emerging organizations sponsored by NYFA receive a custom profile of their organization or project on NYFA's website, which is a virtual hub for artistic opportunities

locally, nationally, and internationally. Through the custom profile, sponsored artists can collect tax-deductible donations online, as well. Finally, members of NYFA's Fiscal Sponsorship program receive access to NYFA's wide range of services and resources (often at a discounted rate), including programs, lectures, and educational tools geared toward—and exclusively available to—our sponsorship program. If you are considering fiscal sponsorship and think that your project or organization would be a good candidate for NYFA's program, we encourage you to reach out to us at sponsorship@nyfa.org.

Figure 19. Svea Schneider (NYFA Fiscally Sponsored Artist, Immigrant Artist Alum and Artist as Entrepreneur Boot Camp Participant), Melissa Riker/Kinesis Project Dance Theatre Performing at INSITU Site-Specific Dance Festival 2017. Photo by Javier Gamboa.

Individual Giving, Crowdfunding, and Corporate Sponsorship

Individual giving and crowdfunding are two broad categories of funding strategies that can be an important part of an artist's "fundraising landscape." Individual giving is simply the process of asking individual people to support your project financially, either with cash or through an in-kind donation, as opposed to asking an institution through a formal application (which we will discuss later in this section, under "grants"). When we use the term individual giving, we are primarily referring to cultivating and making individualized requests to donors, whereas when we use the term "crowdfunding," we're referring to a very specific type of fundraising campaign that centers around an online event that engages many people at once, often relying heavily on social media and the energy of a "crowd." Some of the advantages of these fundraising strategies are that there are usually no set limits to the amount one can raise, fewer restrictions on the way one can use the money, and the artist can set a time line for raising this money in a way that suits their project or practice.

We acknowledge that asking people for money can be very difficult, and even knowing where to start may be equally challenging. Our philosophy is that the process of cultivating individual donors is actually the process of cultivating ongoing relationships—most donors will be people from your own network.

A NOTE ON NETWORKS

Because so much fundraising depends on an artist's ability to connect with their own network, we want to explore the terms "network" and "networking." "Networking" can have negative connotations for some artists. It might bring to mind images of Rolodexes, or of disingenuous conversations while "shmoozing" people at cocktail parties. For many, particularly those who are more introverted, this feels like an impossible task. Fortunately, building your network doesn't have to involve any of this. In fact, building your network should be both organic and enjoyable, because your network is your community.

You might be surprised as to how large and extensive your network already is. Try an exercise of making a list of every organization with which you have a relationship. What schools have you attended? High school, colleges, trade schools, art schools where you've taken extension courses—you are an alum of each. Social media tools like Facebook and LinkedIn have made it very easy to find past academic connections, as well as former classmates. Companies and institutions where you have worked, stores where you've been a regular customer, religious institutions, or community organizations all could be part of your network, as could institutions with which you have had limited contact but where a good friend or supporter works in an influential position. Your list could be quite long.

Next, think about the quality of each relationship in the sense of how easy it would be to connect with these institutions (if you are not already actively connected to them). Do they have an office that actively tries to remain in contact with people, like an alumni office that holds events and reunions? Is there some kind of online community in place, like a Facebook group or message board, or even a hashtag? Are there people still working in these institutions with whom you are on good terms? Are they decision makers?

Try the same exercise with your artistic connections (obviously there may be some significant overlap here). These relationships could very well include a significant number of individuals rather

than institutions. Write down all of the collaborators with whom you've worked, as well as fellow artists in your discipline (or other disciplines) with whom you are friendly. Include students, teachers, customers, contributors, and fans (if you already have a mailing list of people who have attended your shows, readings, or performances, that is a good start). You may also want to include gallery owners, residency coordinators, promoters, booking agents, curators, or anyone who has previously selected you to be part of an artistic project. And if you have hired independent contractors—art movers, sound and lighting design teams, set designers, other assistants—put them down as well. Collectively, these people represent your artistic network.

As you did with your institutional connections, assess the quality of your artistic network. How strong are the relationships you've identified? Do your acquaintances know as much about you as you do about them? After you've gone through these various exercises, you should have a much better sense of the size and scope of your existing network, its relative strength, and even areas where it overlaps and intersects.

Let's return to the earlier question of networking, or more accurately, how you can expand and strengthen your existing network. One advantage that artists have is the large number of organizations and institutions that exist to support the arts. These range from government agencies like state and local arts councils, to large international artist service organizations like NYFA, to local galleries and theaters. There are also likely to be discipline-specific organizations near you, or at least that are accessible online. These organizations offer genuinely useful tools, resources, and information and can serve as hubs for like-minded artists. Get involved with them! Attend the classes, shows, openings, screenings, and other events that they offer, particularly if they are featuring work by artists in your community (geographical or artistic). You should also look to local community-based organizations that sometimes have an arts component, either as full-time programs or one-off events.

To build and strengthen your network, make a real effort to become a meaningful and supportive part of these communities. You don't need to be the life of the party, but you need to invest the time to show up to events, to support other artists and organizations. Networking for fundraising purposes is something that happens constantly. Volunteer, contribute to another artist's or organization's fundraising campaign, and let people from your community get to know you from your actions. If the local library offers an open night for readings, for example, go there and read (if that is relevant to your practice). Not only does it give you valuable presentation practice, but it lets you share your work with others while being an audience for them as well, and it supports the administrators who organized the event. An experienced fundraiser has said that "the person answering the phone is sitting a few feet away from the person who is the decision maker, and may *be* the decision maker in five years." Every interaction is valuable, as it may well help to create or cement a connection that will be meaningful in a few years.

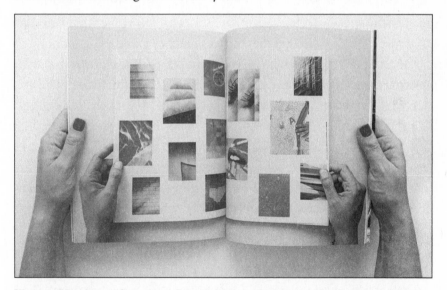

Figure 20. Marco Scozzaro (Immigrant Artist Mentoring Program Alum and NYSCA/NYFA Artist as Entrepreneur Boot Camp Participant), *Sviaggioni* (Part of the Digital Deli project), Pigment Print Mounted to Fluorescent Acrylic, 27 x 40 inches, 2016.

ENGAGING YOUR NETWORK FOR INDIVIDUAL GIVING

Understanding the full reach and extent of your network is an important step, as is beginning (or continuing) the work of expanding it. It will require constant effort to keep it refreshed. But to utilize your network for fundraising purposes, you'll have to convert the individuals within it into actual donors.

A good first step is to start researching your network to understand it better from a fundraising standpoint. Look at other artists in your network, particularly those with whom you share some similarities like discipline, style, subject matter, or geography. What are they doing to raise money for their projects? Are they running crowdfunding campaigns, soliciting donations in other ways online, or holding events? If they are holding fundraisers or other events, try to attend. Not only are you supporting someone who might support you in turn, but you can see who supports them and learn what works and what doesn't. We are not at all suggesting that you should attempt to "poach" the contacts of your fellow artists, but rather that you start to understand how people in your network give and raise money.

Social media can also be an excellent research tool. If your artistic peers are engaged in some kind of online fundraising campaign, you can likely see who has donated to them and for how much. You can also observe the kinds of communications that surround such a campaign and look at what attracts the most positive feedback. Platforms like Facebook often show what events people in your wider network are attending, as well as their likes and dislikes. Other social media platforms offer different kinds of information, all of which can help you to piece together a more detailed understanding of your network. Some artists use social media as a more direct research tool, seeking advice from their various online networks as to how they should raise money for a particular project. These kinds of "passive" posts sometimes lead to direct support but also help you to get new perspectives along with putting your network on notice that you are looking for support.

We refer to this kind of investigation into individual donors as "donor research," or the process of identifying possible donors. Once you have identified a specific donor, you may want to investigate that person more thoroughly. What is their capacity to give? Have they contributed to other artists or art-related causes in the past? If so, do you know how much they have given? Is there any other relevant information related to their ability to give money (have they recently sold a house, filed for bankruptcy, retired, celebrated a major life event, etc.)?

It's important to set realistic fundraising goals when you begin to reach out to your network. In general, people want to feel like their contributions can actually make a difference. If a donor's giving capacity is in the $25 to $100 range, they may be discouraged if you ask for a donation to a $200,000 capital campaign, as they may feel that their $25 check won't be very helpful. However, asking the same donor to contribute to a campaign that seeks to raise $1,500 or $2,000 could spark a very different reaction. No matter how extensive and active your network is, the majority of your donors will be small donors contributing less than $100, so be strategic with how and what you ask from them. Getting fifty people in that range to donate to you can go a long way!

The act of asking people for money may seem stressful to some artists. This is one reason why online campaigns (including crowd-funding, which we will address later in this section), are appealing. It adds a layer of separation between you and the donor, and some people find it easier to ask a large group rather than one person at a time. Asking an individual for a donation directly can be challenging, and there is no one right way of doing it. One useful reference point might be to look at the approach taken by nonprofit development experts, as much of their job involves cultivating individual donors, especially large donors. In that situation, donor research is a key first step. Before you invest the time and effort to solicit contributions from a donor, you want to make sure that they have both the capacity and inclination to give. Once you've determined that this donor is a

good fit, a common technique is to invite them to coffee or lunch, and to ask them there. Here are a few key points to keep in mind:

1. **Your "ask" should not be a total surprise to them.** You don't want them to think that you are inviting them just to hang out. Let them know that there is a purpose to this meeting. "I would like to invite you to coffee to discuss how to further my career and/or my work," or "You have been such a valued supporter in the past, I would like to take you to lunch to thank you and to discuss some new projects." This is easier in the institutional rather than individual context, as representatives of foundations or funding bodies know why you are contacting them and what you want, whereas the line can be blurrier with individuals. However, as we discussed in Chapter 11 on Marketing, if you have implemented a marketing strategy to promote your project, there's a chance that this person is already aware of what you're working on.

2. **Make it about *them*!** While you are asking the donor for money to support your project, you want the focus to remain on the donor. The research you have done will be very valuable here—think about why they would want to support you. Does it have to do with their love of a particular form of art? Perhaps their mother was a former opera singer, and you are asking them to contribute to a new production of one of her signature roles. Or does it draw attention to a particular cause or social issue, for example a documentary film on pollution in the donor's hometown? You want to make them feel connected to your project, and to feel that by supporting you they are advancing their own interests.

3. **Make the ask.** You've done the hard work of cultivation and research, and have persuaded the person to come to a meeting. Ask for what you need, even if you feel uncomfortable doing so. If the donor has the ability and inclination to donate $1,000, don't ask for $200. You'll have missed out on a valuable

opportunity. Let them offer less if they wish to, or even say no—as long as you are genuine and respectful while making a logical, well-reasoned request, you're unlikely to offend. This is also a situation where having a fiscal sponsor can help, as the donor may expect a tax write-off for any contribution.

4. **Thank them.** No matter what they say, you want to thank them and let them know how much you appreciate their time and consideration. If they say no, at least you had the opportunity to put your work and projects in front of a potential donor. They might support you in the future, or in a different capacity (for example, introducing you to people who will in fact donate to you).

CROWDFUNDING

As noted above, we use the term "crowdfunding" to refer to a very specific type of fundraising. The basic premise is that someone puts a project, cause, or product online and seeks donations from the public. This typically takes place on a crowdfunding website (Kickstarter, Indiegogo, and GoFundMe are several well-known examples) and features a video, some kind of reward or perk system, and a time-limited fundraising goal (e.g., raise $3,000 in the next six weeks, as four to eight weeks is a typical time period). The organizer usually relies heavily, though not exclusively, on social media to promote the campaign.

Crowdfunding is by no means a new concept—people have been raising money by leveraging small donations from their communities for years, and there have been well-documented examples of this taking place online dating back into the 1990s. But within the past ten years, websites specifically devoted to crowdfunding have proliferated, as has the technology needed to support them, and the amount of money raised through crowdfunding has also grown exponentially. It makes sense—done well, crowdfunding can be a dynamic way to link valuable projects with communities that want

to support them, and people get to be a part of a rewarding and fun event! Artists have been pioneers in this movement and have proven to be especially adept at it. And you can, too. Let's look at the elements of crowdfunding in more depth.

Crowdfunding Campaign Goals

The first thing to recognize when beginning a crowdfunding campaign is that the main function of crowdfunding is to enable you to collect contributions from your own network. While there have been some high-profile examples of people raising huge amounts of money from the general public (the infamous $55,000 potato salad project on Kickstarter in 2014), these are extremely rare. When artists raise a lot of money through crowdfunding, it is usually a reflection of the quality of the network they have built and the energy, effort, and creativity they used in connecting with that network during the campaign. So as you plan your fundraising campaign, keep in mind that you are targeting your own network.

Begin by setting a specific goal. How much do you want to raise? Is it a number that you feel is within the capacity of your network to give (collectively)? Keep in mind that some crowdfunding sites will make you return the contributions if you don't reach your stated goal. And with any kind of fundraising, you want to make sure that you are raising an amount that is adequate to execute your project. Crowd-funding sites also typically take a certain percentage of all donations, so factor that into your calculations.

Customize Your Page

Next, you need to design the page itself. Crowdfunding sites make this simple to do, providing a template for you to upload a video or images, as well as a description of your project. Be strategic about the images and video you select and create. Remember, the goal of a crowdfunding campaign is to generate energy and excitement from your network. Think of it as an online party—it should be fun! The visuals should reflect that.

Perks

Another essential element of the crowdfunding campaign is the "perks" system. When people donate to a campaign, they typically get something in return. This is usually "tiered," so that the more they contribute, the greater the reward. At the lower levels, this can be a simple thank-you and can progress to autographed copies of artwork, exclusive access to events, personal meetings with the artist, a funding credit, and many other benefits. Some artists use this as a form of advance sales. For example, a musician raising money for a recording might offer a copy of the new recording to donors at a certain level, or an author writing a book might offer a copy. Artists can often utilize both their innate creativity and technical skills to create an exciting and effective perks system. Many people are fascinated by an artist's process and consider it a perk just to learn more and be given access to it (private studio tours, dress rehearsal tickets). And depending on your practice, you might easily generate additional copies of work, or other related items, that will have considerable value to your network, such as outtakes, prints, catalogs, sketches, and many other discipline-specific items. Think about perks that can be turned around quickly during the campaign, and that are shareable through social media (perhaps an image, a credit, personalized haiku, or tickets). Ultimately, you will want to gear your perks to what you think will most engage and activate your network, and real-time digital perks can double as a marketing strategy, as well.

Time Line

Consider creating a time line for the campaign. When will you go live, and when will you end? Build a communications schedule into that time line. Even if campaigns are typically four to eight weeks, you'll need to factor in time to prepare in advance. The most successful campaigns are typically those with the most preparation behind them. Once the campaign finishes, you should also factor in time for thank-yous and fulfilling any of the perks you promised. Other things to think about building into your time line include whether

you will begin with an email announcement to your network and contacts to make them aware of the campaign and to seek their assistance. Will this be accompanied by a social media campaign, where you promote the campaign on the various social media platforms on which you are active? Or will you try more of a "soft launch" approach, launching your campaign and letting people know casually as it builds momentum organically?

Regardless of how you launch the campaign, schedule communications at various key points throughout, reminding your network when you have two weeks remaining, or forty-eight hours (or whatever is appropriate given your network and your communications style). The important takeaway that you should strategize about is how to keep your network aware and engaged, to ensure that everyone who wants to give has that opportunity and is reminded to do so.

Most important, inject your own creativity and energy into the campaign! Promote it constantly. Let your network know how important it is. And take every opportunity you can to thank those who become involved. Let them (and everyone else in your network) know how much you appreciate their support and make them feel like a valued, and valuable, contributor. You have created a well-crafted and fun campaign that advances your project and your art and perhaps other important causes, and you have offered contributors a chance to receive exciting perks. People in your network should know about it and have the opportunity to be a part of it, and if you can inject this sense of urgency and energy into your communications, visuals, and perks, your network may carry that forward.

Think carefully about who is in your network and how best to reach them. Identifying, maintaining, growing, and connecting with your network(s) is a theme throughout this book. Crowdfunding is just another opportunity to continue that process. While knowing your network well may allow you to run a more effective crowdfunding campaign, you can also use the campaign to create even more connections within your network, using social media and other platforms to get your art, project, and message into the world, and

to listen to feedback and thoughts from those in your network. As you generate excitement, you will hopefully motivate them to invite others in, as well. By creating an exciting, time-sensitive campaign, you provide extra motivation for your network to reach out on your behalf.

EVENTS

Many artists successfully use events as a means of fundraising. Events can take a number of forms, from a formal gala-style benefit with the express goal of raising money, to a casual opening or gallery visit. Some organizations do the majority of their fundraising from a single, well-planned event. Even if your actual fundraising goals for the event are minimal, there can be a lot of benefits that come from holding it, such as the opportunity to connect with donors or potential donors from your network in person, and for these same people to see your work (or your space) up close. More than almost anyone, artists need to have donors see and experience their work in order to truly communicate its value.

Here are a few tips to keep in mind when planning an event:

> **Is it appropriate?** What is the appropriate event for the kind of people that you want to attract or otherwise reach? Even if you have the resources to hold a fancy gala, it may not be a good fit for your audience, which might respond best to an outdoor barbecue where you perform. Visual artists might throw a party in their studio. For some artists, it is a "friend-raiser" rather than a fundraiser, where the artist is inviting people with the intent of getting to know the attendees and build support for the future. Ultimately you want attendees to feel comfortable, and you want to be genuine and authentic with how you present yourself. On a logistical level, try to be aware of what other events your guests are being invited to, or what other time pressures to which they might

be subject (for example, many galas and benefits take place in March and April, and school vacations in February, etc.).

Manageable for you. Events can be time- and resource-consuming affairs! Some organizations spend a year or more planning galas. Depending on the number of people involved and what you are trying to do with (and for) them, your event can rapidly become an all-consuming nightmare. Think about what you have the capacity to handle, both financially and time-wise. Taking on a commitment that seriously cuts into your artistic time can be counterproductive. Similarly, be sure to create a budget and do a cost-benefit analysis. Generating $5,000 isn't so impressive if you spent as much or more to bring it in.

Do it right. Holding a bad event is far worse than not holding an event at all. Whatever type of event is the right fit for your audience, the end goal is that you want them to learn about your work and, eventually, donate to you. You want to leave them with a sense of confidence that you can execute a project well. A badly produced event is more than a lost opportunity for developing donor contacts, it's leaving your donors with the wrong impression of you. To that end, start with something small and manageable or do a test run with some trusted friends so that you understand your comfort level and can think through all of the variables before you take on something of a slightly larger scale. Also, regardless of the size of the event, create a time line and a list of things you need to accomplish to make it a success.

These caveats notwithstanding, events really can be a fun and rewarding way to build a strong network and individual contacts. Events are also a great way to leverage your supporters and community in creative ways. For example, a local bar might host a night in

support of your project, donating a certain percentage of net profits to you. Or perhaps a supporter who doesn't have much money to give agrees to host a wine-tasting night at their apartment as a donor cultivation event, inviting their friends and covering some of the expenses. More than anything, try to show people that you have things you are working toward, and how you're making progress. Give these potential donors something to get excited about, and something to be a part of.

CORPORATE SUPPORT

Another potentially important part of your fundraising landscape is corporate support. For many artists (and many arts organizations as well), corporate support can be a particularly challenging area to break into. While there is no formula for making this work, let's take a look at a few themes that have proved successful for other artists.

As a starting point, individual artists who do not have a fiscal sponsor face a particularly difficult road. As we discussed previously in the section on fiscal sponsorship, corporate support is an area where sponsorship can be very beneficial. It is also worth distinguishing between corporate foundations and corporations. Corporate foundations operate in much the same way that any other foundation does. Chapter 16 of this book covers grant writing, and the advice there applies to corporate foundations in terms of applications, letters of inquiry, making sure that your project is a good match with the foundation's mission, and the grant process generally.

If you are looking for support from a corporation itself, the calculus changes somewhat, as you will primarily be targeting their marketing budget. And given that their investment in you will be a marketing investment, they will want to know:

Who is your audience? You will want to be able to talk about what kinds of demographics you can demonstrate,

what kind of geographic reach you have, and any other metrics that could be useful from a marketing standpoint.

What can you deliver? What kind of support do you have from your fan base or artistic network? Are you an influencer? Is an endorsement from you likely to translate into further views or sales for the sponsor?

From a PR standpoint, what are you actually doing for them? How is their endorsement being communicated—is it a logo on a program, or something else? How will people see it? And perhaps more important, what kinds of associations will people draw between the company and you? A frequent criticism of corporate sponsorship is that corporations tend to avoid controversial works or artists, preferring "safer" options that won't offend customers. All of these may factor into whether you are able to successfully receive corporate support. An important question is whether your values align with those of the corporation. Corporate support from an entity that acts in a way that is counter to your own values could be a problematic partner.

Local businesses may be a more viable option for many artists. Many companies are interested in creating positive relationships with their surrounding communities, either because these communities represent their customer base or because their employees live and work there. If your project involves the community in some way, nearby businesses could be a viable source of support. And even where small businesses do not have much in the way of cash donations, consider how in-kind donations could help. Local businesses can be an excellent source for space, materials, food, and even volunteer labor, all of which can help to reduce the overall expenses associated with your project.

Another reason why local businesses can be a good option is access. As many companies do not have clearly defined public pathways to

seek donations, knowing someone inside the company is a great place to start (this goes back to networking). Some large companies only make gifts to employee-recommended projects/causes, and others have matching plans that allow their employees to have a greater charitable impact with each gift. When a business is based in your community, there is a far greater chance that either you or someone in your network knows or has access to an influential employee.

Grant Research and Writing

This next section will discuss grants, a specific part of your funding landscape. Generally speaking, a grant is a set amount (or range) of money that is given by an institutional funder, typically a private foundation, public charity, or government entity, and is given to advance the mission or some other objective of the funder.

Many people find it useful to break down the grant application process into three separate phases—prospecting, applying, and reporting. And it's worth noting that, as you may well be working on multiple grants at once, you could find yourself simultaneously engaged in all three of these phases (a spreadsheet can be invaluable here). Let's explore each phase in more depth.

PROSPECTING

Prospecting is the process of finding funding opportunities. NYFA defines prospecting as "research and alignment." We will discuss "research" first, and it's a good time to refer back to our discussion on the fundraising landscape. Remember that fundraising—and especially research—really needs to be a part of your project from the very beginning. And before you begin researching specific funders, take this opportunity to clarify your project as much as possible. Below are a few questions to help you start. If you can answer these thoroughly,

you will have a clearer picture of the needs of your project as well as its fit with potential funding opportunities:

1. What is your specific project?
2. What elements of your project need additional support? For example, travel, research, specific kinds of expertise, space to exhibit or perform?
3. What part of the project are you fundraising for? For example, some projects may take place in separate phases, like production and postproduction in film.
4. What is your fundraising goal? What is the total amount necessary to execute the project successfully? For your own reference, you might try envisioning two amounts, the "in a perfect world amount" (allowing you to complete every aspect of the project without imposing any cost-based limitations) and the "bare minimum amount" (below which you couldn't do the project in any form).
5. Can you answer the Five Ws—What, Where, When, Why, Who, and How? Keep this list as a reference for yourself, as it will be useful throughout the grant process.

Research Tips

In terms of actually researching specific opportunities, we suggest that you start as local as possible. Visit the website of your local arts council (depending on your location, this might be at the city, county, or even state level). Also search other government websites, as there might be grants for community projects that include the arts. For the broadest possible search, we would recommend visiting the Foundation Center, the largest repository of grant information in the country. They have physical locations in a number of cities, and the database is also searchable online. The vast majority of grants listed in the Foundation Center's database are not applicable to the arts (and most require a fiscal sponsor). Also, there is usually a fee for this service. For a more curated (and free) experience, you should also visit NYFA

Source,[27] one of the largest collections of arts-related grants online in the world with more than twelve thousand opportunities listed. NYFA Source is searchable by a host of different categories, including geography, discipline, and type of award, and also has a daily hotline associated with it, where NYFA staff can assist with research questions by phone and by email.

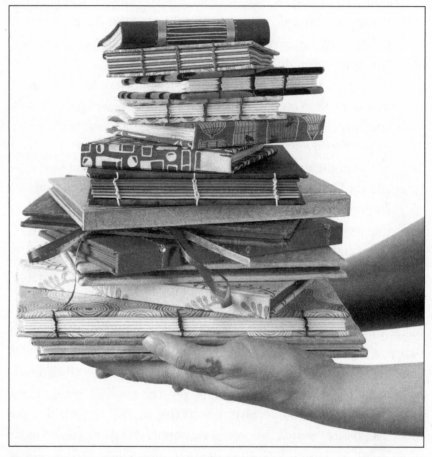

Figure 21. Janna Willoughby Lohr (NYSCA/NYFA Artist as Entrepreneur Boot Camp Participant), Stack of Handmade Books by Janna Willoughby-Lohr of Papercraft Miracles. Photo by Tess Moran.

27 http://source.nyfa.org.

Alignment

The next component of prospecting is alignment. Alignment essentially asks, "Is this program or grant right for me?" Alignment is a two-way street and requires that you have a thorough understanding of the funder's mission and needs, as well as a deep understanding of your own mission and needs. And it is a very practical question, as grant writing (like all fundraising) takes considerable time. Your time is valuable, whether it's spent earning money or for artistic purposes (or both), and you want to be protective of it by applying to things that align with your own mission and needs as an artist.

You can start this internally. Beyond your mission and needs, think about your project's outcome. What change or transformation is achieved as a result of your project? Who is impacted by your project, and how do you quantify or show the outcome?

After answering these questions in relation to your own project, carefully review both the grant's guidelines and the application questions, and see how your project fits with the funder's mission and guidelines. Getting to know the funder (what their interests are and how they support these interests), in addition to thoroughly reading the grant guidelines, helps determine what a good match is. To get a deeper understanding beyond the funder's stated mission, look at the types/style of other projects that this funder has supported in the recent past. Is your project similar to these? Furthermore, what award amounts were given in the past? Is the request amount for your project in alignment, or is it substantially higher or lower than is typically granted? Sometimes the same funder will offer different types of grants with different stated objectives, so be sure that your research applies to the right category. For example, the same organization might offer separate grants to emerging and mid-career artists.

Another valuable step you can take is to contact the program officer responsible for the funder's program. These individuals have an interest in ensuring that the funder receives good-quality applications from

eligible candidates, which in turn helps the funder to fulfill its mission. Whenever a program officer is identified, you should feel free to reach out with questions, particularly about alignment.

APPLYING

Before we discuss some of the common parts of a grant application, it's worth noting that there is no such thing as a "common," or one-size-fits-all, grant application. Each application reflects the unique needs of the funder, as we covered previously under alignment. Overall this is a positive thing, as it means many different types of projects are being funded, even if it means there are no shortcuts.

That said, there are a number of common elements that you will encounter in large numbers of applications. These different portions of the application need to work together to support the entirety of the proposal. With some variation in the names, some of the most typical sections are as follows:

- Letter of Inquiry (LOI)
- Summary
- Narrative
- Outcomes
- Budget
- Work Samples/Letter of Support

Let's examine each in more depth.

Letter of Inquiry

A letter of inquiry (LOI) is a one- or two-page letter to a foundation asking if you might submit a longer application. It should include an introduction, your contact information, and a description of your project or organization. It should also include a description of how your project matches the funder's philanthropic goals (alignment), a statement of need, and a brief mention of confirmed or committed funding sources that you already have, if any. End it with a final

request, something like "I hope you find this project of interest and would be interested in receiving a full proposal. If you would like to discuss the project in more detail, you can reach me at ____. Thank you in advance for your consideration."

The letter of inquiry should be engaging and interesting and reflect your passion for what you are doing in a clear and concise manner. Many funders do not require an LOI, so you should check the guidelines on the application first. In the case of either small family foundations, or larger private foundations that do not have an open application process, LOIs function as a "gatekeeper." In these cases, the LOI is a written version of a cold call.

There is also a growing trend toward electronic LOIs. In these cases, the funders may set the parameters by listing very specific questions and including word or character counts. Always check the funder's website for details about LOIs and how to submit proposals.

Project Narrative

The project narrative is a very important part of any grant application. It's a chance to build interest and excitement for your project on the part of the funder, and to convince them of your project's alignment with their mission. Structurally, it has some similarities to the LOI but is more narrowly focused on the project details. Many begin with an "Executive Summary," a one- or two-sentence summary of what your project is about and how it will fulfill the funder's mission.

Moving into the main part of the project narrative, you should list your background and any qualifications that will help demonstrate why you are capable of successfully executing the project (for example, special technical skills, or a track record of doing projects of a similar size and scope, or with a similar target population). You should then give a thorough description of the project: the who, what, where, and when. You will also want to include a time line or performance schedule of when you will hit key milestones in your project. Most funders will want to know about the audience you will serve, and including numbers and demographics will both demonstrate

your own command over the details and help the funder determine whether your project fulfills their mission. Finally, you should discuss some method of evaluation, so that both you and the funder can know if you succeeded, and how that success will be measured.

To reiterate, there is no such thing as a "standard" grant application, so you should always default to the guidelines that the funder provides in terms of order and what information is required. Make sure to use the funder's language and terms, not just when structuring your project narrative, but to help demonstrate alignment with the funder! For example, if a funder's mission is "to bring awareness to the fate of wildlife in the rainforest," you will want to show how your project will bring awareness to the fate of wildlife living in the rainforest by whatever you propose to do. It will be easier for them to see how your project aligns with their mission if your terminology and style correspond with theirs.

Writing a Project Narrative for Filmmakers

When describing your story, write visually. As people read, they visualize. Without other guidance, the default visualization for the narrative description of a documentary film is generally going to be "talking heads," people talking about the subject matter in a studio, completely disconnected from all other aspects of the film. A talking-head documentary is much less likely to receive funding than a visually interesting documentary. Even when you *are* using interviewees in a talking-head format, offer some description of their unique characteristics. The great power of film is that it is a very empathetic art form. If your film is going to make people feel something, make your reader feel it, too.

Convincingly describe why you are the person who should tell this story. What is it about your life experience that makes you uniquely suitable for this, and why you are compelled to tell this particular story instead of another one?

Work Samples

Work samples can mean very different things depending on the type of grant for which you are applying. In the context of applying for an artistic fellowship or award, this will be primarily about representing your artistic work to the reviewers in the best possible light and ensuring that they understand the size, scope, dimensions, and other physical and environmental elements that make up your work. If you are applying for a project grant, you may need to provide more than just images (or video/audio/textual documentation). If you are submitting images or other documentation for a project grant, the purpose is usually to provide additional context for your project and should be related to it. Other types of project grant work samples might include marketing materials, newspaper articles, or things that help to define the communities you are working with, like maps or census report abstracts.

Regardless of the kind of grant, there are some general tips to keep in mind whenever submitting work samples.

- **Follow the guidelines**: While this is a theme we keep returning to, we cannot overemphasize it! If the funder instructs you to use specific naming conventions, file types, or sizes, or anything else, make sure you adhere to that.
- **Label**: Unless the funder instructs otherwise, make sure to label your work samples with your name, the title of the piece, the year the work was created, a description of the materials used (if relevant), and the size and/or duration of the sample.
- **Descriptions**: Include a description of the work or technical statement. This is especially helpful for work that has a specific process or technical component.
- **Think of the viewer**: Ask the funder how the work sample is going to be presented. On a computer screen, in print, displayed on a wall, played through a DVD player

or over a particular kind of speaker system? For literary artists, will it be read electronically or on paper?

- **Order**: Think about the order in which you want your images to be seen, or your music/film/choreography to be seen. Is there a logical progression? Is there some reason why you would not want reviewers to experience it sequentially?

- **Ongoing documentation**: Invest in documentation of your work on an ongoing basis. Just as you need to track and categorize your expenses for tax and budgeting purposes (see Chapter 6), you'll want to have high-quality, compelling, and engaging representation of your artwork from every period of your career.

Finally, contact the funder's program officer responsible for the grant if you have any questions about what should be included, formatting, labeling, or anything else related to your work samples. If the funder has a preference or requirement, the program officer can help you, especially in cases where the published guidelines are unclear or incomplete.

A note on filmmaker work samples

Unlike some other disciplines where a work can be captured by a single image (or is a single image), or takes place in a shorter period of time that allows for submission of the entire work, filmmakers can face challenges in selecting a work sample that represents and summarizes the larger film. This is especially true when the application is for a film that has not yet been made. Because of these challenges, filmmakers should be especially careful to include descriptions of their project (where possible) that will make it come alive in the minds of the reviewers. As we discussed in the section on project narratives, one approach is to try to describe everything visually. Use adjectives to let reviewers see the landscape and environment in which the film takes place. It doesn't have to overly wordy. Meaningful words, like

"desert" or "city," provide valuable information, and short descriptors like "residential" or "run-down" help to paint a more vivid picture. And if characters are a big part of the proposal, let the reviewers see them—what do they wear, or descriptions like "he was ninety but looked fifty," or "her face was weathered from forty years of farm work."

When submitting actual work samples, remember to use a piece of your film and not a promo or a trailer. If the sample is from a particular stage of production, explain that (for example, a rough cut). Select a piece of the film that captures what your proposal is about, or if you are submitting prior works, use pieces that capture those filmmaking qualities that you highlight in your application. Choose a sample that illustrates the essence of the film or of the main character. If more than one sample is requested or allowed, choose them to show a range of content and emotion. When providing multiple samples, put shorter ones at the top of the list. Get the viewers' attention and draw them in, then get them involved in longer samples. And if there is no work in progress to use as a sample, and previous work is not requested or allowed, a script or treatment will probably be necessary.

Project Budget

A budget is not required for every grant application—artistic fellowships and awards frequently do not ask for one—but for project grants, it is one of the most important elements. Before we look at project budgets in detail, we wanted to take a minute to acknowledge that many people feel intimidated by budgets and numbers, as it's often an area where they lack experience or training. For many people, artists and nonartists alike, money can be a very stressful thing.

However, as we discussed in Chapter 6, budgeting doesn't have to be that way! In fact, in the context of a grant application, budgets really just tell a funder the story of your project. Especially for larger or more complicated projects like films, your budget shows details like how many people are involved, the materials used, any travel, and/or things like animation, music, and special effects. Some of

these budget items may not have been emphasized in other parts of the application and will inspire a different way of understanding your project. The budget may reveal a larger and more complex story than it seems from a first reading, or it may indicate that you are committed to doing a great deal with minimal resources.

A project budget differs from a personal or organizational budget in that it is a specific amount of money allocated for a particular purpose, over a specific period of time. For example, directing a film or play, curating an exhibition, or writing a book could all have project budgets associated with them. Your project budget should have two parts to it, expenses and income. Expenses are all of the costs associated with your project and include categories like personnel, production costs (such as purchasing materials and renting space), documentation, and publicity/promotion (including printing, postage, and website costs). Income can fall into several different subcategories. There is earned income, which includes commissions/fees, salary, sales, stipend/honorarium; contributed income, such as foundation grants, individual contributions, corporate support, government support, and money raised through special events; and in-kind donations, which often include space and materials that are contributed. When noting income on your budget, remember that it can be "Received," meaning that you have it; "Committed," meaning that the income is confirmed but not yet received; or "Projected," meaning that you hope to get it.

In terms of actually constructing a budget for the purposes of a grant application, use a spreadsheet to format it—not only does that provide a clean and organized look, but it greatly reduces mathematical errors. Excel works well, as do any number of free online spreadsheet programs like Google Sheets. Create a line item for each category in both Expenses and Income, such as those discussed above (personnel, space, sales, etc.). When you finish making your budget in the spreadsheet, save it as a PDF, ideally as a single page and in the "portrait," not "landscape," setting. You will want your budget to be balanced, meaning that the expenses and income are the same. In

balancing your budget, remember to account for in-kind donations, which are income, by including the expense the donation covers on the expense side. An unbalanced budget can raise questions for the funder, such as how you will be able to complete your project if the expenses are greater than the income, or questioning why you need financial support if the income exceeds the expenses. If there are any numbers that you feel require additional explanation, include budget notes doing so. These are typically done as numbered footnotes/ endnotes and would appear at the bottom of your budget sheet underneath the various line items and totals.

Ultimately, the goal of the budget is to answer all of the funder's questions about your project! Check your math (for the numbers people reviewing it) and double-check the language (for the "words" people reviewing). Mislabeling a line item can throw off all of the internal logic of the budget, even if your math is 100 percent correct. Ask for the amount of money that you need, not for the amount that you think they want to hear. Remember, as we discussed in regard to alignment, if you've done your "prospecting" thoroughly, then you'll already be applying for a grant where the amounts awarded align with your needs. Be honest and realistic when putting your budget together and reflect the level of detail asked for by the funder in the application guidelines. Again, here as in all other aspects of grant writing, the funder's guidelines trump everything else, including anything in this chapter.

Some additional budget considerations: projections and compensation

One area that consistently generates questions is that of "projecting" expenses (and sometimes income). When putting together a budget for a future project, especially one that you have never done before, how do you project what the costs will be? Many expenses can be checked fairly easily, especially for things like supplies and artmaking materials, and you can get fairly accurate pricing online. Services like accounting or website design can be a little less predictable, but

a good technique can be to try to obtain quotes from three different professionals in your geographic area, or at least who are providing services in your area. This will help you to establish fair market value (FMV) for the service in question. Projecting income should also be subject to a "reasonableness" test. It is completely acceptable to list grants that you have not received, but for which you are applying, under projected income. These of course need to make sense—for example, an artist who lists a MacArthur Fellowship, an award to which you cannot apply (because you must be nominated), is not reasonable. But listing a grant targeted for emerging arts educators in a particular county, when you are an emerging arts educator living in that county, is definitely reasonable and can be listed as projected income.

A related question that many people have when constructing a budget is, what if my costs change? Am I locked in or committed to the numbers in my budget? In almost all cases, the answer is no. A budget is a living document, one that you will update frequently and as new information becomes available or circumstances change. Funders also understand that budgets are not static. Furthermore, most grant panels are comprised of professionals in the arts who have seen many kinds of projects in different disciplines. So not only will they have a sense of whether a projected expense or income stream is realistic, but they grasp how fluid and dynamic new projects can be. As long as you have built your budget that is both reasonable and based on verifiable information, you should be able to adjust as necessary.

We also want to touch on another issue that frequently arises when constructing project budgets, that of compensating artists—and your-self—for their time. Too often, artists shortchange themselves in the artmaking process. NYFA firmly believes that art and art workers have value, and any legitimate arts funder will recognize that, as well. When you construct your budget, it should reflect that value. Obviously, how much you pay yourself (and other artists) will vary depending on the type of project. Some considerations in determining an appropriate amount include whether the project is not-for-profit or

commercial, what the going rate is for your field, and whether you're paying a flat fee or an hourly rate. Like with other service providers, knowing a range of artist fees and hourly rates will help you to determine FMV, although we acknowledge that there can be a wider variation in artist fees than in many other industries. But having a range of quotes to reference will help to give a frame of reference. And when setting your own fees, there are some very practical considerations to take into account, as well. What do you need to survive, and what do you need to cover your expenses? In most cases this will help provide a baseline, though as we discussed in Chapter 6, these questions can be part of a broader and more sophisticated analysis.

Even though many people find budgets to be intimidating, we hope that following some of the simple tips outlined here and in Chapter 6 will help you to embrace them as an invaluable tool for communicating your project through numbers. Once you have created a project budget, continue to revisit and rework it as your project develops and changes. Do this for yourself and your own project management, and it will make applying for grants easier, too.

REPORTING

Congratulations! The funder approved your grant application—that is excellent news. There are a few steps you should take immediately, and a few others in the near future.

First, send a thank-you note. Like most everyone else, funders like to feel appreciated. Plus, they have just invested their confidence, money, and institutional support in your project, and hearing from you just affirms that they made a good decision. More important, it allows you to begin building a relationship with the funder and any of the relevant support staff. There will likely be questions that you have along the way, and perhaps even amendments to your original application, so a good line of communication is important. And depending on the funder and the grant, you may be eligible for future funding, as well.

Next, notify any other relevant parties. If you applied as part of

a collective, or promised to work with a particular artist, vendor, or service provider, let them know that the project has received funding as soon as possible. This ensures that you'll be able to deliver on what you promised in the grant application.

After you've taken those initial steps, look at the reporting requirements for the grant. Like grant applications, reports will vary according to the funder. Some will ask for a single report at the end of the project, while others need updates throughout in the form of interim reports. Make sure that you understand the requirements right from the beginning and follow up with the program officer if necessary. A related issue is that of documentation. You'll want to document aspects of the project for your own purposes anyway, but some funders have very specific documentation requirements, including metrics or other items that are hard to reconstruct or obtain after the fact. And in certain cases, funders are reimbursing you for expenses, so saving receipts and invoices can be essential for receiving grant funds.

Finally, share the good news with your network (provided the funder has given you permission to do so—sometimes funders will notify you of your selection before they make a public announcement, and most funders will want to make the first public announcement in the form of press release). It's a great opportunity to let people in your network know about your project and its success, which can only open up more options in your fundraising landscape.

MOVING FORWARD (IF YOU ARE REJECTED)

First, don't get discouraged. There are far more projects seeking funds than there are funds available, and most successful artists have had artistically excellent, socially worthy projects be rejected, numerous times. If you can, contact the funder for feedback. Not all funders will give feedback, but many do, and getting the perspective and reaction of a review panel is invaluable. You should ask about reapplying in the future, and if possible incorporate the feedback you received into your next application.

Also, consider sending a note to acknowledge the funder's consideration. There is a lot of time and effort that goes into putting together a grant panel, and someone who is actively giving money to the arts and supporting projects like yours is doing a positive thing. They are also potentially a very good contact. If it's appropriate, keep in touch with them about any new developments with your project.

SOME ADDITIONAL TIPS

In our decades of supporting artists in their fundraising efforts, NYFA has identified a few techniques that have served your fellow artists well. The first is to consider preparing an application checklist. Before you begin writing, go through the application carefully. For each question in the application, list the specific concepts a funder is asking you to supply in that section. Is it about metrics, or the steps to produce the work, or your key partners? Some funders will ask very specific questions, whereas others will be more general and require you to construct and organize the narrative. In either case, having a personal list of information you need to convey will be a helpful tool for organizing your thoughts and making sure you address those things that are truly important to the funder.

You can then answer the questions on this list in short answers or bullet points, and then use these as the building blocks for writing. Pay particular attention to any reporting details and measurable outcomes, because you might be able to write this into your application.

Another highly effective technique for successful grant writing is to find a "grant buddy," or someone who can assist you by reviewing your application. This goes beyond simply proofreading, though that is a valuable function. Ideally, you should find someone who is not affiliated with your project to be a reader and listener throughout the application process. It should also be someone who can reliably give you honest feedback, regardless of how close their relationship is with you. Begin by inviting this person to read the guidelines of the grant application, without letting them know anything about your

project proposal. Then, read aloud your summary or narrative and ask your partner to restate what they heard. If it doesn't seem clear or sound like what you intended, that likely means that it won't be clear to the funder either, and you should consider reworking your application until you can make the narrative more clear. Keep in mind that it's not the listener's fault if they don't understand. And, you're not alone—most of us have difficulty initially explaining and communicating our ideas! We're often so in our own heads when working on our projects, and it's easy to forget to communicate important details related to project feasibility. And there are often problems translating something from one medium into descriptive words on paper. Like any aspect of your practice, it takes time, repetition, and constructive feedback for you to build that skill. A grant buddy can be an invaluable resource in this regard.

KEY TAKEAWAYS FOR GRANT APPLICATIONS

Grant writing can be a time-consuming, detail-oriented process but can also have important benefits for your project or practice that go beyond the most obvious ones of the financial resources that you receive should your application succeed. Just the act of researching and writing an application can make you more aware of potential supporters and resources in your community and can help you to organize your own thinking about your project or practice while honing your ability to communicate it. Here are a few important takeaways to keep in mind as you begin your grant-writing work:

1. The fundraising landscape should be part of your project from the beginning—and grants may be part of that landscape.
2. Make sure your work fits with the funder's mission and needs.
3. Grant, proposal, and application writing is a skill—you will get better at it with practice.
4. Pay close attention to details and stay organized.

5. Have a comprehensive understanding of your project's needs, mission, budget, time line, audience, goals, and resources/partnerships.
6. Know your narrative—the story of what your project is, why it is important, and whom it will serve.
7. Pay close attention to each set of grant guidelines—read and highlight key concepts, look up unknown words, refer to guidelines when writing.
8. Revise your materials for each grant application and keep your materials up-to-date.
9. Ask for advice and feedback—a friend or colleague to be your grant buddy.

This checklist can be a reference guide when doing your own grant writing. Furthermore, many of these takeaways apply to the other aspects of your fundraising landscape, as well!

Pulling It All Together
Entrepreneurship in the Arts and Creating Opportunities

This book is about giving practical information, without editorializing. In many ways, that is the hallmark of NYFA's Learning programs, where we have worked with thousands of artists with great impact. We always emphasize bringing in the most updated, impartial expertise, but we don't tell artists how they have to use this information, nor do we prescribe what path they take. This is because we believe that artists are uniquely equipped to absorb the lessons of the business world, and in turn to innovate with them, writing their own rules in a highly creative and individualized way that supports their practices and projects. There is no magic formula or monopoly on information.

Taken as a whole, the topics covered in this book can give you a meaningful start on the tools and resources that you'll need to further build your practice or execute a project. However, information alone does not guarantee a successful outcome. And while nothing can actually guarantee success, we will share some common elements we have observed about successful projects, practices, and businesses. These include collaboration, openness to creative opportunity, and perseverance. Before we explore these in greater depth, however, let's briefly recap what was covered in the previous chapters.

We began by looking at planning and goal setting in section 1, followed by a review of the Business Model Canvas. Exercises such as defining your mission and vision can help provide clarity and focus

to you, your supporters, and the outside world. SMART goal setting can help you to create meaningful goals that work for you. And the BMC and Lean Methodology offer proven tools to refine your business model, identifying your unique value proposition, the people who want it, and how to reach them.

We then went through some essential elements of the legal issues that impact artists' careers and businesses, starting with protecting your intellectual property (and avoiding potentially misusing the intellectual property of others). We examined contracts, the agreements that govern so many of our business and artistic relationships. And we also explored what types of business entities had what advantages for conducting your business and offering you protection.

Next we covered financial issues, beginning with the process of building a budget and how it could be used in service of financial and other goals. We defined a number of terms that were related to accounting and taxation and then went through savings vehicles and other sound practices for your personal financial health, including considerations for managing and growing your savings, and also insurance. We closed the section with a brief overview of preparation in the event of an emergency, and some useful resources should you ever find yourself in need of assistance.

The next section dealt with marketing, and how it could be used in service of your practice or project. We looked at determining your place in the market and connecting with your target audience and then went over practical tips for creating a communications time line. We also looked at some traditional marketing theory related to branding and offered some alternatives for artists. We surveyed the various tools at your disposal, including social media, websites, traditional media, and analytics, and concluded with some thoughts on creating a marketing budget.

We then looked at the issue of pricing your work, which is closely related to marketing. We examined pricing in several contexts and media but placed an emphasis on the complexities associated with pricing visual work.

Finally, we went through the fundraising process, presenting a "fundraising landscape" that you could tailor to your individual strengths and needs. We analyzed individual giving, both in person and online and through crowdfunding campaigns, as well as fundraising tools like fiscal sponsorship. We emphasized the importance of building a network—which is integral to many other areas of this book as well—and finished with a discussion of grant research and applications.

As we said at the beginning, this book is mainly about presenting information to you, for you to use however you see fit. But in the years that NYFA has worked with artist-entrepreneurs, we have observed that there are other, less tangible elements that can lead to success. These are collaboration, openness to creative opportunity, and perseverance, and we will look at each in turn.

THE POWER OF COLLABORATION

According to Catherine Yu (NYSCA/NYFA Fellow in Playwriting/Screenwriting), "Collaboration requires the practice of listening, along with the balancing of the pursuit of truth in the work with the artistic and emotional history of your collaborators. It's not enough to go with your gut—you have to be responding to what's around you. That practice of listening is not just true in art but across all industries." Catherine Yu (NYSCA/NYFA Fellow in Playwriting/Screenwriting)

Within your network, there are other artists (and some nonartists) who share your goals. If you can identify the similar interests and goals of those around you, leverage shared resources, and create collaborative structures that are mutually beneficial, you will have accessed your community in an even more meaningful and productive way.

Collaboration is the ultimate multiplier, lifting you from a one-person endeavor to (potentially) a community-wide initiative with different skills and resources at your disposal. The entrepreneurial world has certainly recognized this—many of the top business incu-

bators will only select and invest in startups that have strong teams, as it demonstrates that the founder(s) can work collaboratively (as well as spreading the risk and bringing in greater human resources). As an artist, at the most basic level you can think of this multiplier effect in terms of building an audience. If two artists each know ten people who would attend their exhibition, then by holding a joint exhibition, they have a chance of attracting twenty people.

On a more complex level, an effective collaboration can allow an artist to fundamentally shift both their individual landscape, and that of the larger community. A great example of this is the former organization called "13P." Their website states the following:

> 13P (Thirteen Playwrights, Inc.) was formed in 2003 by thirteen midcareer playwrightsconcerned about what the trend of endless readings and new play develop-ment programs was doing to the texture and ambition of new American plays. Together we took matters into our hands, producing one play by each member playwright. We presented our final production in the summer of 2012 and then immediately imploded.[28]

The members of 13P assumed different roles, creating an organi-zational structure for a finite period of time. However, it remained an egalitarian effort, and each member was expected to be an equal contributor, working on behalf of the others. It succeeded and gener-ated a lot of attention from the press and the theater community, but it was ultimately born of the frustration that the members had with their own careers and their inability to change the landscape individually. So they identified others in a similar situation and then leveraged their collective power. On an artistic level, one of the most significant aspects of 13P was that no member had to sacrifice their artistic vision. The person whose turn it was to have their play

28 "13P," *13P*, accessed December 14, 2017, http://13p.org/.

produced retained complete artistic control of the product, while the others worked on that playwright's behalf.

NYFA has seen other very effective collaborations come out of our own programming. Alums of NYFA's "Artist As Entrepreneur" program in Guatemala formed a collective that organized joint exhibitions in New York and Rome, pooling collective contacts and resources to share the related costs of shipping and organizing. New York City–based alums of the same program staged a multidisciplinary arts festival spanning several weeks and more than fifty artists, while dividing the labor accordingly. And Buffalo, New York, alums collectively organized a multidisciplinary group exhibition of twenty-seven artists, with help from Art Services Initiatives of Western New York. When they work together with shared purpose and for mutual benefit, artists can achieve extraordinary results.

Figure 22. Felix Endara (Artist as Entrepreneur Boot Camp for Artists of Color Participant), *Consent Is Sexy*, a collaboration between filmmaker Felix Endara and visual artist Em North, during the latter's artist residency at SOHO20 in Bushwick (Brooklyn), August 2016. Photo by Rachel Steinberg.

OPENNESS TO CREATIVE OPPORTUNITIES

While vast differences mark the techniques, training, and practices of various artistic disciplines, virtually every artist shares the following traits: an ability to recognize obstacles, the inventiveness to find an alternative solution, and the mental flexibility to adjust their original plan. Since the beginning of time, external factors have limited artists' abilities to execute their ideas. Paint dried too quickly, instruments could only extend to certain ranges, film could just capture so much. And yet artists still created masterpieces. The artistic process demands that artists recognize and capitalize on creative opportunities to achieve their goals.

The world of business and entrepreneurship is the same. Great entrepreneurs face innumerable challenges at every step, but they respond to closed doors by building new doors, using windows, or finding a way to make the space to which they have access an ideal place for their business.

NYFA has observed that the most successful artists are able to translate their artistic process into actionable career steps. Those who do are able to make use of all the resources at their disposal, such as atypical funding sources, positive professional relationships and collaborations, people who want to help them, and imperfect opportunities. For some, it's an innate sense that a particular path is worth pursuing, even if it's hard to justify that path from a purely economic standpoint.

And yet, there are others who find it extremely difficult to translate the enormous creativity and adventure of their artistic practice into their professional practice. For many, it's a function of being unfamiliar with the kinds of topics we address in this book, such as law and finance. In the face of something that is unknown and potentially risky, people fall back on things that have worked in the past, either for themselves or others like them. There is nothing wrong with starting from a place of familiarity and confidence, but our hope is that the tools and information provided here will give artists an

increased sense of comfort such that they can bring their openness to creative opportunity from their art into their projects or career. Many of the greatest and most rewarding results come from an unconventional turn.

PERSEVERANCE

Perhaps the most important quality for any artist or entrepreneur is perseverance. When the audience experiences an artistic work or interacts with a company or product, they only see what is in front of them, in real time, as if the art or business came into being fully formed. It is nearly impossible to appreciate *all* of the elements that went into the creation: the years of practice, trial and error, and earlier prototypes. However, artists and entrepreneurs spend the majority of their time engaged in work that will never be seen, or which will result in a discarded draft.

Most great success stories begin with a tireless individual (or group) that perseveres in the face of long odds, mistakes, and rejections, until they finally get their vision right. Steve Jobs, considered one of the great entrepreneurs of the century, was famously fired by his own company, only to return years later to lead Apple to new heights. Oprah Winfrey was fired from her first job on television but later became one of the most powerful names in the history of the television industry. And countless others have had their work or ideas repeatedly rejected by established tastemakers, institutions, or investors but continued to push forward anyway, never losing their drive or focus. The ability to do that is perseverance.

One of the incredible (and transferable) qualities that artists have is their ability to persevere and continue working. Perhaps the most amazing thing is how deeply ingrained this is into the artistic practice. In fact, the very word that is most often used to describe the working life of an artist—an artist's practice—implies that artists live in a constant state of evaluation, refinement, concentration, and effort. Furthermore, artists actively seek this out. The intense competition for

residencies or studio/practice space illustrates that artists crave more time and opportunity to work on the unseen elements of their work.

Much like openness to creative opportunities, perseverance does not always translate from the artistic world into the business world. Some very patient, methodical, and diligent artists give up after one grant rejection, or become frustrated with understanding legal or financial issues, choosing to focus on what they know instead. Again, much of this can be the result of unfamiliarity and fear, which is understandable. This book should help to ease some of that. But we would encourage anyone reading to remember that, as an artist, you persevere every day, as part of your practice. If you can approach the business side of your project or practice in the same way, you will bring an incredible tool with you—and one that you share with the great entrepreneurs throughout history.

Acknowledgments

The new edition of this book would not have been possible without the contributions of the following individuals:

Amy Aronoff
Zahra Banyamerian
Judith K. Brodsky
Judy Cai
Joni Cham
Veena Chandra
Devesh Chandra
JunYi Chow
Mirielle Clifford
Peter Cobb
Sarah Corpron
Maia Cruz Palileo
Madeleine Cutrona

Alicia Ehni
Jonathan Ehrenberg
Felix Endara
Elissa Hecker
Felicity Hogan
Jocelyn Jia
Swarali Karulkar
Evy Li
Rosalba Mazzola
Chris Messer
Elina Onitskansky
Mark Rossier

Michael Royce
Svea Schneider
Julian Schubach
Marco Scozzaro
Matthew Seig
Zak Shusterman
Luiza Teixeira-Vesey
Barbara Toy
Maria Villafranca
Mara Vlatković
Janna Willoughby Lohr
Catherine Yu

In addition, we would like to further acknowledge the excellent written contributions by Elissa Hecker, Esq., for Chapters 3 and 4 (covering intellectual property and contracts), Zak Shusterman, Esq., for Chapter 5 (covering business entities), Rosalba Mazzola for Chapters 6 and 7 (covering budgets and financial terminology), Julian Schubach for Chapters 8 and 9 (covering personal finance and money management), Mara Vlatković for Chapters 11 and 12 (covering marketing timelines, social media, and email). Their efforts, expertise, and positivity were invaluable to this project.

Finally, we want to make special mention of the NYFA Learning Team. They provided countless hours of brainstorming, expertise, and inspiration for this new edition, which is a reflection of their ongoing daily work with artists. And a very special thank you to Zahra Banyamerian, as we would not have completed this project without her tireless efforts.

Index

Books from Allworth Press

The Art World Demystified
by Brainard Carey (6 × 9, 308 pages, paperback, $19.99)

The Artist-Gallery Partnership
by Tad Crawford and Susan Mellon with Foreword by Daniel Grant (6 × 9, 216 pages, paperback, $19.95)

The Artist's Complete Health and Safety Guide (Fourth Edition)
by Monona Rossol (6 × 9, 576 pages, hardcover, $34.99)

The Artist's Guide to Public Art (Second Edition)
by Lynn Basa with Foreword by Mary Jane Jacob and Special Section by Barbara T. Hoffman (6 × 9, 240 pages, paperback, $19.99)

Business and Legal Forms for Authors and Self-Publishers (Fourth Edition)
by Tad Crawford with Stevie Fitzgerald and Michael Gross (8½ × 11, 176 pages, paperback, $24.99)

Business and Legal Forms for Fine Artists (Fourth Edition)
by Tad Crawford (8½ × 11, 160 pages, paperback, $24.95)

Business and Legal Forms for Graphic Designers (Fourth Edition)
by Tad Crawford and Eva Doman Bruck (8½ × 11, 256 pages, paperback, $29.95)

The Business of Being an Artist (Fifth Edition)
by Daniel Grant (6 × 9, 344 pages, paperback, $19.99)

The Creative Path
by Carolyn Schlam (6 × 9, 256 pages, paperback, $19.99)

Fund Your Dreams Like a Creative Genius™
by Brainard Carey (6⅛ × 6⅛, 160 pages, paperback, $12.99)

How to Survive and Prosper as an Artist (Seventh Edition)
by Caroll Michels (6 × 9, 400 pages, paperback, $24.99)

Legal Guide for the Visual Artist (Fifth Edition)
by Tad Crawford (8½ × 11, 304 pages, paperback, $29.99)

Making It in the Art World
by Brainard Carey (6 × 9, 256 pages, paperback, $19.95)

New Markets for Artists
by Brainard Carey (6 × 9, 264 pages, paperback, $24.95)

Selling Art without Galleries (Second Edition)
by Daniel Grant (6 × 9, 256 pages, paperback, $19.99)

Starting Your Career as an Artist (Second Edition)
by Stacy Miller and Angie Wojak (6 × 9, 304 pages, paperback, $19.99)

To see our complete catalog or to order online, please visit *www.allworth.com*.